THE
DOCUMENTARY
IMPULSE

STUART FRANKLIN

INTRODUCTION: A 'CREATIVE TREATMENT OF ACTUALITY'

On Sunday 11 January 2015, two million people marched, or for the most part shuffled shoulder to shoulder, through central Paris to express outrage at the killing of journalists, cartoonists and police in the attack a few days earlier on the satirical newspaper *Charlie Hebdo* in the French capital. It was an unprecedented demonstration of support for a principle at the heart of French history: freedom of expression. Images of defiance appeared on newspaper front pages and in the streets around the world.

Two images sat side by side on social media sites that day. The first was a Eugène Delacroix painting completed after the 1830 July Revolution, *La Liberté Guidant Le Peuple*, which inspired Frédéric Auguste Bartholdi's *Statue of Liberty*. The second was a photograph from the day of the march by the photographer Stéphane Mahé, captured as the light was fading around the Place de la Nation. Both images show the French Tricolore backlit by sunlight. The Delacroix painting, though imaginary, set out to evoke the spirit of freedom that reigned in the queen of cities on that summer day in 1830. Mahé captured that same spirit a little less than two hundred years later.

Both these images were born of what I call the documentary impulse. By this I mean the passion to record the moments we experience and wish to preserve, the things we witness and might want to reform, or simply the people, places or things we find remarkable. The driving factors behind this impulse throughout history have included curiosity, outrage, reform, ritual, self-assertion and the expression of power. These factors encompass the search for evidence, for beauty, even for therapy – and always the search to make memories immortal.

I am a documentary photographer, an enthusiast of the work of others and a collector of photobooks. The future of the medium, therefore, is close to my heart. Over thirty years of working as a photographer, I have been impelled by almost all these motives, barring ritual and the expression of power. I could mention other, more prosaic impulses, too – money, for instance. Photography has been my way of making a living since 1979 and many of my assignments derive from a need to pay bills. However, if I were to rank what excites me most as a photographer, curiosity would take pole position: both journalistic curiosity and also existential

curiosity, which relates to seeking an understanding of one's place in this life and how things interconnect under that large sky.

The documentary impulse underlies an aspect of human self-representation that began thousands of years ago, long before the invention of film or photography and centuries before astronomers, and later artists, used the camera obscura to plot the heavens or trace perspective. This book, however, focuses largely on documentary photography, from the first traces of light captured on mirror-like surfaces of iodized silver to today's dazzling Internet projections or vast 'tableau' installations in major museums.

But just what is documentary? The Scottish filmmaker John Grierson used the term in reference to a film by Robert J. Flaherty, when Grierson spoke of a 'creative treatment of actuality'.[1] It is this essentially flawed definition that this book reflects, considering documentary not as something fixed in a moment but as a creative process full of contradictions about photography, documentary, reality and truth. The nineteenth-century critic John Ruskin elaborated on the distinction between 'moral truth' and 'material truth' in his discussion of J.M.W. Turner's efforts to paint what he felt emotionally, in preference to or as well as what a camera might have recorded. Ruskin felt the 'truth of impression' to be more important than 'material truth'. In the documentary impulse, two species of 'fact' exist side by side: one is coolly objective and the other is fraught, diverse and emotive; one figurative, the other abstract; one prosaic, the other poetic; one factual, the other romantic.

For someone more accustomed to images, words can be confusing. Take the terms photography, propaganda and documentary, all of which relate in different ways to the documentary impulse and all of which describe activities that predate the names. 'Photography' (derived from the Greek for 'drawing with light') was first practiced in 1839 yet describes a process dating to before the Renaissance, when artists began using the camera obscura to draw scenes from life projected onto a plane surface, enabling the artist to envisage space through linear perspective. 'Propaganda', whose original meaning referred to a committee of Catholic cardinals responsible for propagating the faith overseas, evolved into the modern pejorative term in the wake of emergent nineteenth-century communism.

The mode of persuasion to which it refers today, however, is a practice thousands of years old.

As for 'documentary', although Grierson first used the term in Britain in 1926, the French word *documentaire* had already been in use for some time to describe serious films about travel and exploration[2] and in the United States the term was applied to factual filmmaking as far back as 1911. Grierson, however, lent it new meaning. He first met Flaherty in New York in 1925, after Flaherty had made one of the earliest feature-length documentary films, *Nanook of the North* (1922).[3] The film tells the story of an Inuk family's struggle for survival in the frozen wastes of northern Quebec. It was Flaherty's second film, *Moana* (1926), a poetic record of Polynesian life, that Grierson described as having 'documentary value' – bringing the term 'documentary' back to life.

Notwithstanding the fact that several scenes in Flaherty's films were staged – notably a walrus hunt in *Nanook* – Grierson's idea of documentary asserted the importance of intimacy over actuality: 'Intimacy with the fact of the matter is therefore the distinguishing mark of documentary, and it is not greatly important how this is achieved.'[4] Further developing his idea, Grierson later claimed that the Hollywood version of John Steinbeck's 1939 novel *The Grapes of Wrath* was as valuable a documentary artifact as the recording of an actual event: 'Many films shot on location and face to face with the actual are much less documentary in the true sense than *The Grapes of Wrath*.'[5] Grierson accepted that staged filmed events, fiction and – by extension – paintings, relief-carvings and so forth were as valid as photographs in revealing intimate knowledge of actuality, the facts of the matter. This is why I claim that both the Delacroix painting and the Mahé photograph qualify as documentary.

Photography has no special status in this generalized search for truth. It stands alongside painting, sculpture, film, fiction or any diarized account. But what photography can contribute in a way other artistic and literary works cannot is its serendipitous take on life, its surrealistic freshness of vision – effortlessly revealing surprising juxtapositions and, as the writer Max Kozloff has suggested, scenes 'that could not have been imagined'.[6]

Yet to think of photography's evolution as something singular

or geographically coherent would be a mistake. The history of picture-making and documentary practice in ancient Egypt, India, China, West Africa or Latin America is markedly different from what we've experienced in the United States or in Europe. Even in an era of 'globalization', photography carries in its train a disjointed community impelled to document in a variety of ways, for so many different reasons. The visual language has fragmented over time so that, as in the biblical myth of the Tower of Babel, we are left so disconnected as to be almost unable to understand each other's language.

How do individual photographers attempt to be understood? Consciously or not, they deploy tools from what Roland Barthes has referred to as the 'rhetoric of the image'.[7] To take an example. I took a photograph in 1998 for *National Geographic* of a beach near Guayaquil in Ecuador where the fins of hammerhead sharks are traded for cash. Pirogues lay close to the shore where the sharks' fins were hacked off with machetes. The colour of the water turned rapidly from turquoise to blood red. By focusing on the blood-red sea, I drew on the connotation of voluminous spilt blood, which usually implies butchery, massacre or bloodbath. Human blood, like sharks', is red, so what is connoted to the viewer, subliminally perhaps, is that *our* common blood is being spilt. The rhetorical force of such imagery is so powerful that environmental groups commonly trade on highly saturated imagery of animal blood in their campaigns against seal culling and whale, shark or dolphin fishing and hunting.

Another consistent method in which individual photographers attempt to be understood has been with the use of the photobook. From its beginnings with Maxime Du Camp's *Egypte, nubie, palestine et syrie* in 1852 – the first completely realized photobook – photographers have used the book format to present a narrative that may be descriptive, experimental or polemical. Collectively, photobooks have achieved a great deal. Within documentary photography they have opened up space for subjectivity, and they have also been a catalyst to drive forward the visual language of photography. Magazines have done this, but what makes photobooks special is that they are, more than anything, personal statements.

Traditionally, documentary photography has been defined narrowly as either a mode of objective data compilation or a tool for

social reform. For me, what's most interesting about documentary practice is the living record of *extraordinary* people, places and stories that emerge from our collective 'creative treatment of actuality'. This book therefore does not dwell on the recording of populations for the purposes of surveillance, identification and so forth, or on the important work that has been done through evidence-based documentary. Nor do I dwell on the use of 'found photographs' or the purely commercial uses of photography.

I began thinking about this book after a concerning episode in 2013. It was reported on 30 May that the entire photographic staff of the *Chicago Sun-Times* – 28 employees – was to be laid off. Online video, the newspaper believed, was the way to meet the future needs of its 240,000 subscribers. At the same time about 80 per cent of newspaper photographs in Europe were published without a credit. I concluded that photography has been reduced to a lowly subaltern status, serving in most cases merely to illustrate text in newspapers.

I believe, however, that photography plays an important role in shaping democracy and fostering advocacy. The guardians of culture, from the Enlightenment onwards, have tried to lead by example rather than by imposing rules. Photography (and journalism) practiced respectfully has the power to educate us all towards a greater understanding of, and empathy with, others.

As I came to write the last pages of this book in 2015 I saw again, in one tragic example, how powerful photography can be – more so than a million words – in shaping our thinking about humanity. On 2 September Nilüfer Demir photographed a drowned three-year-old Kurdish boy, Alan Kurdi, washed up on a Turkish beach. 'There was nothing to do', she told CNN, 'except take his photograph ... and that is exactly what I did. I thought: "This is the only way I can express the scream of his silent body." ' Demir's pictures changed – *overnight* – deep-felt attitudes towards refugees in Europe. The day after the photographs were published, German citizens met refugees with 'welcome' signs at railway stations while the British Prime Minister, David Cameron, spoke of how moved he had been by the pictures and promptly announced a plan to take in several thousand refugees from the civil war in Syria. When photography is pursued with respect for its subject and with artistic sensitivity, society will benefit.

1
BEGINNINGS: FROM ART TO PHOTOGRAPHY

Through fragments drawn in red ochre on cave walls in Sulawesi or New South Wales, relief-carved onto the walls of Assyrian palaces (and later the friezes of the Parthenon), inscribed around Egyptian mummies and tombs, silhouetted on Athenian black-figure amphorae, stem-stitched into pre-Columbian Peruvian textiles or cast on brass plaques in Benin, the documentary impulse can be traced back some 10,000 to 50,000 years, to when the human brain developed – apparently quite suddenly – an interest in self-representation.

In trying to guess why hand stencils and scratchings were created on cave walls in Indonesia or delicate depictions of horses appeared in caves in southwestern France, scholars can only surmise that sudden regional population increases drove innovation, which in some way created a shamanistic relationship between the natural world and the supernatural.[1] In any event, no single theory could encompass the immense diversity of cave art discovered in about thirty countries since the first finds at Altamira in late-nineteenth-century Spain. Australia, populated by modern humans between 50,000 and 60,000 years ago, has the greatest number of ancient decorated sites.

Stuart Franklin, *Handprints on wall*,
c. 20,000 BCE, New South Wales, Australia, 2008

Handprints discovered in New South Wales echo those from about 13,000 years ago found in Cueva de los Manos in Patagonia and others more recently found in Indonesia. A shamanistic theory of the origins of cave art suggests that, during the process of a hand being placed against a wall, lit by pine torch or grease lamps, and having paint sprayed onto it, 'the hand blends into the rock, taking on the same colour, red or black. It would thus disappear into the wall' and thus provide a means of communication with the spirit world.[2] Lacking empirical evidence, however, we cannot confirm the specific documentary intent behind the act of creation. We can only confirm the documentary value of the visual legacy in what remains.

The carved gypsum slabs that once lined the palace of the Assyrian king Sennacherib in Nineveh, dating back to 700 BCE, reveal one of the first composite documentary accounts of organized society. The collective labour process that the carvings describe – a myriad of guarded prisoners with buckets on their backs rope-hauling a great winged bull up the steep slopes of a quarry – prefigures, in both form and content, the documentary photographs that Sebastião Salgado took in 1986 of gold-mining in Brazil's Serra Pelada. The documentary intent, the striving for fidelity, was the same then as it is now.

We rely on the archaeological record – the legacy of paintings and objects – to interpret or to reinterpret the past that predates the invention of writing. In Mexico, for example, where pre-conquest societies had no alphabetic writing, they resorted to the image to express their identity and assert their power. Codex Borgia, a ritual and divinatory manuscript, is one of the few surviving examples. '[Codices] were painted by specialists known as tlacuilos, a Nahuatl word that meant both painter and scribe. Tlacuilos were probably recruited from the priestly or noble castes.'[3] This hints at a further link in the relationship between ancient art and shamanism through a connection to priestly figures who may have fulfilled the same roles as shamans. The tlacuilos painted pictographs, ideographs and occasional phonetic symbols onto strips of bark and deer-hide that folded like an accordion. These paintings reinforced and refreshed oral memory and the documentary record, incorporating ancient

laws and histories. Their function moved seamlessly from the practical to the transcendental. Human blood was dripped onto these codices in order to nourish the spirits present within them, and in that sense the codices were as much a path to divinity as a means of expression. Beginning in 1520, however, the Spanish conquistadors burned virtually all the Aztec records they could find.

There is a manifest difference between the documentary intent of the few pre-Hispanic codices that survive and those produced under the patronage of the invaders. Aztec artwork *lived* in the sense that people believed that it brought them into contact with actual living deities. Paintings were intended as presentations (rather than re-presentations) of their cultural heritage. Post-invasion work (much of it now held in the Vatican Library) focused on pagan rites, documenting the processes of human sacrifice, cannibalism and self-mutilation, as in the Codex Magliabechiano. This followed various forms of symbolic domination, such as the placement of Christian crosses and Christian iconography in maps of Mexican public spaces, all exercised by the Catholic church.[4]

The Benin plaques of West Africa, dating to around the same time, document the sixteenth-century political landscape of a significant global power. The plaques, cast in high relief from molten brass rings shipped in from Germany, tell the story of a powerful and organized African civilization ruled by the Oba where, before the slave trade and the scramble for Africa, Europeans (Portuguese in this case) appear to have played a deferential role in the commercial relationship. In 1500 the ancient city of Benin had a population of some 60,000 or 70,000, making it a metropolis similar in size and importance to Tenochtitlán, the ancient capital of the Aztecs, and the Mayan cities of Tikal and Dzibilchaltun.[5] At the time only four European cities had populations of more than 100,000, headed by Paris with 200,000 to 250,000 inhabitants. [All these cities were dwarfed, incidentally, by the great urban centres of Vijayanagara in India and Kaifeng in China.[6]]

Following the discovery of the Benin plaques at the end of the nineteenth century, Europeans were forced to review their assumptions of cultural superiority. Theories deriving from natural science of the time, such as Arthur de Gobineau's essay 'The Inequality of

Human Races' (1853–5, discussed further in Chapter 2), sought to establish that black Africans were 'mere savages and have no history at all' and were incapable of civilization.[7] But on seeing the plaques later in the twentieth century, the Nigerian Nobel laureate Wole Soyinka commented:

> It increases a sense of self-esteem because it makes you understand that African society actually produced some great civilizations, established some great cultures, and today it contributes to one's sense of the degradation that has overtaken many Africa societies, to the extent that we forget that we were once a functioning people before the negative incursion of foreign powers.[8]

Before the advent of photography, the documentary impulse was sustained by representations in painting, mosaic, ceramics and sculpture, many of which have been cited by scientists and historians as factual evidence of past atmospheric and climate conditions as well as evidence of the structure of civilization. From the Paleolithic cave paintings discovered at Chauvet-Pont-d'Arc or Ariège in France to scenes of fishing and family life in Egypt from over 3,000 years ago, much that remains of the prehistoric – or preliterate – documentary record describes societal interests or activities, symbolic or otherwise. An 83-cm-tall fragment of wall painting from the tomb of a scribe named Nebamun (c.1350 BCE) shows him standing on a small papyrus boat on the marshes with his wife Hatshepsut, his daughter and the family cat – without doubt an early example of the documentary impulse. Surviving examples of the documenting of daily life, of men at work, in ancient Greece are rare. Many craftsmen were slaves and as a consequence they held low status. Nevertheless an Athenian black-figure pottery jar (550-500 BCE) survives from Rhodes depicting a shoemaker attending to a customer while another man – probably the owner of the workshop – looks on. In another example from ancient Greece, an Attic black-figure amphora lid from 550 BCE depicts boar and deer hunting on foot using spears. A more common theme in Near-Eastern relief carving and Greek vase-painting, however, is mythological. Hunting becomes an heroic activity. After the emergence of settled

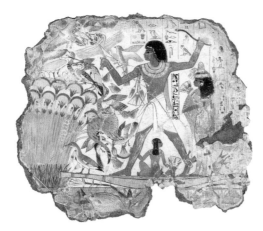

Hunting Fowl in the Marshes, fragment of a scene from the tomb-chapel of Nebamun, Thebes, 18th dynasty, c. 1390 BCE, Tomb-painting, painted plaster, 81 cm (2 ft 8 in) high

agriculture, the hunting of lions, bison, deer and falconry evolved into the sport of kings. There are few better examples of this than the c.700 BCE Assyrian relief carvings from the ancient palace of Nineveh, which depict royal lion-hunting from chariots. From about 450 BCE hunting on horseback signified wealth and leisure.[9] It became an essential part of military training and its documentary value might be viewed in that light.

Hunting also inspired early initiatives aimed at environmental protection, not always successful. Such initiatives began with edicts to protect the European bison laid down by Lithuanian dukes in 1541.[10] Drawings inside the Lascaux Caves in southern France are the earliest surviving life-drawings of the now-extinct aurochs (an ancestor of modern-day cattle), which was last seen in Poland in 1627 after being hunted to extinction. The aim of conservation was to preserve ritualistic hunting for the nobility.

The democratization of documentary practice came much later in history, when widespread access to methods of replication and reproduction became available. The Annales historian Fernand Braudel's weighty volume on the structures of everyday life between the fifteenth and eighteenth centuries covering the *longue durée*, as Braudel termed it, considered paintings by the Brueghel family as reliable historical evidence. It's worth remembering that during this time, the world 'consisted of one vast peasantry, where between

80 per cent and 90 per cent of people lived from the land and from nothing else. The rhythm, quality and deficiency of harvests ordered all material life.'[11] Little time remained for setting out a record of life as it was experienced.

One of the few to venture out into the chill winter to document the actual experience of hunting, rather than as an heroic gesture of masculinity or a conceit of the nobility, was Pieter Brueghel the Elder. His unostentatious 1565 painting, *Hunters in the Snow*, created before the Thirty Years' War (1618–48), when much of the remaining hunting forest in Germany and the Low Countries was destroyed, probably describes a very normal feature of everyday life – fox and wolf hunting or 'pest' control. At that time, the whole of Europe, from the Urals to the Straits of Gibraltar, was the domain of wolves.

Braudel's account of the structures of everyday life refers to several paintings by the Brueghel family as reliable historical evidence. He used Pieter Brueghel the Younger's (1620–40) painting *The Taxpayers* to describe the process of tax administration, while a painting of Jan Brueghel the Elder (a detail from *Windmills*) was used to show that roads in the seventeenth century were 'hardly visible at all.'[12] In a similar vein, the economist and historian Thomas Piketty, exploring income and wealth inequality in Europe since the eighteenth century, cited fictional accounts by Honoré de Balzac, Émile Zola and Jane Austen as evidence.[13] Piketty recognized that these authors had intimate knowledge of the various forms of inequity that existed at the time (some of which persist today). Not a single documentary film or photograph was mentioned in Piketty's account.

Fiction and realist painting – art that omitted deities or the supernatural and that lacked the trace of light on film so prized by photography – have proved as worthy a part of the documentary record as photographs.[14] It would be a mistake, then, to separate documentary photography from the *longue durée* of the 'creative treatment of actuality' evident throughout the history of science and art. There are too many examples from science and from art to list here, but I'll make a start.

Before the invention of photography, the death mask served both as a record of unidentified corpses and as a historical

commemoration of noteworthy figures in history. Since the renowned gold mask of Tutankhamun, the practice has left us with the sleeping faces of Oliver Cromwell, Beethoven, Frederick the Great, Napoleon and Abraham Lincoln (who was also, of course, frequently photographed). One famous example is the death mask of *L'Inconnue de la Seine*, a young girl with an enigmatic smile who reportedly committed suicide in 1880. She became a *cause célèbre* in France, Germany and Russia after she was recovered from the river near Quai du Louvre in Paris and a pathologist decided to make a death mask on account of her beauty.

The influential and overlooked German novelist Alfred Döblin wrote the original introduction to *Antlitz der Zeit* (Faces of our Time, 1929), which the photographer August Sander claimed was his honest portrait of the German people. Döblin approached Sander's work after reviewing a picture book popular in Germany: Ernst Benkard's *Das ewige Antlitz* (Undying Faces, 1927), featuring 126 notable death masks, including *L'Inconnue*. Döblin commented on the contrast between the strange uniformity of death masks and Sander's photographic skill in breathing individual life into these objective and scientific records of human existence – all human existence, not simply the famous. In many ways, *L'Inconnue* was always the exception in being chosen for its beauty rather than the subject's notoriety. In a more recent echo of the death mask, James VanDerZee's funerary photographs in his *Harlem Book of the Dead* (1978) and similar work from India are brought to life by the way the subject is contextualized: the coffin furnishing or the clothing of the dead.

Moving to the history of art, consider the sculptor Ossip Zadkine's work *The Destroyed City* (1951–3), a memorial to the destruction of the centre of the Dutch city of Rotterdam in 1940 by the German Luftwaffe. It represents a man without a heart, photographed so evocatively by Cas Oorthuys in his book on the city. In Oorthuys' photograph (see overleaf), the figurative sculpture rises above harbour or construction cranes, crying out at the sky, apparently pleading to the German bombers – or God – to stop the destruction. Oversized hands are held poised, as if to hold back the bombs before they can reach their targets.[15] Or recall Goya's documentation of the Peninsular War (1807–14) in the aquatint

series *Desastres de la Guerra* (The Disasters of War, 1810–20), a protest against the violence of 1808. Here we find parallels with the 'anti-war' movement in documentary photography that began after World War I (1914–18) with Ernst Friedrich's photobook *War Against War* (1924).[16] The dialogue continued with Richard Peter's *Dresden eine Kamera klagt an* (Dresden, a camera accuses, 1949), David Douglas Duncan's *I Protest!* (1951) in Korea and Philip Jones Griffiths' *Vietnam Inc.* (1971).

Henri Cartier-Bresson once commented that 'not since Goya has anyone portrayed war like Philip Jones Griffiths'. Here he drew no boundary between the documentary value of painting and that of photography. The relationship between painting and photography is not as distant as it might seem for several reasons: the links to the camera obscura, the competing attempts at realism in its many guises, the duplicating of genres and the theatricality – more visible in the genre of tableau photography, which began in the 1970s with pictures designed and produced for the wall.[17]

The camera obscura, first developed for viewing solar eclipses, was recommended as an aid to artists in 1568 by a Venetian writer on architecture, Daniele Barbaro. However, painters were as coy about admitting to using the device as, much later, photographers were about manipulating or staging pictures. The painter Thomas Sandby, in a rare disclosure, wrote an inscription on his 1770 painting *Windsor Castle from the Gossels* 'drawn in a camera T.S.'[18] Vermeer and Canaletto almost certainly used the device, based on evidence of differential focus, painting in of halation effects, darker shadows and exaggerated wide-angle perspective.[19] They just didn't brag about it. In one of his first colour photographs since his days as a student in Los Angeles, in 1999, the photographer Hiroshi Sugimoto attempted to reproduce Vermeer's *The Lady at the Virginal with a Gentleman* from its re-creation in wax in an Amsterdam museum, using the same camera position and lens effect as the camera obscura, thus 'blurring the division between photograph and tableau – all are dissolved into one continuous photographic hall of mirrors each becoming as real and as illusory as the other',[20] echoing the work of Jeff Wall and Gregory Crewdson discussed later in Chapter 8.

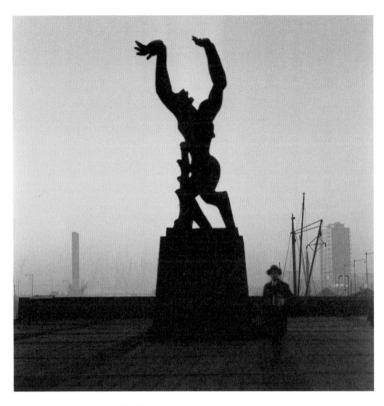

Cas Oorthuys, 'The Destroyed City' by sculptor
Ossip Zadkine, Leuvehaven, Rotterdam, c. 1958

The debate over truth and reality – or more accurately, truth and
convention – pitted the flash photographs of galloping horses taken
during the 1870s by the English photographer Eadweard Muybridge
against convention in painting. With wet collodion plates and 1/1000th
of a second shutter speeds, Muybridge proved that during the horse's
gallop all four legs left the ground at once.[21] He went further, though,
and this is where his problems began. He showed that the 'rocking
horse' posture, the traditional flying gallop used throughout the history
of most Western and Chinese painting, was scientifically inaccurate.
The poet Paul Valéry rose up in his support: 'Muybridge's photographs

reveal clearly the mistakes that all sculptors and painters have made in their representations of the different gaits of the horse.'[22] The sculptor Rodin, however, defended the painters, specifically the French artist Théodore Géricault, who was famed for his depictions of horses. He argued that artists combine different phases of an action in a single image. They create a sense of motion that echoes the spectator's experience of following the horse from back to front and is more 'true' than 'time abruptly suspended'.[23]

When the photographer Paul Strand was asked to define the snapshot, he couldn't, beyond saying that it was a form of photography that could stop movement: 'I was trying to re-create the abstract movement of people moving in the city; what that kind of movement really feels like and is like. That required a technique that can only be described as a snapshot.'[24] He used his photograph *Wall Street* (1915) to explain his engagement with stopped motion.

The painter David Hockney was not the first to note that the freezing of time, together with the one-eyed vision of the camera, presents problems for documentary. In the 1980s Hockney was talking about photographs when he stated that he 'wanted to put time into the picture'.[25] Influenced by the complex visual allure of Cubism, Hockney went on to make a series of 'joiners' and collages from photographs taken over time in the same location. Portraits included several pictures of the subject as they moved around in a room, for example in *Luncheon at the British Embassy, Tokyo, 16 February 1983* (1983).

This may seem like a diversion from our central theme, the documentary impulse, but in fact it is central to a growing awareness of the competing claims to the 'truth' that photography has inspired. Why is something captured all at once, in a moment, any more factual than the painted experience of motion? To answer this, it is critical to understand what we mean by 'factual'.

Most artists, diarists and poets record facts subjectively, precisely as they are witnessed. Machines can be, and are, built to witness life differently. They can record the craters on the moon; the inside of a human brain or tooth; the heat emitting from an object at night. While we might recognize the factual significance of a machine's power to, say, scan the body, the documentary impulse

stems from the psychological and epistemological understanding of being human – being a particular human on the planet at a *particular* time looking around and thinking, Gosh! I want to record that experience to memory. That instinct incorporates both the idiosyncrasies of human frailty and the scientific advances in photography. The impressionist painter Claude Monet, who suffered from cataracts, wrote in 1922, 'My poor eyesight makes me see everything in a complete fog. It's very beautiful all the same and it's this which I'd love to be able to convey.'[26] Anyone reading this with experience of cataracts might applaud Monet's willingness to replace anxiety with appreciation.

Artists painted the world as they saw it, notwithstanding their cataracts, astigmatisms, degenerating central vision or colour blindness. By contrast, photographers, no matter how shaky their vision, could henceforward rely on replaceable optics and, eventually, auto-focus. William Henry Fox Talbot's solar microscope captured the beauty, hitherto unseen, of a damsel fly's wing and a dandelion seed with the same enthusiasm as Monet painted the blurry water-lilies in his garden. Telephoto and close-up lenses came to be used to explore, with a fresh and artificial eye, the wonders of nature.

The documentary impulse, in the sense I am grappling with here, is about human experience in all its range and complexity. Documentary value lies in an honest striving to describe the world around us, without the overt intent to sell a political ideology (propaganda) or a commodity (advertising). There is value both in the excitement of the world seen through the development of optics and the world seen with the naked eye, limited as that might be. There is also value in the world lived through the experience of illness, mental or otherwise. All of this highlights the problem of ascribing documentary value, or 'truth', only to a narrow range of insights or interests, as in old school history books that follow a version of the past or present favoured by the political class of the day.

The painter and critic John Ruskin, in supporting the expressive power of J.M.W. Turner's paintings, wrote of another kind of truth: 'There is a moral as well as a material truth – a truth of impression as well as of form – of thought as well as of matter; and the truth of impression and thought is a thousand times the more important of

the two.'[27] Self-expression was Ruskin's creed, albeit tied to God's will. Turner was his prophet. Ruskin licensed a form of subjectivity from which painting has never looked back.

Ruskin argued, with Turner in mind, that the power of painting depends upon recovering the *innocence of the eye* – a sort of childish, unpremeditated response to the world. Turner's furious brush-marks describing a storm at sea, the scratching of light onto canvas with a fingernail grown out like an eagle's claw, the delicate lemon yellow of sunrise: all answered the call. These emotional responses to nature were far removed from the photograph's machine-made images.

Ruskin's extended argument paved the way for various forms of impressionism and expressionism, beginning with Cézanne, Bonnard, Van Gogh and the Symbolists, of whom Odilon Redon was the most outspoken about photography. He rejected it wholesale, and questioned the assumption that the photographic image was the transmitter of the truth: 'The photograph transmits only lifelessness. The emotion experienced in the presence of nature itself will always provide a quality of truth which is authentic in quite a different way, verified by nature alone. The other [factual truth] is a dangerous one.'[28]

Photography and realism in painting shared common ground between photography's invention in 1839 and the end of the nineteenth century. The invention of photography led painting to move in two directions almost at once. The first was a move as far away from realism as possible. André Derain expressed the sentiment well: 'It was the era of photography that may have influenced us and contributed to our reaction against anything that resembled a photographic plate taken from life. We treated colours like sticks of dynamite, exploding them to create light.'[29] The Fauvist painters of similar mind followed suit.

The second instinct, in contrast, was to ape the realism of photography. The pursuit of realism in figurative painting was far from new. In classical antiquity Pliny praised a successful illusion created by the painter Zeuxis, who painted grapes so realistically that birds came to peck at them.[30] However, nineteenth-century French realist painting was not always so welcome in the age of photography, as best summed up by the travails faced by the painter Gustave Courbet. Although *A Burial at Ornans* (1849–50, see overleaf) and *The Bathers* (1853) were

accepted by the Paris Salon, the critics were unimpressed. Courbet's pictures were simply too realistic for the public's sensibilities. The burial, a majestically exact 6.5-metre-long (12 foot-4-inch-long) tableau depicting the funeral of the painter's great uncle, was criticized for being too photographic: 'One might mistake it for a faulty daguerreotype', one critic complained. The painting's documentary value was not being considered. Courbet's bathers' buttocks were likewise mocked and likened to Percheron draft horses, while his wrestlers' legs were ridiculed for their visible varicose veins. Perhaps concerns over ribald criticism forced Peter Paul Rubens to keep his similarly anatomical *The Three Graces* (1630–1635) in his personal collection until his death in 1666.

In a similar genre, John Singer Sargent's wall-sized oil painting *Gassed* (1919) – showing a line of men wearing bandages around their eyes blindly moving in single file, guided by medics – was fêted at the time and is still revered today as an example of honest reporting of life behind the front lines during the First World War. Photographs of gas casualties were made during 1918, for example by the Australian photographer George Wilkins. Surprisingly, Sargent's fictional painting had more impact than the few glass-plate negatives that found their way out of France. What Wilkins' best-known photograph affirms is that gas casualties habitually wore white bandages around their eyes, giving credence to the Sargent painting.

Many years after the invention of photography, artists have continued to bear witness to tragedy in places where the camera (and journalists) have had little or no access. The Ukrainian famine of 1932–3 and the Great Famine in China in 1958–62 – both man-made disasters – went largely unreported at the time. Two woodblock print series, one made in the 1930s by Sofia Nalepynska-Boichuk and another from 2014 by the Chinese documentary film-maker Hu Jie, set out to tell the respective stories visually from accounts collected in the aftermath of the disasters, and by doing so to fill two important gaps in the documentary record.

Yet ultimately it was photography that became the preferred witness to the age of scientific discovery and exploration as it unraveled during the nineteenth century. The frantic chemistry surrounding the light sensitivity of silver salts began in Germany during the eighteenth century or possibly before, using both chloride

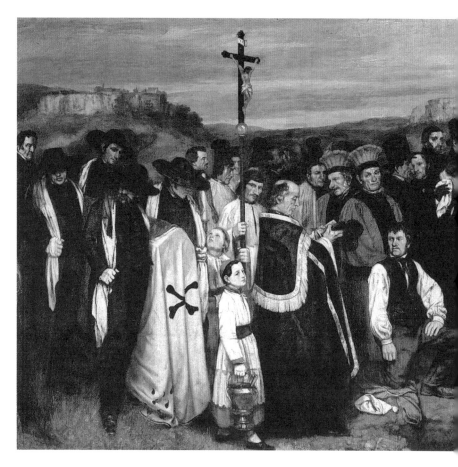

Gustave Courbet, *The Burial at Ornans*, 1849,
oil on canvas, 315 × 668 cm (124 × 263 in)

and nitrate of silver. The discovery of iodine in 1811 and bromine in 1826 helped accelerate exposure times and the chemical tank charge towards perfecting a permanent image of a moving subject. In the peaceful Brazilian village of São Carlos, Antoine Hercule Romuald Florence was working in the 1820s with basic eighteenth-century chemistry and the theory that ammonia could be used as a fixative. Romuald successfully used his own urine for the purpose and

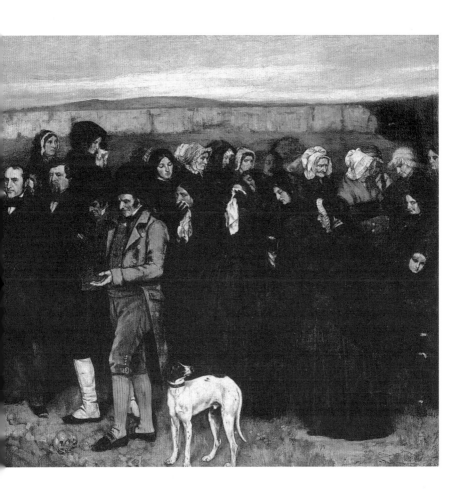

claimed to have used the word *photographie* at least five years before anyone in Europe.[31]

Reportedly, the Englishman Sir Humphry Davy was the first to use silver salts for photography inside a camera obscura, coating silver nitrate onto white leather and paper in 1802: 'the first stain traced upon the prepared surface'.[32] But the stain could not be fixed. So new light-sensitive materials were introduced: a resinous

substance known as *gum guiacum* from England, then bitumen mixed with lavender oil by an amateur chemist living in Chalons-sur-Saône, Joseph Nicéphore Niépce.

The problem centred on selecting the best elements with which to coat the plate or paper, then finding a means of developing and fixing the image. Niépce tried rubbing his bitumen mix onto plates, at the same time gripping a wooden peg in his mouth, itself attached to a circular sheet of paper in order to stave off condensation from Niépce's breath. He then developed the 'heliographs' with lavender oil and gasoline. Exposure times were several hours long and the result was a fickle negative print.

After Niépce died in 1833, Louis-Jacques-Mandé Daguerre continued his work. He managed to decrease exposure times to a matter of minutes using plates coated in silver iodide, developed in fumes of mercury and fixed with table salt. Daguerre's patent, and all the secrecy surrounding image-making with a camera, was removed in 1839, when the French government gifted photography to the world, and at the same time bestowed upon Niépce and Daguerre the credit for its invention. A cocktail of chemicals – some lethal – together with improving optics and camera design gave rise to a medium that has continued to gain in popularity ever since.

At the start, the documentary impulse in photography evolved in several quite separate directions, of which the photographic keepsake became the most private and scientific exploration the most public. In England, the death of Queen Victoria's husband Prince Albert in 1861 led to the fashion of miniature portraiture set into jewellery, a fad that rapidly crossed the Atlantic during the American Civil War (1861–5) to include commemorative tintypes kept with a lock of hair. Photographs, like memories, were to be worn, held close, cherished and forevermore placed on furniture or pasted into albums. The continued impulse to document the personal – the newborn, the family, the dead and the dying – cannot be ignored. Many of the images that I consider some of the finest documentary photographs of the twentieth century – by Bill Brandt, W. Eugene Smith, Sally Mann, Eugene Richards, Larry Towell and Elliott Erwitt to name but a few – are, in fact, pictures of the photographer's family.

Scientific exploration evolved with photography during the Victorian age and has continued to the present time, with the new medium serving as the proof and silent witness to discovery or claims of discovery. Machu Picchu, an Inca stronghold above the Urubamba valley, was 'discovered' by the Yale University explorer, Hiram Bingham in 1911 during an archeological and photographic expedition to Peru. Considerable disquiet persists over Bingham's removal of thousands of artifacts from the site. Bingham brought an archaeological engineer charged with 'the general work of clearing and excavating the ruins'.[33] Without the photographs, first published in April 1913 in 'The Wonderland of Peru' in *National Geographic* magazine, Bingham's entire enterprise might have gone unheeded. In fact, without the $10,000 contributed for the expedition by the National Geographic Society in anticipation of the photographs that were eventually published, the whole expedition may have been less rewarding.

Led by photography, the documentary impulse opened up a vista of the farthest corners of the Earth and eventually into space. The new medium lent a sense of veracity to newly found lands that painting, despite its 'moral truth', had not been able to achieve. When, at the very end of the eighteenth century, Alexander Von Humboldt set out on his epic journey to Latin America, exploring the Orinoco and the Amazon, he was followed by a series of European and American artists, including the Hudson River School painter Frederic Edwin Church. Church was not alone in returning with fanciful and romanticized views of the volcanic cordillera and the jungle but little else. The meteor shower that Humboldt observed in Venezuela could only be described in words.

Photography changed the game. When the Danish astrophysicist and amateur photographer Sophus Tromholt returned in 1883 from an extensive journey to northern Norway, he'd not only begun an important ethnographic survey of the Sami people and their lifestyle but had also produced the first impressive photographs of the Northern Lights. In one image, a lengthy time exposure, the Aurora Borealis appears as a curtain of light reaching out of the dark winter sky.

Exploration and photography enjoyed a symbiotic relationship throughout the second half of the nineteenth and early twentieth century. The documentary impulse that drove many of the early

explorers to photograph was connected as much to the expression of, or the expectation of, governance as anything else; intentionally or not, photography became a way of marking a right of ownership over a territory. Less than thirty years before the British occupation of Egypt, Francis Frith, an English photographer, set out in 1856 on the first of four journeys to the Nile Valley. He believed he could return with images that surpassed the power of painting. His photograph of the *Suez Canal at Ismailia* (c.1860) is an objective landscape view with considerable documentary value. We see clearly the structure of the canal, the architecture of administrative buildings, the planting of trees aligning the waterway and the early design of live-aboard canal boats. Frith's uninflected rendering of landscape was to be a constant refrain throughout the history of documentary practice. It is echoed through the latter half of the nineteenth century in Claude-Joseph Désiré Charnay's work in Mexico and Madagascar and Samuel Bourne's photographs from India and Nepal during the British Raj.

The scientific approach continued with the important three-year geological expedition (1867–9) by Timothy H. O'Sullivan along the Fortieth Parallel to the American West, led by the twenty-five-year-old aristocrat and scientist Clarence King. This expedition and the field trips by the photographer Carleton Watkins to the Yosemite Valley, all sponsored by branches of the US Geological Survey, were driven by a compulsion to document and examine the newly conquered landscape, again with the prospect of governance in concert with scientific discovery.

Watkins not only returned with the geological facts of the landscape but also with specific photographic proof, in daguerreotype stereoviews, of gradual landscape evolution and glaciation. The direction and force of glacial flow became clear from photographic evidence of ice-scratched granite along Yosemite's canyons, the legacy of three million years of intermittent ice ages. All of this helped overturn the dominant Creationist views of the time. Watkins worked until he lost his sight in his sixties. Much of his considerable archive was destroyed in the 1906 San Francisco earthquake.

In 1910 Herbert Ponting, one of the earliest photographers to publish coherent photo essays about China, Japan, Korea and Burma,

set sail on the *Terra Nova*, joining Captain Robert Falcon Scott's first expedition to the Antarctic. Ponting's magic lantern slides and short film sequences were expected to repay the substantial debts incurred from the expedition. As Ponting was sailing home in February 1912 to prepare the films and photographs, Scott was on his last fatal journey after successfully reaching the South Pole. The death of the tragic hero overshadowed Ponting's films and photographs, which are today archived at the Royal Geographical Society in London. An interesting aspect of the Ponting archive is that there are probably as many – if not more – portraits of the working dogs (all named) that accompanied the mission as there are of the expedition's acclaimed heroes. I recall visiting Ponting's Antarctic darkroom in 1990, installed in Scott's hut at Cape Evans, tucked into an embayment in the Ross Sea. The Antarctic is the driest continent on earth. Little or nothing had deteriorated. Two dogs, virtually intact, were still chained outside. Inside, the rows of test tubes, retort stands and Bunsen burners were all further reminders of how an Edwardian science-based photographic expedition might have appeared. More recently, at the same hut, some interestingly distressed 100-year-old cellulose nitrate negatives, souvenirs of a later expedition (views of the Ross Sea from the ship *Aurora*), were found stuck together but intact, reportedly frozen in a block of ice.

The idea of the 'factual' in documentary practice raises many issues. On the one hand there is an argument in favour of a 'moral truth', an emotional or subjective response to documenting the world, as seen in the paintings of Turner and Monet and as later developed within documentary photography. On the other hand there is a tendency towards scientific objectivity in both realist painting, such as Courbet's *A Burial at Ornans* and Singer Sargent's *Gassed*, and in early photography. How can there be two sorts of 'fact', one coolly objective, the other fraught, diverse and emotive? The answer is clear: there can because there are. The documentary impulse embraces a dual approach to the treatment of actuality in which creativity, or the extent to which creativity is applied, is a selective process.

2
LOST EDEN: TRACES OF THE COLONIAL LEGACY

The lament for a lost or disappearing Eden has been central both to the history of art and literature (in all forms) since antiquity. Jacques-Henri Bernardin de Saint-Pierre's novel *Paul et Virginie* (1788) describing an idyllic childhood in the pre-lapsarian paradise of eighteenth century Mauritius, for example, is possibly the most completely 'edenic' novel ever written. Photography has merely borrowed an old romantic idea and lent it new expression. Many of the landscape painters who followed Alexander Von Humboldt to the volcanic cordillera of Ecuador and along the Orinoco and Amazon rivers returned with paintings that had some commercial worth but limited documentary value. They romanticized the subcontinent, imposing a European and American painting tradition on newly discovered territory. At the same time the canvases rinsed the landscape of its people, underlining its availability for extractive colonial regimes. This chapter begins by exploring the impact of the colonial experience and the idea of a lost Eden on early photography in North America, Australia, Papua New Guinea, Burma and central Africa.

Between 1907 and 1930 Edward S. Curtis produced twenty photogravure portfolios entitled *The North American Indian*. These are archived in the National Geographic Society's basement in Washington, DC. The quality of the sepia-toned gravures is impressive, yet there is something discomforting about the collection. Everyone looks old and tired. A portrait entitled *Tearing Lodge – Piegan* (1910, see overleaf) appears to have been taken somewhere in Montana, probably in Curtis's tent. In his seventies at the time, Pinokiminiksh, also known as Tearing Lodge, wears his buffalo-skin war costume – hardly everyday wear. It is rather like an elderly dowager being photographed in the bridal dress she once wore to the altar. As a reflection on a once proud nation, it is one of the saddest examples of 'salvage ethnography' – ethnographic work that seeks to salvage vestiges of vanishing cultural traditions – I have seen. Tearing Lodge's face, in profile, is the picture of disconsolation. It is almost a death mask. The carved-out folds of his skin seem to mimic the cracked lines of the bird's feather that Curtis might have pushed into his headdress. No one in the series is smiling, although such pictures do exist.[1] Most of the Piegan, also known as the Blackfoot, had been wiped out by smallpox, measles, the ill effects of whiskey trading and

starvation over the winter of 1883–4, long before Curtis's photograph was taken. At the same time the buffalo that provided the warrior's war costume had been hunted to virtual extinction. Curtis's impulse was to preserve – almost as collectors capture and pin rare butterflies – a race defeated by European expansion, and the racial superiority assumed in the concept of Manifest Destiny, a term originating in the 1840s to underscore the providential mission of expansionism in North America.

Much of the West's approach to the colonized world derived from hereditary genetics and theories arguing that different races may be derived from the same or separate species (monogenesis or polygenesis). In the 1850s Arthur de Gobineau set out his stall with *The Inequality of the Human Races*, in which he outlined a theory of European racial superiority, sowing the seeds of an Aryan (Germanic) master race that Hitler began to harvest for political gain during the 1930s.

Gobineau's theory was more complex than a very brief mention could express, and it was also written before he had been outside Europe; his views modified after he travelled to Somalia in 1855.[2] Gobineau's key argument was for miscegenation, or racial and cultural hybridity. Without it, he claimed, sub-Saharan Africans or Tahitians could never be civilized.[3] Following in Gobineau's footsteps in 1892, Francis Galton's thesis developed a fundamentally racist premise of intellectual capacity, which placed ancient Greeks at the top of the pecking order and Australian Aboriginals at the bottom, 'one grade below negroes'.[4] This was the religious, natural science and cultural backdrop in front of which colonial-era documentary photography occurred. One powerful reason why early racist theories began to subside after World War II (1939–45) was the fervent opposition to Nazism, which included the rebuttal of Nazi doctrines espousing biological superiority and inferiority.

There is no space to draw this discussion out further, but it must be stated that racism during the period under discussion was experienced not simply because of presumed white superiority, but also due to a much broader range of interracial assumptions made in sub-Saharan Africa, India, China and Latin America. Cultural

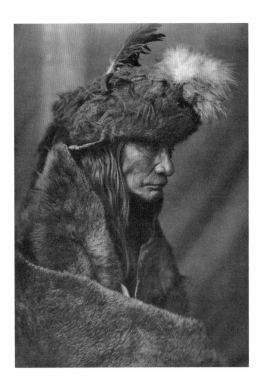

Edward S. Curtis, *Tearing Lodge – Piegan*, 1910

racism, based on misguided reflections about 'backwardness', persists today.[5] Photography has developed side by side with this view of the world based on indoctrinated ideas of white (and by extension) Christian superiority. The Algerian poet Malek Alloula in *The Colonial Harem* (1987) went as far as suggesting that photography was 'the fertilizer of the colonial vision [producing stereotypes] in the manner of great seabirds producing guano'.[6] (The photographed colonial harem, as we shall see, lay farther to the east, in Papua New Guinea.)

Whilst many resisted this view or even tried to overturn it through their work, there's an embarrassing archival legacy that reaffirms the fact. Some years ago I was asked to do research in the National Geographic Society's archive in order to write a chapter on *National Geographic* magazine photography at the

height of the colonial era. I had worked as a National Geographic photographer for over a little more than fifteen years, from 1990. Founded in 1888, the National Geographic Society's stated mandate is 'to inspire, illuminate and teach'. I recall working my way through several hundred so-named 'character studies' of mostly nameless subjects selected for their curiosity value as 'types' or for their adornments of one form or another. Smiling, sullen or angry, all were obedient to the demands of the camera.[7]

It is frightening to think that, had I been on assignment during the 1920s, I might have produced similar work. It is easy to be aloof about what our predecessors did, much harder to reflect upon about the way in which we too might have been conditioned. Photographic archives from the period – whether in France, Belgium, Germany, Italy or Britain – are little different. In many cases the colonized subject is viewed less as a person – a fellow human being – and more as a 'type', commodified as an object of sexual desire, a clothes' horse or a curiosity.

Curiosity value was so important and so intense that a large part of the West's early circus industry was based on spectacles of Australian Aboriginals, North American Indians and variously collected so-called 'human specimens' from Africa, such as those individuals wearing lip-plates or coxcomb facial scarification photographed by the Belgian Congo administrator Auguste Bal during the 1930s.[8] Pygmies were a premium attraction at circuses and international fairs. At the Antwerp World Fair in 1885, visitors could view a 'Negro village' with a dozen Congolese on display. Twelve years later, 267 Congolese travelled from Africa to Tervuren in Belgium to perform as exotic features in a colonial exhibition, to the delight of hundreds of thousands of Belgians.[9]

The photographic narrative normally took two forms: stereo-typed regional and ethnic 'types', not necessarily restricted to the developing world, and a more ambiguous obsession with foreign bodies and their adornments. The idea of the 'type' derived from two branches of natural science, both popular in the late nineteenth century: physiognomy and phrenology. The former judged a person's character by analyzing his or her facial features; the latter achieved

similar results by measuring the shape of the skull. The pseudo-science of the human head and the photography of racial 'types' played a significant role in physical anthropology and, by extension, colonial subjection. According to convention, a 'type had to be photographed in exacting front, three-quarter and profile poses, so that the outcome was an authoritative image useful for scientific purposes'.[10]

It is no exaggeration to say that the large part of documentary photography's first hundred years unfolded against a backdrop of assumptions that must today be viewed as racist. Throughout the early period, professional photographers and amateurs such as traders and administration officers collected 'type' photographs from across Africa, Australia, Burma and Papua New Guinea (where 'savage and sharp-toothed cannibal' types were popular). Body-shaping adornments were also photographed as 'oddities'. Alfred Joseph Smith's 1913 photograph of a Burmese Palaung woman is characteristic of this. Traditionally, Palaung women wore brass rings around their necks, arms and legs: 'The neck rings, as thick as the little finger, are put on the girl in infancy, four or five rings at first and then others as fast as she grows, until eighteen or twenty keep the neck always stretched.'[11] In the picture, two women wearing multiple neck rings stand to attention on either side of a Burmese colonial official. This image formed part of a global survey that included 'types' from all over China, Australia, East Asia and Russia, not to forget the 'typos' of Latin America, the cowboy 'types' of the Camargue or London 'types' by the photographer John Thomson.

Another 'type' popular with the public was the nude or seminude non-Western (usually young) woman. Native girls were popular for the *carte de visite* and cabinet-card market in London. An administrative officer and keen photographer named Captain Francis Barton was a supplier of such pictures. Based in Port Moresby, Papua New Guinea, Barton was a familiar figure in the suburb of Hanuabada, where he staged many of his tableaux using local girls as models to emulate classical sculpture. He used his social position as governor to facilitate his work. In one series he focused on a Hula girl called Luikama in Port Moresby, drawing in her tattoos with lamp-black. O.M. (Guy) Manning, another administrative officer, photographed Barton at work. Manning was

busy collecting his own 'harem series', apparently. In the picture, unearthed from a collection of glass plates in Sydney's Mitchell Library, a young semi-naked girl is being 'tattooed' by Barton centre-stage as two others wait in the wings. The nudity was an affront to Papuan propriety perhaps, but one we can only assume formed part of the business arrangement between photographer and subject.[12] The image carries a key element of the documentary impulse in the colonial era – the search for innocence and beauty, or a lost Eden.

One of Manning's favourite models was a Motu woman named Baia. In one full-length photograph Baia, in grass skirt, stands before a woven mat, hands clasped in front, breasts exposed and her hair neck and arms decorated with shells, bone, leaves and feathers. Perhaps a quarter of Manning's photographs included partially clothed young girls.[13] This kind of photograph, piled high in the documentary record, formed such a significant part of the wider *National Geographic* archive that, in their study of the magazine, the researchers Catherine A. Lutz and Jane L. Collins devoted an entire chapter to the subject, conspicuously labelled 'The Colour of Sex'. They argued that 'until the phenomenal growth of mass circulation pornography in the 1960s, the magazine was known as the only mass culture venue where Americans could see women's breasts.'[14]

A great deal of early photography of a documentary nature arose from the curiosity of white people's ethnographic interests and erotic fantasizing about people and places they hadn't yet seen. 'In *National Geographic* documentary images ... we find a shift', Lutz and Collins discovered, where 'the naked woman moves from being an ethnographic fact ... to being presented in part as an aesthetic and sexual object.'[15] While pictures of black women's bodies were popular with readers, there appeared to be less interest in black men's bodies, unless emphasizing sporting prowess – brawn rather than brain.

Rwandan high-jumping spectaculars or *gusimbuka* arranged for a German explorer, Adolf Friedrich, Duke of Mecklenburg-Schwerin, were an early twentieth-century example of this trope, arousing interest in the duke's native Germany.[16]

In a photograph published in an account of his expedition, *In the Heart of Africa* (1910), a Tutsi high-jumper named A. Mtussi is

seen in silhouette clearing a 2.5-metre bar as Mecklenburg and his adjutant, Weise, pose in sartorial splendour below. This photograph is likely to have been doctored, with the high jumper cut out from another negative and stuck on. Many more were not.

The high-jump event occurred in August 1907. Mecklenburg and his entourage had travelled through the Congo and down into Rwanda, shooting lion and almost anything else that moved: the great white hunter *par excellence*, except that, by his own admission, he was not a very good shot. What Mecklenburg lacked in aim he compensated for in tenacity. In 1909 he supplied an exhibition at the Berlin Zoological Gardens with 3,466 botanical species, 834 mammals, 800 bird skins, 637 worms, 173 reptiles and more than 7,000 insects. The ethnology department wasn't left begging either. He returned with more than 1,017 human skulls, and the results of measuring 4,500 individuals.[17]

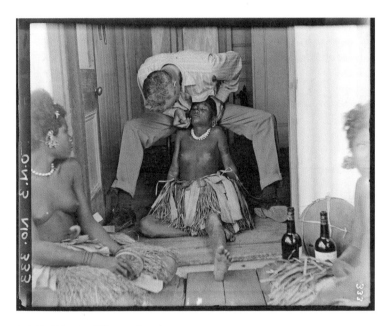

O.M. (Guy) Manning, *FR Barton using paint to accentuate a facial tattoo*, c. 1899–1907

As a result of the kind of collecting mania pursued by the great white hunters (Frederick Selous, Theodore Roosevelt, Carl Akeley and others) supplying public and private zoos, the idea of preserving wildlife in national parks, which began in the American West, was rekindled in Africa in the 1950s as the future of wildlife populations appeared to be in jeopardy. Meckelenburg's interest in Tutsi high jumping and sporting prowess was, it turns out, a sideshow.

Nuba wrestling and stick-fighting, like high-jumping, provided a further opportunity to feature African brawn rather than brain. Although the Nuba had been the subject of photographic expeditions since the 1920s,[18] the door to these warlike spectacles may have been inadvertently opened by the Magnum founder George Rodger. Whilst travelling north from Johannesburg with his heavily pregnant wife, Cicely, in a specially fitted-out Willys station wagon in order to escape from the psychological impact of witnessing the Bergen-Belsen concentration camp, Rodger received a cable from Magnum in Paris suggesting he look for the Nuba.[19] In 1949 Rodger drove from Dar es Salaam to spend a short time in Sudan's Kordofan region photographing the Nuba, as part a wider passion to document disappearing African customs:

> The age of the great warrior tribes – the Zulus and the Masai – is over and the days of the witch-doctor, who tries to hold onto his power at all cost, are numbered. Government by fear and witchcraft is gradually being replaced by an administration whose characteristic tools are paper and ink: the mass-produced ballpoint pen is carried in preference to javelins ... one can still find the real Africa, untouched by white influence, preserving the customs and traditions of the ancient tribes.[20]

Rodger's monochrome photo-essay on the Nuba – focusing on wrestlers – was quietly respectful. The story, titled 'With the Nuba Hillmen of Kordofan', was accompanied by a text by a twenty-three-year-old British district administrator in Anglo-Egyptian Sudan, Robin Strachan, and was published in *National Geographic* in 1951. It proved so popular with readers, perhaps because of its pictorial emphasis on the practices of bracelet or stick fighting, or the wrestling, that fifteen years later another somewhat punchier piece appeared in *National Geographic* by father and son members

of a German scientific team, Oskar and Horst Luz.

In the later article, body culture and brawn were given more prominence and the photographs reproduced in highly saturated colour. One of the captions describes female wrestlers: 'Greased with butter and sesame oil, the bodies of girls and women glisten in the afternoon light'.[21] The men in the article, seen wrestling without much clothing on, were described as 'grunting and grasping' as they struggled to make each other fall over. Another caption describing a photograph of a wrestler highlights his brawn and implicitly suggests that this physicality is at the expense of intelligence: 'Muscles like iron, his leather arm amulet worn as insurance against disaster, a champion wrestler exudes confidence. In his world a man's strength and agility count for much, and at festivals he earns the plaudits of his peers. But modern civilization – a force beyond his comprehension – threatens his primitive way of life.'[22]

Such commentary edges close to the author Joseph Conrad's description of African modes of communication, which he described as a 'violent babble of uncouth sounds' or 'short grunting phrases', a descriptive which the Nigerian author Chinua Achebe later referred to as 'thoroughgoing racism' in his well-known critique of Conrad's 1899 novella *Heart Of Darkness*.[23]

Nevertheless, the passionate drive to document the Nuba continued unabated. In December 1962 the photographer and film-maker Leni Riefenstahl, formerly Hitler's close collaborator – her film coverage of the 1934 Nazi party rally in Nuremberg, *Triumph of the Will*, was a major propaganda victory for the Nazis – followed in George Rodger's footsteps almost literally. After Rodger refused to help her locate the tribes,[24] Riefenstahl set out for Sudan with Oskar Luz's scientific team, hoping to make a documentary film about the Nuba.

Travelling from village to village through Kordofan, Riefenstahl held up Rodger's photographs of Nuba wrestlers published in *Stern* magazine and asked for directions.[25] Eventually she succeeded, although not with Oskar Luz, who refused to take her cinematic direction in filming. Abandoning the film idea, Riefenstahl continued for several years taking photographs not only of the Nuba but also of several other African tribes: the Masai, Samburu and Kau.

Riefenstahl marked the Nuba out for special attention and did everything possible to bypass the semi-legal injunctions placed on her by the regional Islamic administration not to photograph the tribes unclothed. Body culture, nude at that, was a central part of Riefenstahl's aesthetic. In 1936 she'd filmed and photographed the Berlin Olympics, sponsored by Hitler's propaganda minister, Joseph Goebbels, posing several athletes and models as naked Hellenic statues.

Africa was a new hunting ground to search for her dream of an *ur*-civilization unspoilt by clothes, money and the conveniences of modern life. Susan Sontag considered the resulting book, *The Last of the Nuba* (1976), a continuation of Riefenstahl's earlier work, in this case 'about a primitivist ideal: a portrait of a people subsisting untouched by "civilization," in a pure harmony with their environment.'[26]

While the pictures and text in *The Last of the Nuba* echo the interest of Rodger and the Luz family in body culture, there is, in truth, more breadth to Riefenstahl's work in the sense that she photographed so much of the Nuba way of life – largely due to spending more time in the field. She reports that death ceremonies were the most important cultural events of the Nuba calendar, more so than weddings or fighting. Riefenstahl returned over several years to witness such events, as well as to report on the minutiae of agricultural practice and cultural tradition.[27] The work may be problematic in its presentation of a supposedly unchanging world but it is not dishonest except by omission, where the photography excludes the facts of change, such as the Islamization of the Nuba or the presence of the local Baggara population, which would have been considerable when she was there. More than this, the changing administrative and social life of Sudan after independence in 1956 was, apparently, entirely irrelevant.

Riefenstahl writes in her book about the impact of the introduction of money to the Nuba's pre-1960s barter culture, but we see no evidence of this: no trade whatsoever, no intermingling with others. Perhaps this is what Sontag meant in her review of Riefenstahl's Nuba book by the term *fascist aesthetics* – the term she chose as a title – meaning, for her, the reification of racial purity.[28] The Nuba

didn't judge Riefenstahl for being Hitler's appointed film-maker and photographer. Africa after World War II – or Riefenstahl's primitivist version of it, her search for a lost Eden – was her second chance at life, as it had been, oddly enough, for George Rodger.

Edenic narratives are defined as 'presentations of a natural or seemingly natural landscape in terms that consciously – or, more often, unconsciously – evoke the biblical account of Eden. These narratives underlie and colour much of what we accept as fact about particular people and places.'[29] Edenic narratives emerge wherever we detect a yearning for a supposedly vanishing past. An allegedly unspoilt landscape is imagined, sometimes peopled with 'good savages' of the sort Claude Lévi-Strauss observed in Brazil's Mato

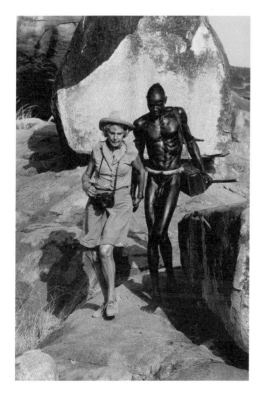

Horst Kettner, *Leni Riefenstahl in Kordofan*, 1975

Grosso region in the 1930s and later described in *Tristes Tropiques* (1955). The process whereby change is imposed by conquest is rarely discussed. People simply vanish.

The conjurer's verbs – 'to vanish' and 'to disappear' – are frequently invoked as euphemisms when building Edenic narratives. Edward Curtis referred to the vanishing Indians of North America when describing a process that can only be seen as a result of a brutal military expansionist campaign. The idea of wilderness determined the reconquest of landscape in the American West, where the national park idea first took root at the close of the American Civil War in 1865. National parks allowed for the redefining of landscape as reborn, Edenic and open for business under a new regime, run by white people.

Landscape photographs by William Henry Jackson, Carleton Watkins and Ansel Adams, from the late nineteenth century to 1964, were instrumental in enforcing the new regime and led directly to the creation of at least three US national parks. What the persuasive photographs largely conveyed was that Yellowstone and the Yosemite Valley were part of an unchanged ancient and spectacularly featured wilderness that needed preservation, and not that the landscape – the field systems, meadows and tracks – had been created by American Indians who had 'vanished'. The fact that the Ahwahneechee had lived and farmed the Yosemite area for 600 years was quietly forgotten.[30] The idea of an empty wilderness was an attractive myth:

> Americans look at an Ansel Adams photograph of Yosemite and see more than a national symbol. They see an image of an a priori wilderness, an empty, uninhabited, primordial landscape that had been preserved in the state that God intended it to be. Ironically, when Adams took his most famous photographs a sizeable native community still lived in Yosemite. What Adam's photographs obscure and what tourists, government officials, and environmentalists fail to remember is that uninhabited landscape had to be created.[31]

Adams used his direct line to the White House to keep up pressure on the government to restrict unwanted visitors to Yosemite, even complaining in one letter to Stewart L. Udall, the Secretary

of the Interior, about over-flying aircraft sullying the Eden he'd 'discovered'.[32] Adams counted fifteen planes in one morning. The problem for Adams, working in Yosemite in the mid-twentieth century, echoed that of George Rodger in the Nuba Mountains. Both produced compelling photographs that triggered a desire in others to explore the places they had photographed. It was a desire that both photographers spent their latter years attempting to suppress, believing that tourism was destructive to both traditional culture and the landscape. Adams saw the trappings of mass tourism in Yosemite as 'a wart on the face of Venus',[33] yet the demonic temple-destroyers Adams so detested were, at the same time, his merchandising angels, enabling him to continue his career unceasingly and to achieve high technical standards that others could rarely match.

Adams's concerns about the threatened Edenic landscape of the American West were echoed in Africa by the Polish photographer Casimir Zagourski. Zagourski, like Edward Curtis, was concerned about cultural change and documenting what remained of an exotic tribal past. Instead of Curtis's verb 'to vanish', Zagourski used 'disappear' to describe his preoccupation in his portfolio book *L'Afrique qui disparaît* (Disappearing Africa, 1938). He based himself in Léopoldville (now Kinshasa) during the 1920s and worked throughout the Belgian Congo. The photographs vary little from the stereotyping work discussed above from Burma or Papua New Guinea. The combination of frontal and profile views of certain 'types', such his *Bapende type* diptych, complies with accepted conventions not only of ethnographic portraiture but also of mugshots of criminal suspects. Nevertheless, it would be unfair to characterize Zagourski as a one-dimensional man: he was also observant of change and, in his better moments, sought to document it. In one telling portrait, Zagourski photographed Msinga, the deposed king of Rwanda, lowered finally from his Sedan chair and stripped of his finery: just a man – a little older – staring bleakly into the powerless void that was to be his future.

The notion and visual allure of a disappearing world continues to attract photographers to the tropics and elsewhere. Recently the war veteran Don McCullin returned to photograph lost or apparently

threatened tribes in Africa. During 2003 and 2004 McCullin accompanied his wife Catherine Fairweather, travel editor at *Harpers & Queen*, to photograph the Mursi and Surma along Ethiopia's Omo River valley. Both tribes are portrayed as nameless, stereotypical stick-fighting and lip-plate-wearing types. Several tribespeople pose with AK-47 Kalashnikovs. I suppose in the past they had spears. 'Poverty, guns and murder are poisoning them, even before they lose their nakedness,' lamented McCullin in the introduction titled 'Troubled Eden' to his book, *Don McCullin In Africa* (2005).

The hunt for tribal nakedness also continues unabated. Sebastião Salgado, in his photobook *Genesis* (2013), went back to the Mursi and Surma tribes in McCullin's footsteps. Somehow, in his pictures, he excludes the guns and the poverty and disengages from the everyday realities faced by the people he photographs. *Genesis* is an Edenic narrative writ large in which actuality is subsumed by Salgado's symphony to paradise lost.

In Pará state, northeast of where Claude Lévi-Strauss found the Borobo in the 1930s, Salgado photographed the Zo'é people. Like the Borobo described by Lévi-Strauss, the Zo'é paint their bodies bright red using *urucu* seeds from the 'lipstick tree' *Bixa orellana*; their lower lips, from a young age, are transpierced by lip-plugs. There is a marked difference between the way the Zo'é are described and photographed in *Genesis* and the more factual account provided by the charity Survival International. The black-and-white pictures in *Genesis* teach us nothing of the red body paint, nor that their jungle encampments abut an airstrip that is in regular use or that a nearby government-funded health centre, or 'mini-hospital', helped prevent their extinction from disease after contact with outsiders in the 1980s. Salgado, like Curtis in the American West or Riefenstahl in Africa, has no interest in modernization.

Earlier in *Genesis* we are taken down the well-travelled track of the 'disappearing' nakedness of Papua New Guinea – this time of both women and men. Several pictures single out the long extensions worn on the mens' penises, like handmade and puffed out party-horns. Then there are the mudmen, 'the most striking figures of the imaginative world'[34] masked and cavorting in Papua's highlands, an Aristophanic comedy for modern times. Yet this is no

comedy. Nor are we sure in which historical era the scene is set.

Over the twentieth century a considerable critique emerged about the aesthetics of documentary photography. Several photographers were upbraided for favouring beauty or composition above a proper and serious engagement with content and change. This began with a Marxist critique by Walter Benjamin of Albert Renger-Patzsch's *Die Welt ist schön* (The World is Beautiful, 1928). Renger-Patzsch's work, linked to the form-and-function concept of the Bauhaus aesthetic in Weimar Germany, recognized an intrinsic beauty in the forms of manufacturing industry. Susan Sontag furthered the critique over Riefenstahl's aestheticization of the Nuba (and her obscured Nazi past). Some years later the blade turned on Salgado in an excoriating critique of his work by Ingrid Sischy in 1991: 'Beauty as a formula – and this is what it has become for Salgado – is as much a cliché as what

Sebastião Salgado, *Zo'é Group, State of Pará,* Brazil, 2009, from the book *Genesis*

he is trying to avoid, and as artificial as any other blanket approach.'[35]

I suggest that the criticism laid at Salgado's door – that his pictures are beautiful, over-composed – is misplaced. The concern, from the perspective of documentary value, is not that Salgado's *Genesis* is well composed or that the pictures are aesthetically pleasing. I don't see the crime in visual eloquence. Would one chastise a writer for choosing verbs or structuring a sentence well? No. So why are photographers berated for using visual language to create photographs that have (to use Josef Koudelka's term) balance? The puritanical attack on aesthetics in photography, championed by Benjamin, Sontag, Sischy and others, opens the door to what critic and academic Susie Linfield sees as 'an insultingly slummy aesthetic so that craft, care, structure – everything that Salgado embodies – are now morally suspect in photojournalism'.[36] No, the problem lies elsewhere: not with aesthetics or composition, but with essentialism – dwelling on the notion of a fixed or unchanging world.

Essentialism, in relation to beauty, has built its rhetorical platform on the Platonic ideal of 'everlasting loveliness': that there is a fixed and unchanging notion of an ideal Form. We saw this pursued in Leni Riefenstahl's Nazi work from the 1936 Olympics and again with the Nuba. Essentialism, in relation to culture and society, privileges a fixed and ideal way of life or tradition and is blinkered to anything else, to change or development. The problem lies in the denial of the facts. A loaded comment by the late poet and playwright Seamus Heaney during an interview in 1991 proves a valuable intervention: 'The poet', he said, 'is on the side of undeceiving the world.' Documentary photography might benefit from heeding this approach. Salgado's *Genesis* is not concerned with undeceiving the world we live in, but the reverse: it constructs a fantasy that imagines, from desires in the present, how the past might have appeared. It resembles Goethe's Faust gazing at the peasant garden, a simple world of bucolic harmony, before its premeditated destruction. Salgado writes that he 'followed a romantic dream to find and share a pristine world that all too often is beyond our eyes and reach ... Discovering the unspoiled world has been the most rewarding experience of my life.'[37] From a documentary perspective it is, as with Riefenstahl, everything that has been left out

from the photographs – signs of change, today's actuality – that brings into question the value of the work. Also present amid all the declamatory puff surrounding the *Genesis* project is the denial of economic development. After attending the *Genesis* exhibition in New York in 2014, the critic Ariella Budick wondered, 'Why shouldn't a steel-bladed knife make a hunter's life a little easier? Does that way really lie perdition? Is it noble to take pictures of subsistence farmers with a $10,000 apparatus in order to celebrate their lack of tools, nutrition or comforts? Does Salgado believe that cultural purity outweighs the very real adversity that his subjects face, however beautifully they cope?'[38]

These are tough questions when considered alongside the commercial expectations of the art world, where Salgado's pictures are pitched. Peter Fetterman, who sells Salgado prints from his Santa Monica gallery, saw a link between the *Genesis* work and landscapes by Ansel Adams: 'When I first saw the contact sheets, I thought maybe I was in the wrong studio, or the Ansel Adams archive', he said. No accident. Both Adams's work from Yosemite and Salgado's in *Genesis* are notable not for what the images contain but for what they omit: the witnessing of change. At the time of writing, Fetterman sells un-editioned 'handcrafted' silver gelatin prints from *Genesis* of naked Zo'é women arranged on some palm fronds for between $8,000 and $15,500, depending upon the size.

It is quite certain that the gallery world would shun the sort of pictures produced in Africa at the end of the nineteenth century: striking, terrifying pictures linked to the expansion of rubber production in Congo. In 1888 a Scottish vet, John Boyd Dunlop, invented the inflatable rubber tyre. Within three or four years the Belgian King Leopold II, who held sway over the absurdly-named Congo Free State, decided to turn the colony into a brutally run factory-farm to meet the demand for rubber. Leopold's staff were given free rein to do whatever was needed to boost production. A bloody regime ensued such that rubber from the Congo was nicknamed 'red rubber'. If production waned, cultivators were murdered. Léon Fiévez, a district commissioner who was originally a farmer's son from Wallonia, produced the greatest volume of rubber

in all the Free State. After four months in his post, he had murdered 572 people.[39] Murder was so widespread that bullets were rationed. To discourage the agents of Belgian concession companies from wasting bullets, they were made to cut off the hands of those they shot as proof of death.

Missionaries based in the Congo, such as Alice Seeley Harris and her husband John, began to collect evidence of the atrocities. A photograph by the Harrises from May 1904 shows a Congolese man, Nsala, looking down on a verandah at the hand and foot of his daughter. The caption reads: 'These were the only body parts that remained after she had been eaten by sentries harassing the village for their rubber quota.'[40] In another picture by Alice Harris, a man stands in an otherwise standard group portrait but holding two other men's severed hands.

More photographs from the Congo rubber plantations depict victims with sawn-off limbs. It was when lantern slide shows of the collected photographs were shown in London and New York, together with reports from diplomats, that Leopold's empire began to crumble. The Kodak camera led to his downfall, as Mark Twain emphasized in his fictional parody of Leopold: 'The kodak has been a sore calamity to us. The most powerful enemy that has confronted us indeed ... the only witness that I have encountered in my long experience that I couldn't bribe.'[41]

An anti-essentialist approach to documentary places change at the centre of narrative. The poet and feminist thinker Adrienne Rich wrote that 'Any real poem is the breaking of an existing silence', suggesting that we might therefore ask of any poem, 'What kind of silence is being broken?' Parallel to the idea of documentary practice being, perhaps, about undeceiving, an anti-essentialist approach to documentary photography may be one that actively sets out to break the silence. It neither creates nor upholds myths or Edenic narratives. Instead, photography can and has been used to counter fixed and stereotypical views about race and racism in order to foster greater understanding while still embodying a creative treatment of reality. Photographers such as Ian Berry, Ernest Cole, W. Eugene Smith, Leonard Freed and Wayne Miller practiced this approach by

From the lantern slide archive of Alice Seeley
Harris, *A young man and woman with severed
arms*, Congo Free State, c. 1904

their empathetic engagement with the plight of black South Africans
living with apartheid and African Americans over rights issues.

In South Africa, Ian Berry summarized the rationale behind
his powerful documentary work on apartheid: 'I was disturbed by
what drove, and in many cases still drives, white people to believe
themselves to be superior.'[42] Berry was the only photographer present
after 1.30 p.m. on 21 March 1960, when the shooting took place that
led to the massacre of more than seventy people in the township

of Sharpeville. 'The majority of those killed were running away',[43] recalls Berry. His best-known photograph from Sharpeville is of a police officer reloading his weapon as a young boy, running towards the camera, hoists his coat to protect his head from bullets raining down on the crowd. The sequence of photographs, later shown in court where Berry appeared as a witness, enabled him to intervene in support of the forty or so mostly wounded black Africans who had been arrested and charged with affray. Berry's witness statement testifying that the police had reloaded with live ammunition ensured the case was dismissed.

Berry worked at *Drum* magazine under the editorship of the late Sir Tom Hopkinson, a courageous journalist who arrived from the magazine *Picture Post* in London. *Drum* was founded in 1951, and at its height had a circulation of 450,000.[44] Berry travelled with Hopkinson to the Congo in 1960 to document the Belgians handing over power to the post-independence president, Joseph Kasavubu. Berry recalled how Hopkinson risked his life to prevent a man being beaten to death by a crowd of Congolese: 'Tom got out of the car, walked across the road and stood over the guy on the ground, and shouted at them [the assailants].' Nonplussed, they backed off. Berry (who had been photographing the affray) remembers, 'He taught me when it was right to intervene'. Hopkinson was a committed humanitarian, guided by a strong moral purpose to challenge racism. He encouraged South African photographers, such as Peter Magubane and Ernest Cole, to tell their story of life under apartheid.

Few people risked more or pushed harder to penetrate the realms of social injustice in South Africa than Ernest Cole. In 1963, following treatment at Johannesburg's Baragwanath Hospital after a scooter accident, he saw for himself the poor state of the black healthcare system. Once discharged, Cole snuck into several other medical facilities reserved for blacks with a camera hidden under his jacket to document the appalling healthcare facilities. A memorable image from Cole's book *House of Bondage* (1967), a compilation of several of his photo-essays from South Africa, shows a woman covered in a blanket stretched out along four high-backed chairs that serve as a bed. Another woman, asleep with a cigarette in her mouth, lies outstretched in an adjoining cot. Cole wrote: 'The cruelty

Ian Berry, *Sharpeville,*
South Africa, 1960

of *apartheid* – separateness – has infected us as well as them. It is an extraordinary experience to live as though life were a punishment for being black. No day passes without a reminder of your guilt, a rebuke to your condition, and a risk the trouble of transgressing the laws devised exclusively for your repression.'[45] To get some insight into life for black prisoners he went further still. He got himself arrested, then smuggled a camera into jail.[46] He sacrificed a great deal to document what was happening to his fellow South Africans. This was no Edenic narrative. It was hell.

In the United States, photographers were also working to make a difference against an upsurge tide of prejudice and segregation in the South that paralleled Cole's experience in South Africa. One was W. Eugene (Gene) Smith, a *Life* magazine photographer whose own traumatic personal life fuelled a passionate and humanistic sensitivity that inspired his photojournalism. Tragedy began when Gene Smith was just seventeen. Ravaged by debt, Smith's father –

a grain merchant – shot himself in the stomach with a .410 shotgun in a car close to the family home, outside the St Francis Hospital on Ninth Street, Wichita, Kansas. He left three notes on the dashboard. One was to Gene, leaving him the money to go through college.[47] The psychological pain Gene Smith suffered – he gave his own blood trying in vain to save his father's life – made a considerable imprint on his life and career.

The second time Smith gave blood in an attempt to save a life was on assignment in South Carolina. Smith was already known for his seminal 1948 photostory 'Country Doctor', a feature on Dr Ernest Ceriani and his practice in Kremmling, Colorado. Three years later, Smith accepted a new assignment from *Life* magazine – 'Nurse Midwife' – to look at healthcare in the South. The difference between the two stories was that, in the latter, the protagonist was black.

Driving through South Carolina en route to covering the story, Smith stopped in Leesville to attend a Ku Klux Klan rally. He stayed on to photograph the cross-burning. Appalled at everything he witnessed, Smith's mind was set: 'The emotional experience of racism … shaped the photographer's intentions for the photo-reportage.'[48] To complete the assignment Smith followed the nurse midwife, Maude Callen, for half a year. It was while attending a complicated birth procedure that Smith intervened, offering his own blood in a failed attempt to save a baby's life. Smith's deep commitment to and engagement with his subjects is a measure of the documentary impulse that drove him from one assignment to another. Why do we care about this story? Because Gene Smith cares. It comes across in every single photograph he took in that clinic where Smith projected his feelings onto the people he photographed.

Maude Callen's job title – nurse midwife – is a less than adequate description of all the roles that she unofficially fulfilled: mentor, doctor, psychiatrist, teacher, pastor, to name a few. As Smith himself wrote after watching her work to the point of exhaustion: 'Tears cut deeply and hot through me. No story could translate justly the life depth of this wonderful, patient, directional woman who is my subject – and I love her, do love her with a respect I hold for almost no one.'[49] Smith's words give a clue to the visceral bond formed between the photographer and his subject.

W. Eugene Smith,
*Maude Callen attending to a woman
in labour*, 1951, from 'Nurse Midwife',
published in *Life* magazine

'Nurse Midwife' was published on 5 December 1951, with a sequel appearing in April 1953. 'Maude gets her clinic' was a celebration of the new clinic that Callen had been pictured building in the original article, funded by the donations *Life* magazine received. Of the many essays that Smith produced, he considered 'Nurse Midwife' the crowning glory of his career. It served not only to undermine racial stereotypes and the concept of racial superiority, but also to empower the role of women in US medical practice. Smith wrote to his mother: 'I feel (as do others) that the story struck a powerful blow (though not miracle-working) against the stupidity of racial prejudice and the theory of inferiority.'[50]

Leonard Freed first photographed black American soldiers in Berlin in 1961 before pursuing his seminal book on racism, *Black in White America* (1967/68) – a project with a moral purpose. Freed's empathetic approach set out to reduce racial antipathy. He explored the everyday life of racial segregation, such as the challenge faced by mixed-race couples seeking to marry in the South. Freed documented the Civil Rights movement, travelling the country with Martin Luther King, Jr., as far as the March on Washington in August 1963, when quarter of a million people demonstrated for jobs and freedom for African Americans.

One Freed photograph, perhaps the most powerful in *Black in White America*, shows King just after receiving the Nobel Prize in 1964. The picture is all about the joining of hands, the physical belonging to the quest for racial equality. King is in a car moving away from the photographer, but his hand is clasped by at least four African Americans who appear to never want to let it go. This clasp of hands is so powerful, so urgent and so meaningful that it entirely shapes the rhetoric of the picture. The photograph engenders nothing but warmth, and of course is all the more poignant when we consider that, less than four years after it was taken, King was assassinated in Memphis in 1968.

Wayne Miller made his most important body of documentary work in Chicago, the city in which he was born. Leaving the US Navy after World War II, Miller had seen enough of conflict and thought the only way to avert it was through promoting an understanding of other races and cultures and in so doing dispelling prejudice and

racism. He returned home with a mission: 'To document the things that make this human race of ours a family. We may differ in race, colour, language, wealth and politics. But look at what we all have in common – dreams, laughter, tears, pride, the comfort of home, the hunger for love. If I could photograph these universal truths, I thought that might better help us understand the strangers on the other side of the world – and on the other side of town.'[51] This Miller did by documenting daily life in the poorer parts of Chicago with empathy, giving dignity to those he found leading strike action, playing pool, dancing, sitting down to dinner or chatting on a street corner. It was a mission that inspired Miller's landmark book, *Chicago's South Side 1946–1948* (2000). Miller also acted as the much-valued assistant to Edward Steichen, the director of photography at the Museum of Modern Art, for the celebrated 'The Family of Man' exhibition and book in 1955. Steichen created the exhibition, he said, 'in a passionate spirit of devoted love and faith in man'. The book of the exhibition, launched at the height of the Cold War and the fear of nuclear annihilation, became the best-selling photographic book of all time.[52] Steichen's comment that the exhibition was to be 'a mirror of the essential oneness of mankind throughout the world' reflects exactly Miller's own life's project in photography.[53] Miller's work, like that of Berry, Cole, Smith and Freed, is anti-essentialist in outlook, unafraid of engaging with change in a way that is both informative and respectful.

Photography that is empowering and respectful has considerable documentary value. It is anti-essentialist in recognizing the challenges faced by societies undergoing change or upheaval, and recognizing that there is no ideal Form within the human condition. We evolve, most of us, in the manner of our choosing. In the case of oppression or subjugation, documentary photography again has a role in breaking the silence.

3

PHOTOGRAPHY'S BID FOR A BETTER WORLD?

Because of its capacity to visualize deprivation, need and social injustice, documentary photography has, since its invention, been instrumental in advocating reform. The role of the image in reform, however, predates the invention of photography. William Hogarth's 1751 print *Gin Lane* is a dystopian vision of the St Giles district of London produced to help lobby for the passage of an act to regulate the sale of gin.[1] A mother is depicted pouring gin into a baby's mouth while two girls sip gin outside a distillery. The year Hogarth's print was published, more than 9,000 children died in London from the effects of gin; the poor were drinking 11 million gallons of it a year. Four months after Hogarth's print was published, in June 1751, a new act of Parliament limited the sale of gin. While the new law was not a direct result of Hogarth's artwork, the image may have been influential in the campaign.

The reformism discussed in this chapter, in which photography has been harnessed to drive social change, must be seen as pragmatic. Documentary photographers have sometimes stood at the vanguard of revolution, such as in Cuba or Nicaragua. Mostly, however, photographers have used the power of images to struggle for incremental change in laws or conventions protecting the poor and their rights. Some of these efforts – such as the photography of slum housing in Leeds, England – have privileged the interests of property speculators over those of the poor.[2] The documentary impulse to shine a light into some of the darker corners of society raises questions about the representation of poverty and the impact and effect of photography on its subjects.

Recurring issues explored by documentary photographers include slum housing, landlessness, mental institutions, the prison system, domestic violence, the plight of street children, poverty and drug addiction. Much that underlies the projects raised here comes down to low state accountability and support, a progressive trend in Britain and the United States since 1979.

The work of social-documentary photography, with an emphasis on reform, can be seen as having begun in the nineteenth century in London and New York. An important contributor was the Danish-American journalist Jacob Riis. Riis made use of the 1887 invention

of magnesium-flash photography to capture evidence of insalubrious and overcrowded tenement housing. His book *How The Other Half Lives: Studies Among the Tenements of New York* (1890), together with his lantern-slide lectures, were highly influential. Riis's inspired work led to improved housing and sewage management in the Lower East Side and the inner city as a whole.

Revisionist histories of Riis's small photographic archive (he took only 250 photographs in his ten-year photographic career) range from trenchant criticism to winsome praise. The Welsh writer Derrick Price noted that, with the new and dangerous flashguns, Riis 'brought terror everywhere he went. ... Tenants bolted through windows and out of the fire escapes'. They were escaping a camera that, according to Riis's critics, recorded its subjects as 'passive sufferers of poverty' in an 'act of subjugation'.[3] Reportedly, Riis twice accidentally set tenement houses on fire. The New York writer Luc Sante, by contrast, saw Riis as a 'one man band of social reform [whose work] altered the outlook of the whole city, and eventually the nation'.[4] Sante argued persuasively that, while it is easy to find fault with Riis's methodology, sentimentalism and ignorance of economic cause, he 'convinced the average reader that the poor were not so by choice; that the dangerous and unhygenic conditions in which they lived were imposed, rather than the result of loose moral standards; that the slums were something that needed to be fixed, rather than gaped at or shunned.' Despite his methods, Riis was a pioneer in his impulse to use photography to draw attention to contemporary social injustices.

In the first half of the Progressive era – a period of social activism from the 1890s to the 1920s – reformism drove the documentary agenda in America's inner cities. Nineteenth-century slum clearance, on both sides of the Atlantic, was a complicated and not always benign process, with injustices to match those reported during slum clearance events in China and Southeast Asia during the 1990s. But inner-city improvement was eventually expedient, as was legislation on child labour – another aspect of social reform driven by the power of photography coupled with the professionalization of social work. In 1900 it was reported that there were 1,752,187 child workers in US industry, although the figure is an underestimation.[5] In the same year the US national census

recorded that 18.2 per cent of children between the ages of ten and fifteen were working; in 1910 the figure had risen to 18.4 per cent.[6] Wisconsin-born teacher, photographer and sociologist Lewis Wickes Hine recognized the potential for socially concerned documentary photography while teaching geography and natural science at New York's Ethical Cultural School. He had never handled a camera before 1904.[7] Four years on he became a staff photographer for the National Child Labor Committee (NCLC), one of the first organizations committed to using photography to bring about change. He took more than 5,000 photographs of children working as bootblacks, postal messengers, factory workers, newspaper vendors, sweepers, mineworkers, berry-pickers, shrimp pickers, oyster shuckers, dressmakers, lace workers, melon basket-makers and helpers in lumber yards. A photograph from August 1908 features a young newsboy, John Howell, selling newspapers in Indianapolis (see overleaf). The foreground is dominated by Hine's imposing shadow: a man in a hat triggering an exposure on a plate camera mounted on a wooden tripod on what appears to be a well-appointed main street. Another photograph depicts twelve-year-old Meyer Slein out selling newspapers in St Louis, Missouri, on a Saturday afternoon on 7 May 1910. He looks wanly at passers-by as they drift past, not buying. The composition of both pictures is frontal – typical of Hine – the subject centred in the frame.

Hine considered himself an artist, but the dullness of many of his compositions is rescued only by the handful of pictures that break his formulaic mould and by his tenacity as a social campaigner. His career and his letters trace the life of a frustrated man who considered himself overlooked – both as artist and documentarian – until he died in poverty in 1940, after the bank repossessed his home.

Cornell Capa, writing in *The Concerned Photographer* (1968), considered Hine an early 'humanitarian-with-a-camera'. He quoted Hine's life mission: 'There are two things I wanted to do. I wanted to show the things that had to be corrected. I wanted to show the things that had to be appreciated.'[8] Hine managed the first, insofar as child labour laws were finally made federal in 1938, but – photographically at least – struggled with the second.

Roy Stryker, the head of the information division of the Farm Security Administration (FSA) from 1935, shunned Hine's efforts to work on the FSA project. He did, however, launch the documentary career of Dorothea Lange.[9] The FSA was a government bureau with an agenda linked to Roosevelt's 'New Deal' administration, and was focused on the plight of Dust Bowl farmers. It had strict rules and Stryker 'killed' pictures that didn't fit his expectations, piercing the negatives with a hole-punch.[10] It was not surprising, then, that Lange appealed, with the support of Ansel Adams, to be allowed to print her own work; she didn't want her negatives tampered with. Lange was the only FSA staff photographer not based in Washington, DC. In the spring of 1935 she set off from her home in San Francisco on her first assignment to California's Imperial Valley with the agricultural economist Paul Taylor, a professor at Berkeley.

Lewis Wickes Hine, *John Howell, an Indianapolis newsboy, makes $.75 some days. Begins at 6 a.m., Sundays. (Lives at 215 W. Michigan St.) Location: Indianapolis, Indiana*, 1908

Taylor was a pioneering social reformer who was in league with, and soon married to, Lange. They formed a formidable partnership, one of the most effective in the history of documentary. Their marriage was consumed with an impatient documentary determination: Lange was out photographing on the afternoon of her wedding in New Mexico.[11]

Lange and Taylor's seminal book, *An American Exodus* (1939), still stands as a classic analysis in words and pictures of both the causes and consequences of unregulated agricultural intensification and exploitative factory farming. The text – both captions and longer explanatory inserts – underlines the inequity of both smallholder-tenant and factory farming during the Depression. In fact it attempted more than that. By focusing on the plight of farmers across a wide area of the American West and Midwest, it exposed the confluence of a number of factors facing farming in the United States at the same time: the impact of drought, economic depression, the mechanization and industrialization of agriculture, exploitation of labour, forced mobility and, finally, the opportunity for partial recovery offered by the outbreak of war in Europe. Describing the Dust Bowl, Taylor wrote: 'Dried by years of drought and pulverised by machine-drawn gang disk plows, the soil was literally thrown to the winds which whipped it in clouds across the country'[12] – perceptively linking a natural hazard, drought, to human impact.

Several photographs in *An American Exodus* depict Oklahoma farmers in 1936, uprooted from their homes, setting out on the road west. In 1938 and 1939 we see these same migrant 'Okies' as pea pickers drawn away from their land into intensive, large-scale, seasonal agriculture in California. Beneath a photograph of farmers lining up with their buckets of peas (see overleaf), Taylor speaks of 'a large, landless and mobile proletariat'.[13] Although the images carry their own symbolic power – for example, a picture of the road heading west – the text lends information and force.

The FSA's most famous photograph, Lange's *Migrant Mother*,[14] was omitted from *An American Exodus* and from Lange's initial publication, which aimed to secure help for tenant farmers suffering from a frost-damaged pea crop. Driving home exhausted from a road trip in March 1936, Lange doubled-back after spotting a pea-pickers'

Dorothea Lange, *Pea pickers line up on edge of field at weigh scale. Near Calipatria, Imperial County, California,* 1939

camp in Nipomo, California. There she met Florence Thompson, a thirty-two-year-old mother sitting in a lean-to, surrounded by her seven children. Lange took six pictures and Thompson, according to the photographer, 'asked no questions'.[15] Thompson told how she had been living on frozen vegetables from the fields and birds the children had killed. She claimed to have sold her car's tyres to buy food. It was car trouble that brought Lange to Nipomo in the first place: the timing chain had broken en route from Los Angeles to Watsonville.

The photograph became emblematic of the whole Depression era, even though it had undergone some darkroom manipulation – the airbrushing out of Thompson's thumb – that would eliminate it from a press award today. However, as with many so-labelled iconic pictures, it tells us almost nothing of the processes that impacted upon

America's migrant population or tenant farmers at the time, only the fact that Lange's subjects appear as 'deserving poor', with the added rhetorical force of a Madonna figure to connect the image to Christian iconography. Lange, like many documentary photographers, projects her own sense of despair at what she is witnessing onto her subjects, selecting moments where they appear forlorn.

One of the issues facing documentary work during the 1930s, of which Lange's photograph is an example, was an expectation of a certain kind of pensive yet stoical expression attributable to the needy, the worthy poor. The writer Robert Coles explored this further in interviews with farmers after the photographers had left, noticing that the mood changed once the cameras are out of sight. In one interview, a farmer recants:

When they were gone, finally, I took a big breath in, and I unbent myself. We all started smiling and we had a good laugh. For a few minutes we looked around: they might still be there, picturing us one more time! But no, they were truly gone! My wife said to me: too bad they didn't get us this time, having some fun for ourselves! But if they'd been about, we wouldn't be the way we are with ourselves when we're alone.[16]

Clearly, farmers were encouraged to adopt a set look for the cameras, one demanded by the media and perhaps expected by the commissioning body, in this case the FSA. One of the important rhetorical tools at the disposal of the photographer is the act of selecting, at the picture-taking stage, the mood or expression of the subject. Often that captured moment is more a projection of the photographer's own guilt, sorrow or moment of reflection than it is a typical instant in the subject's life. The camera stills the subject. Florence Thompson, when not posing for Lange's photograph, would likely be extremely busy tending to the needs of her children, some of whom were left out of shot. The framing was carefully selected to further a humanitarian cause. 'Humanitarian imagery', the historian Heide Fehrenbach suggested, 'is moral rhetoric masquerading as visual evidence.'[17]

The term 'humanitarian', first used in its modern sense in 1844 in Britain, implies an ethical standpoint, one normally associated with religious concern for others. Humanitarian imagery upholds

human welfare as a primary good: it is connected with 'aid, relief, rescue, reform, rehabilitiation and development' – in short, with benevolence towards humanity as a whole.[18]

In its reformist mode, humanitarian photography evolved in the 1960s to address the crisis facing the mentally sick, along with prison welfare, inner-city poverty and racism. Some of the early critical documentary photography of mental institutions began in Italy and Argentina, prompted by the Italian social psychologist Franco Basaglia.[19] Writing on those interned in asylums, Basaglia recalled words written by Primo Levi, aged twenty-five, when he arrived at Auschwitz. Levi described the hollow man: 'Imagine now a man who is deprived of everyone he loves, and at the same time of his house, his habits, his clothes, in short, of everything he possesses: he will be a hollow man, reduced to suffering and needs, forgetful of dignity and restraint, for he who loses all often easily loses himself.'[20] When I think of these words, first published in Italian in 1958, it is easy to understand how people involuntarily lose themselves without support, familial or otherwise.

While Basaglia's theories on the humanitarian management of mental illness were powerful – he argued for an 'open-door hospital' and then its gradual elimination through care in the community, – they needed photography to deliver the message. 'We know the images', wrote Michel Foucault in 1967, opening a chapter on the birth of the asylum that described the cruel way in which the insane were treated and pictured.[21] Images of what? Restraint? A remedy? Bestiality? Late-eighteenth-century descriptions of one of Europe's most notorious asylums, La Salpêtrière (where early photographic experiments were made of schizophrenics), referred to women 'chained like dogs to their cell doors'.[22] Food and the straw on which they slept were passed through a grille, and the filth that surrounded them was collected with a rake. In other words, patients were treated like zoo animals. An account from the photographer Eugene Richards in Paraguay describes a thirteen-year-old boy he photographed in 2003 'being held in a cage barely big enough for an average-sized dog'.[23]

One might suppose that little has changed in two hundred years. Public holidays once drew crowds to London's Bethlem Royal

Hospital, then known as Bedlam, where onlookers paid to gawp at the insane. Certainly, the popularity of the asylum, with what Bedlam's governor described as the 'frisson of a freakshow', has declined over time. Did photographs eventually serve as a proxy for the supposed entertainment of visiting the asylums or as reform-driven evidence? Mostly, I would hope, the latter. This is shown in Eugene Richards's photographs from 1999 of Ocaranza, a Mexican psychiatric hospital, depicting men standing or slumped on either side on a pool of urine. The outrage surrounding the publication of Richards's pictures in the *New York Times Magazine* in January 2000 – backed up by Michael Winerip's text – led to the closure of Ocaranza later that year.[24] Another example of this approach is a much-published Raymond Depardon photograph from 1980 of a psychiatric hospital near Turin, depicting a seated man with his coat pulled over his head, revealing a small black void where his head should be: the quintessential hollow man.

The reformist images from asylums that are most disturbing to me depict the stark inhumanity of institutions where men and women – bullied or coerced into a catatonic stupor – sit listlessly against peeling or decrepit walls. The Italian photographer Gianni Berengo Gardin, who worked with Franco Basaglia to expose the asylum scandal, took several of these moving photographs that appeared in a jointly published book, *Morire di Classe: La condicione manicomiale* (The Dying Class: The Condition of the Asylum, 1969). One photograph shows two women, one with her fingers pulling against cage wire in the hospital compound, her face full of anguish (see overleaf).

At the same time the photographers Sara Facio and Alicia d'Amico, with help from a commission from Argentina's Ministry of Health, worked on the book *Humanitario* (1976), a similarly cheerless vision of mental institutions in Argentina, including an 'open door' hospital.[25] Here we see men, women and children coexisting, yet each alone in a private hell. If we believe madness lies just under the surface in all of us, then a punishment regime for those who, through no fault of their own, just can't keep a lid on it seems inappropriate. Echoing the Depardon picture described above, one man's large wrinkled hands obscures his face so that he can't be seen. This motif is reproduced, in triplicate, over two pages.

In Chile the photographer Sergio Larrain, whose work will be discussed in more detail in Chapter 7, had completed work on the plight of street children in Santiago in his first book, *El rectángulo en el mano* (The Rectangle in the Hand, 1963). The work was no new revelation – the suffering of children abandoned to the street had been documented in Russia by Dmitri Baltermants in the 1930s – but the book format was new for this topic. *El rectángulo en el mano*, made in collaboration with Fundación Mi Casa, comprises twenty-eight pictures of street children accompanied, on some pages, by collarless dogs that they draw close for warmth at night.

There is a marked difference between the intent behind Larrain's early street photography and that of those photographers who went on to document street-children in New York and Europe, such as Walker Evans, Helen Levitt and the French humanist photographers: Willy Ronis, Izis, Robert Doisneau, and Henri Cartier-Bresson. Larrain's *El rectángulo en el mano* was produced with the specific intent of raising awareness and bringing about societal change rather than simply picturing society as a cultural project, whereas Evans once made clear: 'I never took it upon myself to change the world'.[26]

In fifty years much of Western society has inched towards a public-service-lite 'hollow state', a term used to describe a society, most pronounced in the United States and Britain, where the state withdraws from primary responsibly for public-service provision. The move in this direction is based upon 'trickle-down' economic theory and the belief that self-regulating markets will solve social problems with minimal care in the community.

World War II and the post-war political shift to the left imposed upon the wealthier section of society a sense of communal responsibility, or, as Evelyn Waugh put it, introduced 'the bleak age of the Common Man'.[27] In 1987, the British Prime Minister, Margaret Thatcher, asserted in an interview with *Women's Own* magazine, 'There is no such thing as society ... [or] entitlement without obligation'. Life changed after that on both sides of the Atlantic, and much of the work that has been done by documentary photographers, with scant support from the media, has tried to raise awareness of the fallout.

Gianni Berengo Gardin,
Mental hospital, Gorizia, 1969,
from the book *Morire di Classe*

A documentary project looking at inner-city poverty in 1970s
Britain was initiated by three photographers who formed the Exit
Photography Group: Nicholas Battye, Chris Steele-Perkins and
Paul Trevor. Their work, influenced by the British Prime Minister
Harold Wilson's 1968 Urban Programme, was published in
Survival Programmes: in Britain's Inner Cities (1982). Interviews were
conducted across the country and matched with photographs, very
often from a different region. Trevor explains:

> Very early on in the project, while still shooting, we agreed on
> the basic structure of the book – the one-picture-per-page visual
> narrative on the right, text on the left. When it came to putting
> it together we weren't interested in matching the text on the left
> with the picture on the right. On the contrary, we were interested

in discovering contradictions, ironies, complexities, insights that this structure might throw up. In this way the book offered three narratives – visual, verbal and the often ambiguous relationship between the two. It was a deliberate departure from standard photojournalism.[28]

In an interview placed next to a photograph of a school in Middlesborough, a primary-school teacher in Liverpool told Trevor, 'the future for most of these kids is the future for all of the kids in this area – they're written off '.[29] The structural constraint that concerned the young teacher was less to do with social mobility *per se*, and more with widespread lack of parental involvement in their children's education. That is what 'wrote them off'. In 1975, more than a quarter of the British population were living in or on the margins of poverty. However, understanding this as a process – explaining why many people remained in poverty – proved more challenging, as the photographers discovered: 'To document a condition is not to explain it. The condition is a symptom, not a cause; more precisely, it is the outcome of a process.'[30] The *Survival Programmes* photographs in themselves were, ultimately, unable to develop a narrative that entirely succeeded in explaining inner-city poverty, although the interviews helped. They hinted at a sort of self-perpetuating 'culture of poverty' exacerbated by families unprepared for the form of social change that the political class deemed to be good for them.

Various theories have emerged about a 'culture of poverty', the best known being that of Oscar Lewis, who claimed in 1966 that poverty was self-perpetuating: 'By the time slum children are six or seven', he wrote, 'they have usually absorbed the basic attitudes and values of their subculture. Therefore they are psychologically unready to take full advantage of changing opportunities or improving opportunities that may develop in their lifetime.'[31] Documentary photographers committed to exploring the condition of those living in poverty have struggled to understand its nature. Surely, I remember feeling, people are more aspirational than Lewis's theory assumes.

During the 1990s I spent several months during three trips to Mexico City seeking, in part, to disprove Lewis's theory. During my

first visit I photographed a slum area known as Barrio Norte, an old sand quarry. At the beginning, many inhabitants lived in makeshift huts and had no water, electricity or drainage. When it rained the whole valley became a sea of mud. Little by little, over several years, I watched as the community worked to improve housing, dig drainage channels and plant gardens. The last time I visited Barrio Norte was in 2001, on assignment for *National Geographic* magazine as part of a project on megacities. By then it was almost a suburb: houses painted in bright colours, playgrounds built. I found no evidence of a 'culture of poverty' as a fixed and permanent condition in any slum or barrio I visited in what used to be called the Third World: mostly I found hard-working people full of aspiration.

I thought that with this evidence I'd succeeded in debunking Lewis's theory until I started looking at the work of Eugene Richards, Jessica Dimmock and Darcy Padilla. There I found a fourth world: dark, seemingly hopeless – and in America. It is almost impossible to find optimism in lives destroyed by drug addiction, much of which is connected to poverty. In the United States in 2011, over 15 per cent of the population were living below the poverty line – reportedly the highest figure since records began in 1959.[32]

Many of the issues that photographers have sought to address in the medium's first 150 years have been driven by outrage at various forms of what the economist Amartya Sen calls entitlement failure. Sen used the term to imply that the problems faced by the poor were not necessarily of their own making. His context was famine, but the same thinking might easily be applied to landlessness, drug addiction, domestic violence, poverty, foreclosure and inner-city housing.

This type of social-documentary photography differs in intent from less critical essays made from 'inside the goldfish bowl' by participants photographing their friends behaving (at least some of the time) badly. Photobooks of this latter type that come to mind are: Bruce Davidson's *Brooklyn Gang* (1998), Larry Clark's *Tulsa* (1971), Nan Goldin's *The Ballad of Sexual Dependency* (1986) and Mike Brodie's *A Period of Juvenile Delinquency* (2013). Divisions between objective versus subjective accounts are unreliable and probably artificial, however, since in many cases photographers working on challenging subjects such as domestic violence and drug abuse

befriend their story's protagonists during the (sometimes very long) period of the work. We find this in the following photobooks: Jim Goldberg's *Raised by Wolves* (1995), Mary Ellen Mark's *Streetwise* (1988), Eugene Richard's *Below The Line: Living Poor in America* (1987) and *Cocaine True Cocaine Blue* (1994), Jessica Dimmock's *The Ninth Floor* (2007) and Darcy Padilla's *Family Love* (2015).

Goldberg's *Raised by Wolves* lies on the borderline between art and social documentary. It is an essay in book form about several Hollywood street kids: their hopes, dreams and stricken lives. One character we meet early on is Dave Miller, known as 'Tweeky Dave'. He calls Goldberg 'dad', although they are not related. Dave escaped to Hollywood to make it as a rock star, but quickly became a child prostitute and an addict. At the book's close Dave is dead, not long after he appeared on a California TV chat-show. Goldberg faithfully records the dialogue:

Host: This is Tweeky Dave. He's nineteen and it's amazing he's still alive. He's a drug addict, a former prostitute, plus he's dying of leukemia. He lives on the streets of Hollywood. He's the epitome of those we call 'street kids'. *Shortly after that there's a commercial break. The camera returns focusing on the rotten stumps of his teeth.* Host [again]: Dave, perhaps you can remind our audience of how you ended up on the street. Dave: My father raped me, then shot me in the stomach when I was nine ... I haven't seen my parents since.[34]

After Dave passed away, Goldberg heard from a sister he never knew Dave had. She told a different story: 'He was not abused. He was not shot. My daddy never even owned a gun. My family are good, God-fearing people who worried and prayed for David every day.' Late in the book there are two photographs of Dave, one out of focus and one not, across two pages. There are no captions; sad as it sounds, Dave's toothlessness is our breadcrumb-trail tracing his presence through the book. I'm struck by the proximity of the TV chat-show dialogue – pitched as entertainment – and the ambiguity of the work's ultimate aim, which is perhaps to describe a journey ... and a harrowing one at that.

Heroin addiction as a life-threatening crisis emerged in the 1960s. Twenty years later, crack cocaine followed suit. In 1963, Tokyo-based photographer Kazuo Kenmochi produced one of the

first photo-essays of campaigning social documentary work on drug addiction: *Narcotic Photographic Document*. It was followed in quick succession by James Mills's two-part article 'The Panic in Needle Park' (made into a film in 1971) in *Life* magazine. Mills's account, together with his search for a solution, was illustrated by Bill Eppridge's 1965 magazine feature 'Two Lives Lost to Heroin': an ordinary-looking middle class white couple, their lives torn apart by heroin addiction, a story simply told.

Sensitively photographed and taking a similar approach to Eppridge, Jessica Dimmock's *The Ninth Floor* (2007) was the culmination of a documentary project about a small community of addicts and dealers surviving in an apartment leased by a former millionaire turned heroin addict in the Flatiron district of Manhattan. Dimmock's commitment to the project – her impulse – was based on unresolved issues from childhood:

> As the child of a former drug addict, there was something hauntingly familiar upon entering this space for the first time. I recalled the friends of my father I had been brought to as an eight-year old – the lone bulb hanging in the corner, the vacant and unengaging grown ups, the mattresses without sheets, and the crying baby that could never seem to get the attention of the adults in the room, even when she had rolled onto the cement floor. I have been motivated to do this work from my personal history, a concern about the destructive effects of addiction, and a commitment to make photographs that are socially relevant.[35]

Eugene Richards's 1994 *Cocaine True Cocaine Blue* took the photography of drug addiction to an entirely new level: courageous, sensationally graphic and unrelenting. Richards's images show the tragedy of lives – virtually all black and Hispanic residents of notoriously poor neighborhoods in Brooklyn, East New York and North Philadelphia – in graphic proximity. In North Philadelphia we are right on the sofa-bed beside a screaming baby while we are led to assume the mother, on the other side of the mattress, smokes crack. Arrests, guns, needles, white powder, drug-users and dealers flow past, uncaptioned, in a canted, verité and monochrome art book.

The impact of the book was diminished, however, by the relegation of a brilliant explanatory text by medical doctor Stephen

Nicholas to the back pages. Nicholas, a perceptive and well-informed writer, places the tragedy of crack cocaine addiction into a clear social and economic context, which the pictures fail to do. If Richards had shared the project with Stephen Nicholas, as Paul Taylor did with Dorothea Lange, the national debate that Nicholas claimed to be the book's intent might have been faster coming. The result of removing the narrator's voice is that we are left with the tape recorder on playback, tripping from one story of hopeless despair to another. Over the years, the horror – like the increasing dose of a drug – has intensified. The more sensationally explicit the photographs or the stories surrounding them, the faster our defence mechanism (rather than our compassion fatigue) reacts. The criticism that *Cocaine True Cocaine Blue* attracted might have been averted with a re-ordering of the narrative so that the social context could be grasped alongside the images.[36] Indeed, Richards's earlier book, *Exploding into Life* (1986), made with his partner Dorothea Lynch, was successful precisely because the text was allowed to share the narrative, and was commended for doing so.[37] Not until the back pages of *Cocaine True Cocaine Blue* do we begin to understand the context and process:

> In the early 1980s America grew dramatically more impoverished as a result of failed economic policies and the loss of well-paying, low skill manufacturing jobs. During the same period, a relatively cheap, smokable, and highly addictive form of cocaine dubbed 'crack' was created and then marketed with the imagination and genius of a blue chip corporation … What more studies of illicit drug use in America do not account for, and what they must begin to address, are differences in socioeconomic status.[38]

Photobooks or essays on social crises can be maddeningly formulaic. In many, captions are scant at best and informative text by the photographer (if any) is separated from the photographs. The landmark photobook *Let us now Praise Famous Men* (1941) – centred on three rural Alabama families enduring the Depression – with text by James Agee and photographs by Walker Evans, marked a turning point here. Perhaps it was Agee's occasional lapses into confessional solipsism in his otherwise eloquent and explanatory book that

made photographers turn away from using the author's voice in photobooks.

A photographer who does effectively use text in her photobooks is Darcy Padilla, whose documentary impulse has been to describe photographically the plight of America's 'permanent poor', a term she uses to define a culture of poverty that has proved almost impossible to escape. Padilla began working on a long-term personal project that concluded with the tragic death in 2010 of Julie Baird. The pair had met in 1993 in a single room occupancy (SRO) hotel called the Ambassador in San Francisco:

> My enduring study for the last twenty-one years has been the life of one woman and her family. Julie Baird personifies how the accident of birth can unwittingly fix someone's path in life. When I met her, she had just given birth to her first child and she had just found out she has AIDS. This project is one that has set a direction for my approach to photography.[39]

At fourteen, Alaska-born Julie lived on the street and quickly became dependent on alcohol and amphetamines. She had escaped from an alcoholic mother and a stepfather who sexually abused her from the age of seven. When she refused to have sex with her stepfather, she was thrown out of a second floor window. Between 1993 and 2008 she gave birth to six children, all of whom were taken into the care of social services as she moved from SRO hotels in San Francisco to prison for kidnapping and child endangerment and eventually to a hospital in Anchorage, Alaska. Her oldest child, Rachel, gave her a reason to live. Julie wanted to try to take responsibility for her wellbeing.

Padilla, who had been working on a project on HIV-AIDS, continued to follow Julie's life, inspired by W. Eugene Smith's 'Country Doctor' story. The book *Family Love* (2015) takes us from one disastrous species of abuse to another until we are left with a feeling of utter helplessness, despite the remarkable efforts that Padilla herself made to intervene in the narrative, to help Julie to keep custody of her children, her responsibilities and her life. She diarized her role:

> Darcy: 'I really think you need to take her in. Julie, you have CPS (Child Protective Services) on you and you need to show

that you are responsible.' Julie then explained how she gave Rachel one-half or one-third of an opium diarrhea medicine leftover from a prescription of a friend – who died from AIDS. I told her, I did not think that was a good idea. I saw them the next day.[40]

At the close of the book and the documentary film about Julie's life, we hear again from the oldest daugher, Rachel. Padilla has known her all her life. Rachel writes, in 2014: 'I was adopted at age five and we moved to a small town. I now am married to an amazing man, Matt, and we have two beautiful children ... Thank you for telling her story. I can now finally begin to heal. Can you answer me why she saw me two times a week then one day didn't show up? I am twenty-one years old. I blocked everything from my childhood out.'[41] These lines send some last message of hope and of healing.

Padilla's work sits within a history of documentary work setting out to expose domestic abuse and violence and the challenges that women face in prison. The tradition is exemplified by the photographer Donna Ferrato in her seminal project *Living with the Enemy* (1991), an initiative that began a lifelong commitment to supporting women who find themselves the victims of abuse.

The work discussed thus far in this chapter connects with both reformist and a broader scope of humanitarian photography. In the 1930s social documentary reports or stories were described as 'human documents'. As the historian William Stott pointed out, 'The adjective "human" recurs throughout thirties literature as a synonym for emotional or touching or heartfelt.' In the Progressive era, social documentary developed strong roots and networks in the US. During the McCarthy era of the 1940s and 1950s, however, socially committed documentary photography, which was perceived as having a socialist agenda, came under attack from two sources: the publishing media and the FBI.

The Photo League, an offshoot of the Film and Photo League, began in New York in 1936. At the start its work was not proscribed. It ran classes and offered support to photographers engaged in social-documentary projects aimed at exposing inequity in the city. Lewis Hine and W. Eugene Smith were members; both photographers

Darcy Padilla, *Julie with Rachel*,
San Francisco, 1993, from the book
Family Love

and staff were vulnerable to the Cold War politics of the age. One of
the Photo League photographers, Aaron Siskind, worked on a project
with all-white photographers, blithely unaware of the work that the
African American James VanDerZee and others in Harlem were doing.
Siskind focused on the poor, aiming to produce a sympathetic report.
The photographs represented Harlem as joyless and dysfunctional.
Unfortunately, when an illustrated article on the project appeared
in *Look* magazine on 21 May 1940, it was headlined: '240,000 Native
Sons – Harlem Delinquents in the Making'.[42] The Harlem project was
thus seen to be perpetuating stereotypes of racial inferiority. That was
not the aim of the Photo League.

The second problem the Photo League faced was being infiltrated
by Angela Calomiris of the FBI, who named Sid Grossman, its
president, as a member of the Communist Party. Finally, in 1947, the
Attorney General accused the organization of being 'totalitarian,
fascist, Communist or subversive'.[43] Partially rescued by support from

Paul Strand and W. Eugene Smith (who took over as president), the Photo League finally closed its doors in 1952.[44]

Its closure had a severe effect on socially concerned documentary photography. What followed was a turn to more authored personal projects – exemplified by the work of Robert Frank – that remained aloof from mass-circulation magazine publishing. Magazine photography in turn became both sanitized and overtly sentimental, as seen in the 'The Family of Man' exhibition that opened in 1955 at New York's Museum of Modern Art under the curatorship of Edward Steichen. The exhibition was irrefutable proof that photography was a universal language that could touch and deeply move people. By 1968 more than 9 million people in sixty-nine countries had seen the show.[45] But it was not without its critics. Susan Sontag referred to the exhibition, which closed with a photograph by Smith, as 'sentimental humanism'. She contrasted it with the 'anti-humanism' of Diane Arbus, whose photographs suggested a world 'where everyone is an alien, hopelessly isolated, immobilized in mechanical, crippled identities and relationships'. The project was overtly linked to the 1948 Universal Declaration of Human Rights, which defined those rights as the 'common standard of achievement for all peoples and all nations.'[46] Yet it failed to address minority rights issues and those of black South Africans.

The term 'humanist' as a description of documentary practice gained popularity during the 1950s in Europe, and especially in postwar France, when photographers such as Robert Doisneau, Willy Ronis, Henri Cartier-Bresson and others had regular features in photo-heavy magazines such as *Paris Match*, which sold a million copies each week. These magazines demanded street photography that reflected a positive image of 'Frenchness'. Humanistic photography in France in the postwar period was a unifying construct designed to re-glue a splintered nation. As the twentieth century advanced, the smugly anthropocentric tenor of humanism started to wear thin.

The philosopher Kate Soper has proposed a less assertively anthropocentric definition of humanism: 'Where the relationship of "humanity" to "nature" is to be understood as a totality: the world is what it is as a result of its being lived in and transformed by humanity, while humanity in turn acquires its character through its

existence and situation in the world.'[47] Humanitarian (more actively reformist) and humanistic photography, viewed in this way, would need to be more inclusive and open to the contradictory forces. So is humanistic photography contingent on a human subject? The question concerns one of the primary impulses behind documentary work: photography as a form of therapy – as a way of dealing with the past. This tendency was noted to explain the motivation of W. Eugene Smith and Jessica Dimmock, but need the subject always be human? In seeking to explore this question I looked closely at the life and archive of the Czech photographer Josef Sudek.

Sudek was born in 1896 in Kolín, 32 kilometres (20 miles) east of Prague, the city where he died in 1976. His father, Vacláv, was a house painter who succumbed to pneumonia when Sudek was an infant. Twenty years on, while fighting in World War I, Sudek lost his right arm to friendly fire from an Austrian artillery shell on the Italian Front. Unable to pursue his career as a bookbinder, he developed an interest in photography while he was convalescing.

Sudek's struggle to overcome pain and disability can be compared to that of the photographer Dorothea Lange, who was afflicted with polio but whose work had what the poet and physician William Carlos Williams described as a 'redemptive vitality'. Stubborn and resolute, Sudek kept going even after the Nazi occupation of the Czech borderlands in 1938, when to be out with a camera invited suspicion and persecution. Later, he retreated to the inner world of his studio – a wooden shack on a steep hill below Prague castle.

In a 1963 sepia-toned short film about Sudek by Evald Schorm called *Žít svůj život* (Living Your Life), the photographer potters in his garden wearing a loose-woven wool jacket and wets a small metallic bird (the work of the welder Andrej Bobruška) with a watering can. Inside, in shuttered window-light, we see some filmic cutaways: darkroom bottles, Sudek's large left hand, photographic prints, a turntable. As the camera pans slowly over the roofs below Prague castle, we hear Sudek's dry whistling. As the film continues, Sudek is outside again, tightening the wing-nuts on a wooden tripod: the embodiment of Sisyphus, hauling a huge view camera over his left shoulder up the steep inclines of Prague and then through

woods. His teeth and in some instances the grip between his knees serve to replace the function of his right arm, gone from he shoulder down. In this way Sudek adjusts the black cloth that shields his view from extraneous light or cocks the lens' shutter. His back is curved, hunched almost. His face, when we see it in close-up, is asymmetrical. The left eye is half shut; the right one arched, wide-open and alert.

The protagonist of Sudek's series *The Window of My Studio* (1940–54) – featured in one-third of the seventy-five published photographs – is a sinuous and stunted apple tree that stands outside his studio. Surviving the seasons and the deep shadows of the yard, weathering the harsh years of political and economic turmoil, the repetition of this twisted tree becomes a metaphor for Sudek's misshapen physique. According to Jan Mlčoch, the curator of the photo department at the Museum of Decorative Arts in Prague, there are several hundred versions of this tree in the museum's archive.

A persistent beggar looking in or a mirrored self-portrait peering out, half-veiled in mist and condensation, the anthropomorphic apple tree stamps its presence on us. In one photograph, beads of condensation like hanging fruit are held in focus whilst the tree itself is soft. In another, an enigmatic reflection, the tree wears what looks like an eye, visible above vases of lungwort, cowslip and snowdrops (see overleaf).

In his book *Prague Pictures* (2003), the Irish writer John Banville suggests that Sudek was 'so fascinated by closeted and cluttered interiors that these photographs, these sudden glimpses into, *out* into the exterior world, seem a break for freedom, an exit into the air and the light'.[48] This 'break for freedom', so described, seems charged with the spirit of existentialism as humanism, defined in Jean-Paul Sartre's 1945 Paris lecture on the subject: a humanism of freedom and self-definition. Banville discussed a later Sudek series, *Vanished Statues* (1952–70), as 'stark, austerely beautiful studies of crippled trees,' captured in Mionší Forest. 'It is perhaps too obvious,' Banville added, 'to see in the many images he fixed of these maimed giants a composite, covert self-portrait.' Sudek called the trees of the Mionší Forest 'sleeping giants,' adding that he saw in them reminders of people he had lost: 'When someone you love dies on you, it bothers

you of course. But after a while you find out that he didn't completely die. Suddenly, you see he's somehow alive in something. We don't know why that is.'

Sudek's trees, in this way, share something with the men and women photographed by W. Eugene Smith. Jim Hughes, Smith's biographer, wrote of his celebrated image of Tomoko Uemura, a victim of Minimata disease: 'If only from his deepest memories, Gene surely must have experienced an instant of recognition when he made the exposure ... It was as if he'd found the ultimate image of love – contorted though it may have become – for which he's been searching his entire life.'[49] Sontag compared the photograph to Michelangelo's *Pietà*.

There was, in Tomoko, something of a reflected self-portrait, an image that in its depth spoke of Smith's anguished life, forever thrown off course, psychologically, by his father's suicide. Hughes wrote: 'Wherever he looked in Minimata, Gene found the outward expression of the un-nameable pain he had felt deep within himself for most of his life.'[50]

André Kertész's 1926 photograph of a vase of painted white flowers in Mondrian's hallway seems to invoke the character of the painter, even in his absence. It was included in Cornell Capa's *The Concerned Photographer* (1968) exhibition and book, where Kertész explained: 'The spirit in his studio was absolutely Mondrian's spirit. His style was cool, static and exact. Everything was white, and for cutting this cold atmosphere he used an artificial flower in a vase. He had painted the flower white because the white went with the apartment. When you entered the studio this was the first thing you saw. As you see, I always walked in the spirit of the people.'

Walker Evans, in similar fashion, photographed one end of the hallway, or dog-run, in the home of the Burroughs family, Alabama tenant sharecroppers whose life Evans documented during the Depression. With no human presence, the photograph depicts an unadorned orderly pragmatism, and ultimately, a complex sculpture of human survival, one so eloquently inventoried by James Agee in *Let us now Praise Famous Men* (1941).

Shannon Jensen looked to document the peoples' spirit in her ongoing project *A Long Walk* (2012–), about refugees along the

Sudanese border. Jensen noticed their shoes: 'The refugees were wearing an incredible array of worn-down, misshapen, patched-together shoes. Each pair provided a silent testimony to the arduous journey. Each detail revealed the persistence and ingenuity of their owners and the diversity of the hundreds of thousands of men, women, and children brought together by tragic circumstance.'[51] Jensen's aim was to 'honour the resilience, determination, and perseverance of the people', but without showing the people themselves: just their shoes. Her photography in Sudan won the 2014 Inge Morath Award, an award largely associated with humanistic photography. In a similar approach, Donovan Wylie's photography of the Maze prison in Northern Ireland (2003) has echoes, in its repetitious concentration on the individual empty cell-room bunks, of Sudek's multiple views of a twisted apple tree.

It seems to me that Sudek's work is humanistic in every sense of an evolving idea. It is emancipatory in its bid for freedom. It is anthropocentric in its psychological reflection on the human condition. And it is passionately human in its explanatory power, its rejection of geometry and its redemptive vitality. His work is, as John Banville put it, 'suffused with life'.

Josef Sudek, *The Window of My Studio*, 1940–54

4
OF WAR
AND FAMINE

Much has been written on the photography of war and famine, often questioning the ethical nature of photojournalism. My aim here is different. I have no quibble with the work of photojournalists who, at considerable personal risk, set out to gather evidence and cover stories that some would rather we did not see. My interest is rather in what drives this work and how it is shaped: how the photographs are selected, framed and disseminated, and how they convey messages that have been powerful enough to inspire international human rights agreements, appeal to and shape humanitarian aid (as in Biafra), bring conflicts to a close (as in Bosnia) and effect change. I am interested in considering the didactic force of what is called in France *image-choc* – the shocking photograph of war or famine – against the power of more ambiguous and subjective interpretations of conflict or starvation.

Photography differs from film in a critical sense: documentary film tends to be didactic. It often sets out to educate, even to persuade us of a moral position on something, be it gun law, domestic violence or a story told from behind the front lines. Sometimes film balances the argument, engaging in what the BBC refers to as 'due impartiality'. The narrative context within which images speak is conveyed through an interpreter or several. The dialogue of the film's characters, or of the narrator, drives the idea. In Ken Loach's documentary film *The Spirit of 1945* (2013), for example, the postwar landslide Labour victory in Britain that led to the creation of the National Health Service and state ownership of public utilities and transport is presented as a positive change and its subsequent undoing as a mistake. Every sentence, every image, every scene in the film contributes to Loach's argument.

Photographs, by contrast, float. They remain untethered to anything solid unless placed with a text explaining their context. When covering war or famine, however, photographers have often felt a compelling need to work didactically, either by using words to support the images or through the brute force or violence of the content.

In covering atrocity, photographers are often moved by two parallel emotions: first, the awfulness of conflict, especially where violence is directed at the innocent; second, a feeling of unease

or guilt at somehow profiting from the misfortune of others. The first emotion drives a range of approaches. One is to shape the resulting images into an appeal to stop: to end this war, to feed the starving. The resulting photographs are often frontal, the gaze directed at the viewer. Another approach is more psychologically motivated and reflexive. The photographer projects his or her feelings onto the subject. Some of these feelings may be connected to the photographer's personal circumstances: his or her marriage, children, absence, political views and so forth.

The feeling of unease and of guilt is something that has evolved recently in the age of photography. The French photographer Gilles Caron spoke of his helplessness during the Biafran famine as between 3,000 and 4,000 victims died daily during July 1968 – and that was just people who were in camps and had been identified.[1] James Nachtwey, war messenger *par excellence*, has always been haunted by guilt:

> The worst thing is to feel that as a photographer I am benefiting from someone else's tragedy. This idea haunts me. It's something I have to reckon with every day because I know that if I ever allowed genuine compassion to be overtaken by personal ambition, I will have sold my soul. The only way I can justify my role is to have respect for the other person's predicament. The extent to which I do that is the extent to which I become accepted by the other; and to that extent, I can accept myself.[2]

Thus shocking images are often driven by a need to act as an intermediary in a tragic situation, believing 'with my photographs I'll bring help', or in a post-conflict setting to deliver evidence or appeal for peace.

The most powerful example of this latter approach is a photobook that Ernst Friedrich published in 1924 called *War Against War*, an album of more than 180 photographs, mostly drawn from World War I German military and medical archives. In a section entitled 'The Face of War', twenty-four close-ups of soldiers with atrocious facial wounds are laid out – a catalogue of disfigurement of the sort that maxillofacial surgeons necessarily share with each other.

The book was widely distributed, despite the obstacles faced by bookshops in displaying it. Nevertheless, it had gone into ten editions in Germany by 1930 and several translations (including

French, Dutch and English). It was dedicated to 'all war profiteers and parasites, to all war provokers'.[3] In later life Friedrich continued his antiwar agenda, with photography playing a decisive role in his campaign. He joined the French Resistance during World War II, participating in the liberation of Nîmes and Arles. In 1947 he bought a barge and founded *Arche de Noé* (Noah's Ark), a ship for peace, moored on the River Seine at Villeneuve-la-Garenne, a northern suburb of Paris. Ernest Hemingway, in a similarly brazen antiwar initiative, published graphic images of dead Italian soldiers during the Spanish Civil War (1936–9) in *Ken* magazine. He wrote under the images, 'Because those pictures are what you will look like if we let the next war come'.[4]

Throughout World War I only two British photographers were assigned to the Western Front. Army officers Ernest Brooks and John Warwick Brooke were accredited to supply official propaganda. None of their photographs were released. Freelancers faced the firing squad if caught.[5] In World War II the camera came of age as an instrument of information and propaganda *on both sides*. Cameras recorded the Japanese attack on Pearl Harbour, the Battle of El Alamein and the D-Day landings. It was in Russia that war had the most devastating impact: six million Russian soldiers were killed in battle and an estimated fourteen million more – soldiers and civilians – were murdered by the German army during what the Russians call the Great Patriotic War (1941–5). The pictures by Russian World War II photographers are some of the finest photographs in the documentary archive, the result of vision and courage. Much of their didactic power derives from the connection between the war and its impact on noncombatants. Many who set out to document the war had one objective: to show its horror as a way of ensuring a future peace.

Dmitri Baltermants is best known for his images of the aftermath of the 1942 offensive in Ukraine's Kerch Peninsula, notably his photograph *Grief*, which depicts relatives searching for their loved ones, a picture of a massacre of civilians rather than a military defeat. 'War', Baltermants wrote, 'is, above all, grief. I photographed non-stop for years and I know that in all that time

I produced only five or six real pictures. War is not for photography.'[6] Another poignant Baltermants photograph was taken near the end of the war. Working for the army newspaper *Na Razgrom vraga* (To Destroy the Enemy), he documented the Soviet march through Germany. The photograph *Tchaikovsky* (1945) shows soldiers gathered round an upright piano amid the rubble of a destroyed building. Dead or dried flowers standing in a vase on top of the piano convey a haunting sense of home. The search for a home is also the theme of a photograph by another Soviet war photographer, Arkady Shaikhet. It depicts refugees shuffling through the war-torn streets of Königsberg in 1945. Old men and women carrying everything they own flee from burning buildings, most of which have been reduced to rubble.

Mikhail Trakhman, a special correspondent for the news agency Tass, wrote of the desolation he experienced: 'I don't feel I have yet come to grips with the war nor have I depicted it in all its horror. This does not represent my admiration for war, but for peace. It is my desire to create a textbook for young people so they will not forget.'[7] One of Trakhman's most chilling images, from 1942, shows what I assume to be a mother and daughter dragging a wrapped body down the wide, central shopping street of Nevsky Prospect in Leningrad (now St Petersburg). The image was a prelude to Trakhman's documenting of the Holocaust. The Soviet armies fought against nine-tenths of the German army for most of the war – and never against less than three-quarters of it.[8]

On 24 July 1944, when the Third Belorussian Army liberated Lublin, Trakhman and several other Russian photographers and journalists working for the Russian magazine *Ogonyok* witnessed the *Vernichtungslager* (extermination camp) of Majdanek after it had been overrun by the Red Army. Trakhman and his colleagues documented the gas chambers where 250 prisoners at a time would have been killed. The prisoners were exposed to Zyklon-B chlorine gas, a cyanide-based pesticide, and suffocated while still standing; they were then dragged away in carts, 100 at a time, and burnt. In 1944 Soviet investigators estimated that about two million prisoners were murdered at Majdanek. The current (Polish) estimate is closer to 80,000, half of whom were Jews and the others Russian prisoners of war. Trakhman and his colleagues photographed angry Polish

Mikhail Trakhman, *Nevsky Prospect, Leningrad*, 1942

mourners and bystanders staring down at massed skulls and skeletons
in the pits where the dead were dumped. *Ogonyok* published their
story over four pages on 31 August 1944. This was after initial articles
about the camp had appeared in Russia and the West, including
the *Los Angeles Times*, on 13 August. The British press dismissed
the reports, arguing that they were Soviet propaganda. The BBC's
Moscow correspondent, Alexander Werth, had actually sent a
dispatch from Majdanek in July 1944, but it was never broadcast.

It was not until 20 April 1945, nine months later, that the world
woke up to the magnitude of the Holocaust. That was when the
Magnum founder George Rodger reached the liberated concentration
camp at Bergen-Belsen to find German camp guards unloading bodies

into a pit and the American photographer Margaret Bourke-White accompanied General Patton's Third Army into Buchenwald. An extended caption to one of Rodger's most shocking pictures describes 'SS girls and men working in the mass grave and unloading the dead from trucks. These girls seem to be completely indifferent to what they are doing ... [but] the former tough SS men crack up under ... the strain of continually handling the bodies of those they helped to kill.'

Life magazine first published Rodger's and Bourke-White's pictures on 7 May 1945. Few sets of photographs have had a more lasting or more profound impact on the public at large and on international policy. Newsreel reports were also impactful, together with heartfelt written testimony such as that of the fifteen-year-old Elie Wiesel, who watched children burning on pyres on his first night at Auschwitz: 'Never shall I forget that night – never shall I forget those flames that consumed my faith forever.'[9] All this testimony – photography, newsreel, text – led directly to Eleanor Roosevelt's drafting of the Universal Declaration of Human Rights in 1948, and to a line being drawn in the sand of world history behind which world leaders and the public at large hoped they would never return.

Photographs of the atomic bombing of Hiroshima and Nagasaki taken by the Japanese remained hidden under an embargo imposed by US censors until 1952. While the Allies were liberating Germany during the spring of 1945, war continued in Japan and the Pacific. In March that year, 84,000 people perished during the firebombing of Tokyo. When the Emperor still refused to surrender, the 'New Style Bomb' was rolled out.

Hiroshima was hit by an atomic bomb on 6 August, followed by a similar attack on Nagasaki on 9 August. When the Nagasaki bomb landed, the young Japanese photographer Yosuke Yamahata, attached to the News and Information Bureau of the Western Army Corps, was sent to document the devastation. The bomb was dropped at 11 a.m. Four hours later, Yamahata boarded a train that reached Nagaski at 2 a.m. on a starlit night. He recorded what he saw in words and pictures:

> I tried climbing on a small hill to look – all around, the city burned with what looked like small elf-fires, and the sky was

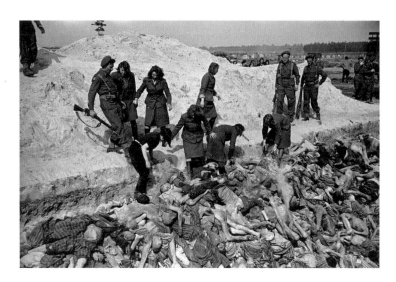

George Rodger, *Bergen-Belsen concentration camp, Germany*, 1945

blue and full of stars. It was a strangely beautiful scene. Dying people called out for water. People were blind, skin that had been exposed was a reddish brown colour. Faces were horribly inflamed. Backs of the eyelids were red and inflamed. The blinded groping their way forward were the few. Most had died immediately from the blast or been crushed to death, so very few had survived even in that state ... I was completely calm and composed. Walking through the tragedy of Nagasaki at the time, all I thought of was the photographs I had to take, and how to avoid being killed if another New Style Bomb were to fall. In other words, I thought only of myself.[10]

Yamahata's photographs form an extraordinary account of the aftermath of a nuclear strike that speaks to the documentary impulse to put history on record. One photograph shows charred bodies piled beside railway tracks (see overleaf). In another, survivors, their heads covered with scarves, wander aimlessly though the devastated city – covering their heads, they were told, would offer protection. Emperor Hirohito finally surrendered on 15 August. It is estimated that about

350,000 people died over five years as a result of the bombing of Hiroshima and Nagasaki. Another of Yamahata's photographs from Nagasaki, depicting a small boy holding a rice-ball, was included in the 'Family of Man' exhibition in 1955. Yamahata himself was exposed to radioactivity and died of cancer in 1966, in his late fifties.

Photography of the aftermath of the atomic bombing has continued, with new generations seeking to comment on the memory of their forebears. Shomei Tomatsu's moving *Hibakusha Tsuyo Kataoka, Nagasaki* (1961), a portrait of a survivor bearing the facial scars of the event, is echoed in the wrinkles – much like scars – on the Japanese flag published in Kikuji Kawada's *Chizu* (The Map, 1960–5).[11]

Some war photographers, set on radical political change rather than reform, have deployed text polemically to emphasize the injustice of war in general or the asymmetric nature of a specific conflict. Welsh photographer Philip Jones Griffiths set out in 1966 on a five-year mission to photograph the Vietnam War. He had been since his teens a conscientious objector opposed to the siting of nuclear weapons in Britain, a member of the Peace Pledge Union – a nonsectarian pacifist organization – and a participant in the Aldermaston peace marches. His commitment to pacifism, together with his Welsh-bred partisan empathy for the underdog, became fixed ideals generating an emotive power that is visible in most of his work.[12]

Jones Griffiths lambasted the stupidity of war yet at the same time photographed with intimate tenderness victims on both sides of the conflict, resulting in some of the most poignant war photographs of the twentieth century. The photographs are especially moving because they focused not on 'industrial war' between two opposing armies but on war amongst the people. The photographs, in stark black and white, mined a deep seam of feeling that ran alongside the actual fighting. They showed a vulnerable population outgunned but defiant. In one photograph, from late 1967, a US soldier is shown in standard issue spectacles staring quizzically at a Vietnamese woman with her child. The text confirms that the photograph was taken six months before the My Lai massacre in Quang Ngai province: 'The woman's husband had been killed a few moments earlier because he

was hiding in a tunnel'. Reading the text beside the photograph, the look of bitterness on the woman's face seems to harden.

Jones Griffiths's resulting book, *Vietnam Inc.* (1971), became a classic in the history of photojournalism. Its moving photographs and accompanying polemic helped turn public opinion against the war in Southeast Asia, although by 1971 there was already widespread disaffection. In 2002 Jones Griffiths commented on the photograph described above: 'Many GIs were very unhappy about what they were told to do. Somebody recently asked me what stopped the war in the end. I think one factor it's impossible to overlook is that all these guys were writing letters home.'[13]

It is almost impossible to look at Jones Griffiths's pictures from Vietnam, with their acerbic text-bites, without siding with the Vietnamese people. This is no war junkie's adventure. There is no reification of soldiery or of the weapons of war. Vietnam was the first war in which photographers found themselves able to work freely – and it will probably be the last.

Don McCullin, the first British photojournalist to receive a CBE, was among them. Between 1966 and 1984 he worked for

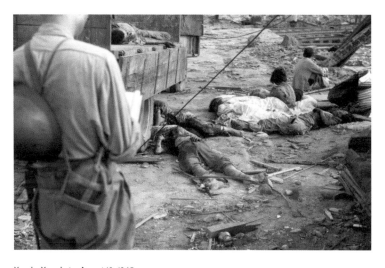

Yosuke Yamahata, *August 10, 1945,
Nagasaki*, 1945

The Sunday Times Magazine. Before reaching Vietnam, he was already a veteran and a self-confessed war junkie. McCullin has many qualities as a documentary photographer: honesty, remarkable courage and the feeling eye of a humanitarian. All are reinforced by being there, by spending the time rather than being part of the 'snap and go' entourage, a term one Vietnam veteran used to distinguish McCullin's approach of dogged commitment.

A 2012 documentary film, *McCullin* by Jacqui Morris, describes the tenacity that characterized the photographer's career. Disguised as a mercenary, McCullin joined Colonel 'Mad Mike' Hoare in 1964 to photograph the brutal suppression of the Simba Revolution in the Congo's Kisangani region (formerly Stanleyville). Colour film footage of the mobilizing forces appears in juxtaposition to McCullin's photographs of the rounding up and brutalizing of rebels. McCullin recalls his powerlessness in the face of executions of rebel militia in Kisangani and later in Nigeria, where the Nigerian–Biafran war, normally referred to as the Biafran War (1967–70), was on another scale altogether. On 30 May 1967 Lieutenant Colonel Odumegwu Ojukwu, the governor of Nigeria's Eastern Region, formed the Republic of Biafra following a unanimous vote by elders of the predominately Christian (Catholic) Igbo people who inhabit the area. On 6 July the Nigerian government launched a series of sea, land and air attacks to crush the rebels, eventually blockading the populace and starving them into submission. General Yakubu Gowon, Nigeria's acting president, anticipated a 'short, surgical, police action', but the conflict lasted until January 1971 and cost the lives of more than two million – mainly the elderly, women and children.

The government used famine as a weapon of war. Gowon's deputy, Chief Obafemi Awolowo, claimed: 'All is fair in war, and starvation is one of the weapons of war. I do not see why we should feed our enemy fat in order to fight us harder.'[14] It was a perfect storm. Oil exploitation in Nigeria, which began with Shell-BP in 1956, raised the stakes in an already fragile political dynamic. Britain, which armed the federal government, did so in large measure to protect both its considerable oil investments and its energy security after the Six Day War in June 1967, which resulted in the blockade of the Suez Canal.[15] The French, whose oil interests lay

primarily in Ojukwu's Eastern Region, clandestinely armed – albeit with lessening resources – the Biafran secessionists.[16] Nigeria joined the Organization of the Petroleum Exporting Countries (OPEC) as the world's eighth-largest oil producer in 1971.

Frederick Forsyth, journalist and novelist, wrote of the conflict in 1969: 'Never in modern history has a war been fought between armies of such disparity in strength and firepower'[17], enforcing the historical point that the bulk of the firepower was supplied by Britain and that the conflict was asymmetric, and certainly prolonged by outside intervention.

Biafra was a landmark event in the history of documentary photography, although at the time the oil story was barely pictured. A so-called new humanitarianism emerged. It was fuelled by imagery of the famine victims. A church-led airlift began in 1968 in defiance of the British-backed Nigerian blockade. It became one of the most successful emergency aid operations of all time.

It was Michael Leapman, then diplomatic editor of *The Sun* newspaper, and the photographer Ronald Burton[18] who broke the Biafra famine story in Britain on 12 June 1968, the same day that ITV broadcast a documentary about the war. Don McCullin travelled to Biafra later that month. By then two-thirds of Biafra's area had been recaptured, including the strategic oil town of Port Harcourt. Biafra was considerably more challenging for reporters than Vietnam. Editors were divided over their support for the secessionist cause. *The Sunday Times* foreign desk were avid supporters of the Nigerian federal government, yet the magazine's deputy editor, Francis Wyndham – a personal friend of Ojukwu – supported Biafra.

Risky *sub rosa* transport flights from Portugal via San Tomé – on aircraft packed with ammunition – were the only way into Biafran-held territory for journalists. McCullin travelled with his friend Gilles Caron, a French photojournalist and co-founder of Agence Presse Gamma who was to die in Cambodia, a prisoner of the Khmer Rouge, in April 1970. In McCullin's first magazine story, written by Chinua Achebe and published on 9 July 1968, the famine was not mentioned. *The Sunday Times* was silent on the subject. A *Sunday Times* cub reporter, Alex Mitchell, travelled to Biafra on 22 July 1968 (again via Portugal and Sao Tomé). In the Biafran stronghold of

Uli he witnessed appalling humanitarian conditions and children dying of starvation, but on his return he failed to write about it in the paper.[19] Perhaps the pro-British *Sunday Times* foreign desk was steadfastly aligned to government interests.

It was not until 1 June 1969 that *The Sunday Times Magazine* published McCullin's photographs of the Biafran famine, almost a year after the story had been seen in virtually every major international colour magazine: *Stern, Life, Paris Match, Manchete, Time* and *The New York Times Magazine*, each of which splashed the story over the summer of 1968.

In his autobiography, *Unreasonable Behaviour*, McCullin revealed that in Biafra he was continually plagued by a 'whiplash of compassion and conscience'.[20] His Biafran famine photographs, taken in 1969, focused on the most vulnerable: children with kwashiorkor (entered in death certificates at the time as Harold Wilson Syndrome), a starving and naked sixteen-year-old girl called Patience staring into the lens, whose unclothed body he asked to be covered so that 'I could show her nakedness with as much dignity as possible.'[21] In another scene, a twenty-four-year-old mother, prematurely aged, was photographed attempting to feed a child with her dessicated breasts.

The mother was one of 800 Biafrans whom McCullin found close to death at Father Kennedy's Holy Ghost Catholic Mission, 32 kilometres (20 miles) from the town of Umiaghu. The academic Terence Wright made a direct comparison with her photograph with the Virgin and Child iconography in Rogier van der Weyden's painting *St Luke Drawing the Madonna* (c.1435–40), a popular theme in gothic German, Czech and Dutch painting.[22] The religious iconography of the Madonna-figure lent documentary force to the picture, enhancing its memorability. McCullin's work emerges from a certain closeness, in feeling above all else, to the plight of those afflicted: 'Photography for me', he wrote in his autobiography, 'is not looking, it's feeling. If you can't feel what you're looking at, then you're never going to get others to feel anything when they look at your pictures.'[23]

The colour image on the cover on *The Sunday Times Magazine* and the closing photograph in the layout both depicted a starving

child in rags holding up a begging bowl and gazing at the camera, hapless victims in a war not of their making. Direct and frontal as the pictures were, the message was clear – 'pity us'. Interestingly this message was juxtaposed with the 'buy us' message of the advertisements published in the same magazine issue for four brands of British cigarettes, three British cars, two British trousers and one British scotch whisky, further differentiating two worlds: that of a continuing, albeit unofficial, colonial power from that of those represented as victims.

For McCullin, some solace might come from the recollection that, during 1969 antiwar demonstrations in Europe, the crowd used his pictures of the Biafran crisis as banners to call for an end to the conflict. McCullin himself had resorted to direct political action. After *The Sunday Times Magazine* published his photo-essay on Biafra in 1969, McCullin, funded by Francis Wyndham, converted one of the photographs described above, captioned as 'twenty-four-year-old mother suckles her child', into a poster with the strapline: 'Biafra, the British Government Supports this War. You the Public Could Stop It'. He then fly-posted the placards around London, paying special attention to Hampstead Garden Suburb, where the Prime Minister, Harold Wilson, had his home.[24]

McCullin's friend and colleague Gilles Caron was described by Hubert Henrotte – who over time became director of both the rival French press agencies, Gamma and Sygma – as 'the greatest of his generation'. At Sygma, where I worked under Henrotte in the 1980s, Gilles Caron was a legend. It's clear from his contact sheets that he was less inclined towards *image-choc* (shocking pictures) and more prone to reflection. McCullin described Caron to me as a quiet man who spoke very little. He was thoughtful and, fitting for an ex-paratrooper, brave.

One of Caron's most telling photographs from Biafra is a portrait of a mother holding her malnourished child (see overleaf). It's photographed on colour transparency film (and on Tri-X) and accentuates, and at the same time juxtaposes, the printed pink roses on the mother's dress next to the frail, almost monochrome body of the dying child. There is nothing sentimental about the image. The woman's stare is neither direct nor accusing, but simply pensive.

We can see from Caron's contact sheets that shortly afterwards a naked and malnourished boy occupies a pew in an open-air chapel. Taken in both colour and black and white, the colour version is powerful for its lack of tonal accentuation and lack of drama. Once again, the child's expression is reflective, the chapel a nod perhaps to Biafra's principal source of support. Many of Caron's subjects look down and away from the camera, both in Biafra and Vietnam. Michel Poivert, professor of photography at the Sorbonne in Paris and author of *Le conflit intérieur* (The Inner Conflict, 2013) about Caron's photography, considered him an existentialist and made emphatic reference to Auguste Rodin's sculpture, *The Thinker* (1904), in describing Caron's approach to photographing war.[25] It is as if Caron was projecting his own search for answers about life and war onto his subjects – choosing his moments or inducing reflection.

While Caron was quiet and thoughtful, he was also a focused and effective photojournalist. The humanitarian story in Biafra, for him, was paramount. Together with the journalist Floris de Bonneville, Caron produced a book, *La Mort du Biafra!* (The Death of Biafra!), self-published by Gamma in the summer of 1968. The photographs and text described both the civil war and the famine. On discovering the extent of the famine in July 1968 while visiting a Catholic mission in the town of Uturu, north of Umiaghu, where twenty-seven children were dying of starvation a week, Caron disseminated a photo-essay on the famine that was to be published worldwide: on 17 July in *Paris Match*, a month later in the Brazilian magazine *Manchete* and on 8 September in *The New York Times Magazine*, which reported the Biafran death-toll from starvation as 6,000 a day. In the days that followed the US president and senior Canadian diplomats weighed in. Genocide, they said, was taking place in Biafra. Since 1944 images, like those of Caron in 1968 or McCullin in 1969, have borne witness to genocide in southern Sudan, Rwanda, Bosnia and Darfur, and documentary photographs, by those who have put their own lives on the line, have been instrumental in raising awareness of such atrocities.

Photographs form part of a complex surfacing of knowledge that inspires politicians, diplomats and cultural luminaries to lead action. Jean-Paul Sartre, François Mauriac, Joan Baez, Jimi Hendrix

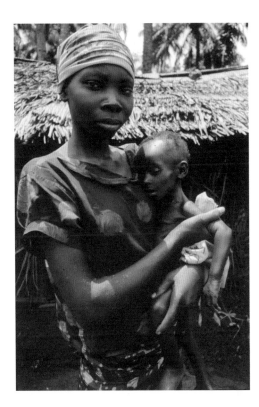

Gilles Caron, *Child of the Igbo ethnic group suffering from famine in the arms of a young girl during the Biafra war in Nigeria in April 1968*, 1968

and John Lennon all stood up for the plight of Biafra. On 29 May 1969, Bruce Mayrock, a Columbia University student, set fire to himself at the United Nations headquarters in New York in protest at the genocide. Comparisons were made with the Holocaust, inspiring a link with America's Jewish community.[26] In November of the same year John Lennon wrote to the Queen: 'I am returning my MBE as a protest against Britain's involvement in the Nigeria–Biafra thing'. Lennon's chauffeur duly delivered the medal. The great Nigerian world champion boxer, Dick Tiger, followed suit, returning his medal to the Queen before he died of liver cancer in 1971.

That same year saw the creation of Médecins Sans Frontières (MSF). It was founded as a result of a dispute over neutrality with the International Red Cross, but its inspiration lay in the impact

that Gilles Caron's pictures had made on a group of French doctors, including MSF's first director, Bernard Kouchner, whom Caron had met in Biafra.

There are two points to consider when thinking about images of conflict apart from their specific content. One is the extent to which such photographs are didactic; the other is whether they move us. The latter issue is one that the war photographer James Nachtwey has spent a great deal of time considering. After studying art history and political science at Dartmouth College in New Hampshire, Nachtwey became inspired by imagery from Vietnam (from Larry Burrows, Horst Faas, Nick Ut and others) that confronted the US government's own unfaltering commitment to the war. His impulse to bear witness to human suffering began in Northern Ireland in the early 1980s. In a career spanning almost forty years, there are few wars or famines that Nachtwey has missed.

In the introduction to Nachtwey's retrospective monograph *Inferno* (2000), Luc Sante described him as an 'antiwar' photographer.[27] The book is unrelenting, merging atrocity, graphically depicted, into atrocity. *Inferno*, Nachtwey wrote, 'represents a personal journey through the dark reaches of the last decade of the twentieth century. It is a record of loss, grief, injustice, suffering, violence and death.'[28]

A photograph in *Inferno* that depicts an emaciated, starving elderly man crawling on sandy ground beside some thin rush-mat walls in Sudan – first published as a double page in *Time* magazine on 23 August 1993 – is almost impossible to forget. It is the envisaged loneliness of this dying man that I found so haunting when I first saw the picture. When Nachtwey and I discussed this photograph he paraphrased a statement he recalled making at the time: 'I'm a witness, and my testimony has to be honest and uncensored ... This man literally had nothing left – except his will to live. As weak and emaciated as he was, he continued to struggle. He summoned the will to keep moving, he refused to surrender life, even in the face of all the tragedy and loss he must have suffered to arrive at that moment. He had not given up hope. Why should anyone else give up hope for him?'[29] With this in mind, Nachtwey has a particular issue

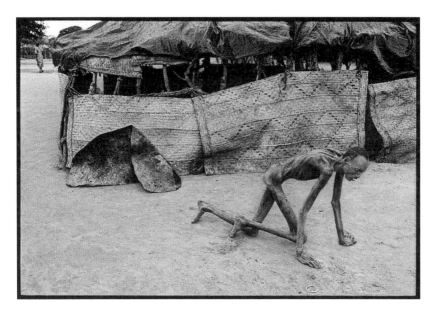

James Nachtwey, *Ayod, southern Sudan*,
1993, published in *Time* magazine

with the term 'compassion fatigue' and the implication that there is
a finite boundary for people's concern for others. He explained, 'What
allows me to overcome the emotional obstacles inherent in my work
is the belief that when people are confronted with images that evoke
compassion, they will continue to respond, no matter how exhausted,
angry or frustrated they may be.'[30] Thus the documentary impulse, for
Nachtwey, lies in this sense of purpose, that his photographs of the
downtrodden will reach millions of readers and make them take notice.

Also published in *Inferno* is an image from the famine in
Baidoa, Somalia in 1991–2. As in Biafra, the famine had been used
as a weapon in the civil war that began in January 1991, following the
overthrow of the ruthless and corrupt government of President Siad
Barre. The Somali famine was highly selective. It primarily struck the
inhabitants of riverine areas (where the looting was most severe) and
displaced people. But even there, according to a Somali doctor, during
the worst period of the famine, 'you could go a few kilometres outside

Baidoa and find villages of normal people'.[31] In Baidoa, a town with a population of 60,000 before the famine, most had fled, primarily from fear rather than hunger. Nachtwey's photograph shows a man lying under a silk cotton tree, having found relief in some slender shade. It is not easy to guess the man's age: perhaps forty. His eyes appear barely able to open, his ribs form corrugations above his curled-up and stick-like legs. Veins stand out on his forehead that he cups with one hand. Most unnerving is the fact that the man is not alone. Two boys, equally malnourished, sit behind him to the right of the tree. The older boy, perhaps ten, rests one hand gently on the man's ribcage. The other attends to covering the man's rear with a ragged goatskin. Nachtwey explained, 'the child was comforting his father who was suffering in pain and distress'[32] and who – as the caption explains – began to perish in front of his sons. The image is less widely known than the image from Sudan of the lonely man crawling but, for me, it says so much more. I have tried to understand why I find it more impactful. Perhaps the surprise lies in the relationship that's established between the living children and their dying father. Perhaps because it steps back from a position of maximum shock, it is more effective.

While photographs have shown us the outcome of several African famines since the 1960s, they have failed to explain the process – why some people starve to death while the majority of the population continue to eat well. Globally there has been no shortage of food in modern times. Grain profiteering precipitated famine crises in India, Burma and Bengal during the late nineteenth century, and more recently in Malawi. War, exacerbated by drought, has been the root cause of almost all cases of mass starvation since World War II. Famine, therefore, like the Dust Bowl documented by the FSA photographers, is not a 'natural' disaster.[33] Locally throughout Africa famine has been used as a weapon of war, as we saw with Biafra. It has led to both distribution and entitlement failure. Starting long before the 1960s and continuing to the present day, war and starvation have been coterminous in Nigeria, Mozambique, Somalia, Ethiopia and Sudan (both North and South).

Let us return to the Nachtwey photograph from Sudan in 1993. It was taken at a feeding station at Ayod before South Sudan became

independent in 2011. The crisis that led to the famine is historically linked to the 'scramble for Africa' at the end of the nineteenth century. When Europeans created the jigsaw of countries that divided Africa into nation-states, Sudan *en bloc* was created as a 'buffer zone' between the Muslim north and the freshly proselytized Christian south. Conflict continued inevitably as the oil-rich south of Sudan sought to protect its economy from the political heartland in the north. Intermittent factional fighting between opposing militias in the south lay at the root of the 1993 civil war. Conflict led to famine – and to that lonely stick-like man crawling past the rush-matting walls. I showed the photograph to the leader of the Irish charity Concern's mission in Ayod during 1993, Toireas Ni Bhriain, to try to learn more of the context in which the photograph was taken. She told me that during the worst months of 1993, her team set out at 4.30 a.m. each day to fly from the UN camp in Lokichoggio in Kenya with five or six nurses to help distribute food to the most vulnerable of the several hundred waiting in Ayod.

Beneath Nachtwey's photograph in *Time* was the sub-heading: 'At the root of yet another devastating African famine ... is not drought but a seemingly endless civil war.' That was the abridged version of the story, which was far more complex than photographs could portray. In 1993 Sudan was not a poor country. Its gross national product was US $7.5 billion for 23 million people.[34] As in Biafra, much of the money that might have been used to alleviate hardship was being diverted to fight a civil war.

The starkest images, *image-choc* pictures, are habitually deployed by magazines to acknowledge tragedy and raise public awareness, and by aid agencies to fundraise for a country that, as we saw in Sudan, had no need to be dependent. The urgency to act derives as much from guilt as from a shared sense of humanity. We feel comforted that money can help, but sometimes donor funding just makes things worse: destabilizing local markets, undermining the existing state and drawing people away from their communities to where they can no longer plant food when the rains come, as occurred during the 1984–5 famine in Ethiopia. Guilt is a killer.

Take the case of Kevin Carter, a young *Johannesburg Star* photographer. Aged thirty-three, he stepped off a UN mercy flight

distributing corn to a feeding station to Ayod in 1993. He can't have been on the ground very long – probably under an hour. Whilst the village women were occupied with the unloading, malnourished children roamed the airstrip. A vulture on the ground was gazing at a young toddler. Carter lined up his picture: the girl nearest to him, the bird behind. The photograph was first published in *The New York Times* on 23 March 1993 and subsequently won Carter a Pulitzer Prize. Three months on, in July – financially broke, emotionally fragile (he'd attempted suicide before) and depressed – Carter killed himself. Carter had received a great deal of criticism for the Pulitzer-winning photograph because the public perceived him to be a callous photojournalist of moral turpitude who had looked on as the vulture neared without intervening to help. It is an unfortunate fact that photographers are forced, sometimes, to face blame for their work. A news photographer's job is to report with compassion from places the general public cannot see: he or she is a messenger. Some make the ultimate sacrifice for their trouble.

The discomfort of guilt is a recurring emotion when faced with tragedy, a point I raised earlier. A balance must always be struck between documenting actuality and becoming actively involved in the event. Most of us who have worked in conflict zones know what mutually supportive environments these are. Photographers try, in small ways, to help those in need: to buy water, food, blankets, share a taxi, lend a phone, carry the wounded. Nachtwey told me in 2015 (while packing to document the collateral crisis of today's wars – refugees arriving in Croatia and Greece) that, after he took the 1992 photograph of the man and his two sons in Baidoa, Somalia:

> The man was too weak to move, and they had become stranded a few miles from a feeding centre. Giving them a lift would be the man's last hope for survival. I gave him some water, and along with the three Somalis whose minivan I had hired, carefully lifted the man into the vehicle and drove him and his sons to a place where they received food, water, medical care and shelter.

Compassion fatigue is a myth (as Nachtwey has also argued) constructed, I suspect, by those with little or no experience of conflict. I don't believe it exists except in the most extreme circumstances of psychological duress in which people have become traumatized by

war. The defence mechanism that all of us deploy to deal with crises is a more likely reaction.

The issue of voyeurism and photographers' perceived interest in gratuitous horror has been a habitual refrain since Susan Sontag first presented the argument in *On Photography* (1977). Since then the most commonly heard views have been both supported and vehemently contested.[35] In 2014, after complaints about the graphic nature of Jérôme Sessini's award-winning photographs from Ukraine of the downed Malaysian passenger jet were raised on social media in Switzerland, I was asked by a Swiss newspaper to comment. One photograph showed the body of a passenger still strapped into a seat in a wheat field. In an article published in July 2014 entitled 'Beweise für das Böse – wir brauchen mehr davon, nicht weniger' (Evidence of Evil, We Need More of It, Not Less), I argued that there are two positions that photographers can take when confronted with reporting on death: a utilitarian one and an absolutist one. A utilitarian position looks to bring the maximum benefit to the most people by showing the atrocity of conflict with the aim of ending it. An absolutist position states that we never show pictures of the dead if they are identifiable, no matter how much the wider public may benefit from understanding the story.

The arguments around these issues have continued for as long as I have been a photojournalist. Everyone is entitled to their view, but my position – and that of Magnum – is a utilitarian one. Sessini's work is not 'voyeuristic' or undignified in its approach to the dead. It tells this atrocious story powerfully, for the wider benefit of helping society to understand that this kind of reckless war crime is unacceptable.

For many documentary photographers the impulse to report has been evidence-based. An important aspect of documenting the sites of war crimes, such as Sessini found in Ukraine or photojournalists have unearthed in Russia, Germany, Vietnam, Cambodia, Kosovo, Bosnia and Nicaragua – to name but a few – is to gather evidence, to tell the story of what happened. The photographer Susan Meiselas's 1978 photograph titled *Cuesta del Plomo* (see overleaf) – taken shortly after she arrived to photograph the civil war in Nicaragua – showed the remains of a body half-eaten by vultures after an execution.

It provided visual evidence, hard to find at the time, of the evil work of President Somoza's National Guard. Meiselas stated in a 1993 interview with Jay Kaplan that 'the essence of documentary has always had to do with evidence'.[36] Her interest in evidence-based documentary continued with her human-rights work on domestic abuse and on politically motivated disappearances in Kurdistan.

Because photography is short on narrative, the graphic power of the image serves to compensate. It is the editor's job to decide how much the public can stomach or, in the case of television, to decide an appropriate slot-time to schedule a programme. The intentions of photojournalists are as well meaning as those of anyone on the scene: aircrew, engineers, drivers and so forth. Working photojournalists with medical expertise, such as the Soviet World War II photographer Galina Sankova, readily lend even more support.[37]

Yet there remains a difference between feeling compassion and, at the same time, remaining positive about the outcome. Nachtwey's unwillingness to submit to cynicism and his belief in humanity sets him apart from many of his contemporaries who photograph war. At a discussion on war photography at the Perpignan *Visa Pour L'Image* festival in 2013, I witnessed an exchange where the panel, which included Don McCullin and the veteran war photographer David Douglas Duncan, expressed the unanimous view that photography made little or no difference. Nachtwey categorically dismisses this stance: 'Giving into despair is not a useful option – despair will not resolve a single conflict, it will not save a single life. If it's within mankind to fight wars, photography will not change that. But it can have a real influence on resolving a given war, or a given social problem. Another one will surely come along, and we will have to address that one. That's engagement. It never ends.'[38]

In 2001 the director Christian Frei completed a documentary film on Nachtwey: *war photographer*. The film allows us to see Nachtwey at work, among his subjects, facilitated by the use of a mini video camera attached to Nachtwey's own camera. The film's narrative takes us from the middle of conflict zones to the offices of *Stern* magazine to see how photo-essays are assembled.

The film follows Nachtwey in Kosovo after the Serb withdrawal in 1999. A scene focuses on a group of four women attending a

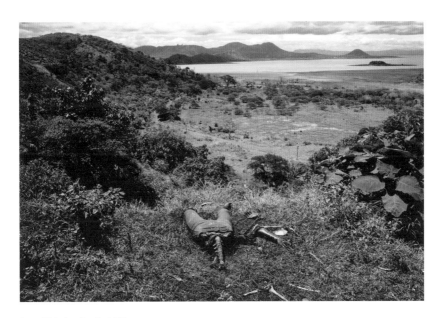

Susan Meiselas, *Cuesta del Plomo*,
Nicaragua, 1978

funeral who are beside themselves with grief. The shot is so close
that it feels uncomfortable to watch. Their wailing is too much
and, as a viewer, I want to retire to let the family deal with their
loss. But if Nachtwey weren't close, that extended group of family,
neighbours and well-wishers would have formed a ring around the
bereaved and no pictures of the tragedy surrounding the mass graves
would survive, at least not bearing the poignancy of Nachtwey's
photographs. But there's more to the event than is evident from the
film footage. Nachtwey had, in fact, been welcomed and embraced
by the family. He'd sat down with the villagers at home and listened
to their stories: 'Most of the people I photograph are exploited,
ignored and victimized by the powers that be', he told me. 'They've
been silenced – rendered invisible. When a photographer from
the outside world shows up who's willing to share the same risks,
who wants to tell their story, people open up. They know their grief
will speak.'

During the Kosovo conflict some 128,000 homes were destroyed; up to 2,000 bodies of Serbs and Albanians were later exhumed from mass graves. This was the context of the story that Nachtwey was uncovering, using the approach of evidence-based documentary. Being a witness to conflict is about steeling oneself for facts such as this. It is not that Nachtwey is unaffected; it is that he knows he has to get close to see anything at all. Closeness is expedience, which is probably why Robert Capa once said, 'If your pictures aren't good enough, you are not close enough.' If the photographer is close to the story, it helps to draw the viewer in and to understand how war has affected people's lives.

As the film draws to a close, we cut to the photo-editing department of *Stern* magazine. Frei films the staff as they select from prints pegged magnetically to steel panels. They know what will command public attention. In editorial photography, editors, writers and photographers work together within a team, each with his or her own objectives. Many years earlier I recall the photographer Chris Steele-Perkins returning, upset, from Chad during the 1984 Sahel famine. *Stern* had returned his photographs because, he said, 'the people weren't thin enough'. Chronic malnutrition was not enough to move the magazine's editors. People enduring a 'biblical famine' are supposed to look like matchsticks.

My own photographs from Sudan suffered from the limited time I spent in the field, together with my failure to grasp the wider context. I was a young man with an assignment, following the abridged version of the story. Two trips to Sudan in 1984, aged twenty-seven, helped me to understand my own weaknesses as a photographer. Impatience hampered my early work: a result of working for a weekly deadline, or that was how I excused myself. I shared an MSF flat in Khartoum with Sebastião Salgado, who worked tirelessly on his first major project, published in 1986 as *L'Homme en Détresse* (Man in Distress).[39] Everyone without exception was drawn to the majesty of that work, very different in feel from *Genesis*. *L'Homme en Détresse* was inspiring, shocking and, at the same time, beautiful. It bestowed a dignity on those who endured that terrible and unnecessary famine. It raised the bar within the world of photojournalism. It broke down the doors of magazines,

such as *The Observer Magazine* in London, which in 1985 had virtually vetoed the publishing of black-and-white picture stories. The colour supplement editors wanted colour and the picture editors were losing the battle for black and white until Colin Jacobson, then photo-editor at *The Observer Magazine*, put Salgado's moving portrait of a woman at the heart of the crisis on the magazine's cover. What Salgado's *L'Homme en Détresse* lacked in narrative connectivity it made up for in its ability to engage and move the public. Image after image felt like Pathos on a monument, staring at Guilt.

After unravelling the story of their dissemination, what the most notable examples of the photography of conflict and famine since World War I emphasize is that photography has made a difference, often where words have failed. The Holocaust was probably the most telling example of this, where photographs provided visual evidence of atrocity to a wide public audience. Directly related to the impact that documentary photographs made on the public conscience, universal human rights protection became legally enforceable and humanitarian aid began to operate without respect for sovereign borders in the post-Biafra era. These were significant advances, which continue to offer hope to people living at the worst of times under the worst forms of political malfeasance. It is this hope that has steered the documentary impulse to put history on record; and it is this hope that drives photographers to war zones to tell the stories that, as I've suggested, many don't want to be told.

5
TAKING SIDES: CONFLICT AND CIVIL SOCIETY

The ownership of the means to document has evolved rapidly in the postwar era. The power of advocacy has extended geographically and numerically. The means to record events visually exists in almost every town and village. The documentary impulse and the gift of being able to tell one's story in the pursuit of social justice have never been more widespread. This can only be beneficial for democracy and for the future of civil society.

Documentary photography, as we have seen, has made a difference. Human rights have been guaranteed under the law. But how effective is international law in practice? Here I examine some of the challenges faced by documentary photography in influencing change since World War II. Frequently the documentary impulse involves taking sides – the side of the environment or the side of the underdog in the aftermath of corporate or industrial negligence. Photojournalists and their backers take sides in revolutionary struggles and in any number of small wars being fought each day. The psychological trauma of photographing conflict is disturbing. I found it terrifying, but cannot imagine how much worse it is for those who are living in places almost permanently embroiled in conflict or civil strife. Naturally, people take sides. The pursuit of social justice in Bangladesh and the documentation of the ensuing struggle between Israel and Palestine are accessible examples.

In Bangladesh the photographer Shahidul Alam developed a following of students and a school of photography – Pathshala, the South Asian Media Institute in Dhaka – whose aim was to use photography to challenge the government and multinationals over human rights issues. The plight of textile workers has been one of their key concerns, together with environmental injustice.

The photographer Taslima Akhter, a former student of Pathshala, is a Bengali activist who turned to documentary photography to take a stand with Bangladesh's garment workers and women's right organizations. Today she lectures at Pathshala and is a coordinator of the Bangladesh Garment Workers Solidarity. Her photographs of the Tazreen Factory fire in November 2012 and the later Rana Plaza garment factory collapse in April 2013, together with her work as an activist, have made it difficult for those who consume clothes made in Bangladesh to ignore the connections between outlets in

the West and the conditions in factories in Dhaka. The pictures of these tragedies are painful to see: a couple (or are they friends?) cling to each other in a final embrace under the Rana Plaza rubble, where more than 1,134 people died. *Time* magazine described the photograph as 'capturing an entire country's grief in a single image'. In another photograph a mother, Shahana Akhter, grieves for her daughter, Poly – a victim of the Rana Plaza collapse – who we see only as a photograph on a bed in Dhaka. Shahana's hand reaches across the picture of her daughter, her fingers at rest over the gilt frame. The small portrait sits askew within the larger photograph bathed in purples and mourning, but like all of Taslima Akhter's work it has helped to 'break the silence'. The work also connects, historically, with the 'evidential, questioning and accusatory reportage' of the German *Arbeiterfotografie* (worker photography) movement of the 1920s.[1] One of the key aims of the collective vision was to take the side of the workers: to document industrial disputes and strikes.

Palestinian photographers living in Gaza are motivated to document by their experience of oppression and by the practical need for economic survival (photography is, after all, paid work). In January 2009, in the aftermath of Operation Cast Lead, I interviewed several Palestinian photographers who had not only endured the Israeli onslaught but had also held the world's front pages for eighteen days (Western journalists were banned from entering Gaza). For almost three weeks densely populated sectors of Gaza came under intense aerial bombardment. One of the photographers was Abid Katib who told me: 'In this war I lost my home, the building of my apartment was destroyed and burned. I got two or three missiles in my apartment. There was a big difference [with this war]... I believe the army when they want to send missile they know where to send it.' As if the horrors of war were not enough, cultural constraints, such as the unwritten rules about photographing women, conflict local media who are Arab speakers and who are likely to know the families of those who have suffered. I found that Palestinians rarely considered their own immediate family lives as having documentary value, even when their own homes were under attack. Few photographs were taken indoors of family life, especially in times of direct conflict.

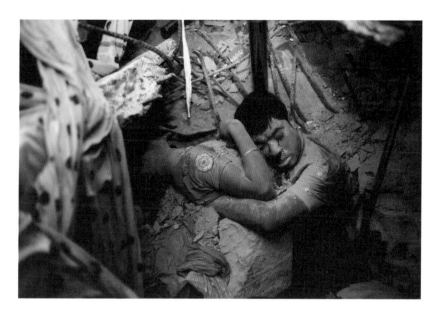

Taslima Akhter, from 'Rana Plaza Collapse:
Death of a thousand dreams', 2013

Most Palestinian photographers are self-taught: training
resources are scarce. The Islamic University in Gaza City, where
some studied photojournalism, reportedly had only one book on
photography. The fact of living and reporting on a war in a place
that is also home sharpens the impulse to document. Commitment
to reporting is total. The photographer Mohammed Al-Hams, who
documented the fighting in Gaza and the dead and dying in the
hospitals, felt he was making a difference. He wanted his pictures to
be used in protest demonstrations against the war, as Don McCullin
had done in Biafra. Al-Hams worked in support of his family and
his people, rather than polemically against war in general: 'I was
sure that people abroad would be moved by the pictures I sent
out. Sometimes I saw on TV many of my pictures used in antiwar
demonstrations [on placards].'

Another photographer, Mohammed Abed, had to struggle with
his own family to report on the devastation in Gaza, he told me in

Josef Koudelka, *Off Route 1 – East*,
West Bank, 2011, from the book *Wall*

2009. Living with his wife and five children during the war, working
as a photographer was not easy. Every night when he wanted to go
to work they pleaded with him: 'Please don't leave the house, please
save yourself'. He remembers on one occasion his wife tried to
stand in front of the door: 'Don't go', she said. At night there was no
electricity and no people in the street. It was much more dangerous.

Further, a number of non-Palestinian photographers have set
out to make partisan photo-essays on the conflict, often using text
quotations to reinforce the work. Paolo Pellegrin's portrait of twelve-
year-old Iyas Al-Kafarna, taken in 2014 in Beit Hanoun along the
Gaza Strip, is accompanied by the quote: 'I'm scared. I want to live
in peace and I want to play outside safely. I don't want the army to
shoot me.' The quotes in the essay lend credence to the view that
children in Gaza live untenable lives. No one could possibly draw

another conclusion. The photographs were also, it should be added, commissioned by a children's charity. Pellegrin is working on a long-term book project about Gaza.

Didacticism is equally effective in the photography of landscape. Josef Koudelka's photobook *Wall* (2013) comprises panoramic photographs depicting landscapes of division between Israel and the West Bank. Viewed from above, the separation wall appears, in parts, like a curled concrete zipper stitched along the 1949 Jordanian-Israeli armistice line, also referred to as the Green Line. Roads, culverts, anti-vehicle ditches, watchtowers, razor wire and graffiti compete for our attention in an arid and monochrome landscape peppered with bright low-rise apartment homes and olive trees. A photograph entitled *Off Route 1 – East* reveals the carved trenchant figure of a lone olive tree, its limbs sawn off. Only the trunk remains, rooted to calciferous

soil under a clear sky. Rows and rows of the stumps of olives, barely reaching above the ground, survive in silent protest. The text under this picture reads: 'Thousands of olive trees in the West Bank have been cut down, uprooted or otherwise vandalized.'[2] The remotest understanding of the symbolic role that the olive tree continues to play in the century-long conflict over the Holy Land leads the viewer to see both the documentary value and the didacticism of these landscapes of division.

Landscape scarred by conflict is also a commanding presence in Sophie Ristelhueber's 1992 photobook, *Fait*, showing ravaged aerial landscapes made during the first Gulf War in Kuwait (1990–1). Rather than seeing the conflict from either side, Ristelhueber takes the side of the desert: tortured, burning and voiceless. In this series the scarred environment becomes a metaphor describing the futility of war. This metaphorical approach reaches back to the powerful *Desert Cantos* work of Richard Misrach, which began in 1979. Misrach focused on a range of themes, all concerned with humans' relationship to nature in the Midwestern deserts of Utah and Nevada. The *Desert Cantos* work takes a position against the militaristic aspect of American culture, against the violence revealed in Misrach's excavation of landscape. One Misrach series, *The Playboys*, comprises photographs of pages torn from the magazines that have been used by the military for target practice and now lie abandoned in the dust. The violence – evident in the bullet-riddled face of Ray Charles, the punctured bodies of women and pictures of *Playboy* models that were all once pinned up and shot at – imparts a forceful antiwar polemic. Few words are needed. In another series, *The Pit* (1989), dead cattle described as victims of radiation poisoning caused by atomic weapons testing lie scattered and bloated across the arid landscape.

Misrach's work was self-assigned. That is not always the case. Photographers are often used as instruments through which to promote a cause or an idea, as demonstrated in the tenor of photographs requested and accepted by the Farm Security Administration in 1930s' America. Since then, the world of public relations has grown far more sophisticated. Documentary may not necessarily involve actuality – events that would have happened without there being a camera present – but rather the capturing of a

Richard Misrach, *Cover Playboy, November 1989*, 1989, from the series 'The Playboys'

version of actuality as it was created for the camera. In this case the camera's presence becomes intrinsic to the shaping of events, leading to what the historian Daniel Boorstin once described as a 'pseudo event', which he defined as a constructed media event that is 'dramatic, repeatable, costly, [and] intellectually planned.'[3] The political entity or editor supplies the message, the photographer the means. Sometimes the selection of compositional detail, lighting and camera angle are available to the photographer, sometimes not. A political rally with purpose-built press stands or pens, from where media are accredited to report, is an example of how documentary images may be pre-designed to limit any rhetorical interference from the cameras.

A worrying number of documentary images that we might regard as creative treatments of actuality are, in fact, treatments of someone else's creativity. A good place to start is Leni Riefenstahl's film coverage of the 1934 Nazi Party rally in Nuremberg: *Triumph of the Will*. The documentary was designed to replace an earlier Riefenstahl film, *Der Sieg des Glaubens* (Victory of Faith, 1933), which had featured

Ernst Röhm and various other perceived threats to Hitler's power-base. They had all been slaughtered in the Night of the Long Knives earlier that year.

The 1934 Nuremburg Rally promised a fresh start for party unity, expunging the past and empowering the elite paramilitary Schutzstaffel (SS). The credits roll to Herbert Windt's Wagnerian score. In early scenes the camera is perched, disturbingly, behind Hitler's right shoulder. The camera once more makes the viewer feel present, so we are on the staff car on which Hitler is standing as it weaves through the vast saluting throng. Scary. Yet the whole event was staged to maximize the cinematic power of the film. It worked. As the German historian George Mosse put it, the German *Volk* 'fell into the arms of the [Third] Reich like ripe fruit from a tree.'[4] Because it lacked a voice-over, Riefenstahl claimed the film was not propaganda. In an excoriating essay Susan Sontag disagreed: 'Riefenstahl was, as she relates in the book she published in 1935 about the making of *Triumph of the Will*, in on the planning of the rally – which was, from the beginning, conceived as the set of a film spectacle.'[5]

Since the 1930s similar made-for-TV events have become so widespread that it is impossible to imagine what actuality would look like without the invention of photography. Displays of nationalism from the Zócalo in Mexico City to Pyongyang's central square may take on an altogether less ostentatious look. Consider Philippe Chancel's photographs of Pyongyang's 1 May public rallies in his 2008 project *Arirang* (part of a wider series 'DPRK').[6] Chancel tried to capture the mass choreography of the events from the perspective of the dictator.[7] The 120,000 spectators huddled in front of the gymnasts, soldiers and sundry performers comprised a fraction of the television audience who sit down to watch the Supreme Leader and this supreme spectacle.

Supreme leaders come and go. The toppling of the Saddam Hussein statue in Firdos Square in 2003 is another media event that appears to have been staged by the US Army to reinforce the idea that they had 'liberated' Baghdad, à la General Patton in Paris in 1944. In fact, according to a *Newsweek* photographer at the scene, Gary Knight, 'The Iraqis didn't think it was a liberation. I didn't

think it was a liberation. *Newsweek* in New York thought it was a liberation and that's what they wanted to sell.'[8]

In the journalist Peter Maass's account, on 9 April 2003 US Marines were progressing slowly towards occupying central Baghdad when some photographers, travelling with the army, persuaded the colonel in charge to head straight to Firdos Square, where journalists were trapped in the Palestine Hotel.[9] The photographers and journalists travelling with the Marines were 'embeds' engaging in what became known during the 2003 invasion of Iraq as 'embedded journalism', the practice of media cohabiting with military units, one that has been criticized for promoting Pentagon propaganda and a 'soda-straw' view of war. A more common problem is that journalists lose their objectivity and natural scepticism about what they are being told. The resulting coverage may then start to look like propaganda.[10]

The 'embeds' moving towards central Baghdad on 9 April were concerned for their colleagues' safety. Once there, however,

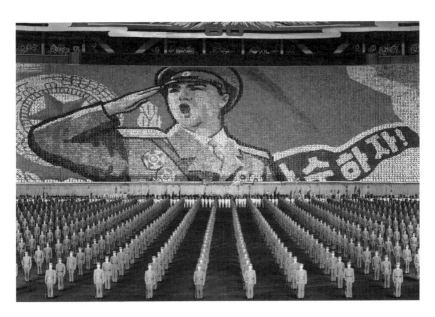

Philippe Chancel, *Arirang*, 2006,
from the series 'DPRK'

the opportunity to make a media event out of tearing down the Saddam Hussein statue became irresistible. The ingredients: some loudspeakers (to ensure that no-one was hurt), a small knot of Iraqis idling near the statue with intent, a crane operated from one of the Marine vehicles and 200 journalists looking for a story. Then add a US flag, as the AP photographer Jerome Delay found it, blown by the wind onto Saddam's Hussein's stone face, and the image, wrapped in symbolism, verged on what might have been labelled 'iconic'.

Yet in this case it was US media outlets, such as Fox News and CNN, who drove the news agenda. Knight again: 'Most of us felt that the story was being written from home'. *Newsweek* magazine, struggling financially at the time, felt in too weak a position to go against the grain.[11] As the photographer Michael Kamber commented: 'Propaganda has been a staple of warfare for ages, but the notion of creating events on the battlefield, as opposed to re-packaging real ones after the fact, is a modern one.'[12] Baghdad 2003 was not the first, nor will it be the last, time that the US news media has been instrumental in creating the news agenda by conferring documentary value on a particular interpretation of events. Rewind to Tiananmen Square 1989.

Between April and June 1989 the world turned its attention to the gradual build-up of tension in China. The focus was on a student-led protest movement in Tiananmen Square. Protests began after the death of Hu Yaobang, the purged General Secretary of the Communist Party (CCP), who collapsed aged seventy-three after a heart attack on 15 April. The CCP was simplistically divided into factions favouring either conservatism or reformism. Hu Yaobang had wanted better treatment for intellectuals and more money for education. But the CCP's Central Committee was unwilling to single out for special treatment the elite 1 per cent of the population who were able to attend university. The leadership's views, although split, had not evolved from a policy perspective since 1979 or 1986, when similar grievance movements unfolded, demanding a greater role for the intelligentsia.

In the final assault the People's Liberation Army established control of the Square more by intimidation than mass slaughter, although there were many casualties during advances in the early

hours of 4 June. Most of the killing had already taken place in other parts of Beijing by the time the lights in the Square were switched off at 4 a.m. and the protestors who had gathered around the Monument to the People's Heroes decided to leave.[13]

Before the massacre the mood during the occupation of the Square ranged from heady optimism to desperation. Political street theatre, in situationist style, led the approach to challenging the state. The final act on 30 May 1989 was to rock China to its foundations. In the courtyard below the dormitories of China's leading art school, where peasants once learned to copy approved portraits of Chairman Mao, a noisy new venture kept any light sleepers awake: the round-the-clock building of the goddess of democracy. As dawn broke on the clear morning of 30 May the statue, reminiscent of the Statue of Liberty, challenged the state's monopoly over the iconography of Tiananmen Square. Facing the 6 x 4.6 metre (19.5 x 15 foot) portrait of Mao hanging on Tiananmen Gate, the 'goddess' became a challenge to the inherent sacredness of China's national emblem.[14]

The statue, especially the photographs and global television coverage of it, galvanized support for the protest movement at a time when it was flagging. To no-one's surprise 'the official media exploded in an orgy of condemnation',[15] especially when the student leadership decided to set up a Democracy University at its base. 'Tragically', wrote the seasoned analyst Robert Suettinger, 'the symbol of students' hopes was probably the last straw for the government. Any chance of averting a violent showdown was now gone.' A *Newsweek* correspondent concurred: 'But we journalists loved the Goddess. She was the perfect symbol for China's pro-democracy protestors. She was also the movement's angel of death.'[16]

Four days later the goddess of democracy was gone, demolished by an APC or a tank (accounts vary) just after dawn on 4 June, its life a little shorter than that of the average butterfly, its impact as devastating as a plague.

Democracy was neither a new nor an entirely Western-imposed idea in China.[17] Support, in the form of faxes and funding from Hong Kong, was of significant value throughout the protest. As the grand idea of the 1989 uprising, democracy had little traction – certainly at the outset[18] – yet with the aid of countless Voice of America

broadcasts,[19] media reporting and backstage 'advisers' handling the student leadership, the idea caught on. In a later survey of US media coverage conducted by Harvard University, it is clear how the student protest quickly became labeled as a 'pro-democracy' uprising:

A number of journalists, sinologists and American government officials we interviewed criticized United States media for giving viewers and readers the false impression that protesters in Beijing desired an American-style democratic system. 'I believe we tried to put a "made in the U.S.A." democracy stamp on it,' said Jackie Judd of ABC.[20]

The emphasis on 'pro-democracy' was criticized in hindsight in Britain by pro-Chinese analysts and at the time by the *People's Daily*. The main objective of the 'small group of plotters', they reported, was to 'negate the socialist system'.[21] In fact, reviewing recent experience in Iraq, Afghanistan and Ukraine,[22] the term 'democracy', as used in political rhetoric by the West, is concerned less with specific political systems it might support and more with ones it vehemently opposes: those which are opposed to the West, and those which erect barriers to free trade and the pursuit of *laissez faire* market practices.

In a rare glimpse backstage, *The New York Times* reporting duo Nicholas Kristof and Sheryl WuDunn, both of whom had written enthusiastically on the 'pro-democracy' movement from their first report on the uprising on 18 April 1989 to their last, allowed the curtain to lift briefly in their book *China Wakes* (1994):

Deng Xiaoping later charged that the democracy movement was a conspiracy by a small number of counter-revolutionaries who used the students for their own purposes. In a sense, he was right. From the beginning, students like Wang Dan were advised, guided – and, yes, used – by various graduate students, professors, businessmen, and officials … In addition these 'advisers' gave tens of thousands of dollars to the students, as well as access to printing presses, cars, and meeting rooms.[23]

The democracy idea, attractive as it might have been to outside supporters, failed to describe the issues that were central to the unrest: bribery, corruption (especially involving senior Party figures), *guandao* ('official profiteering'), poor students' living conditions and a lack of free speech or a voice for the student elite after Hu Yaobang's

death. The goddess of democracy, short-lived as it was, became a playful but ultimately dangerous intervention on the sacred playing field of China.

Following the downfall of the goddess of democracy early on 4 June 1989, Tiananmen Square was cleared of civilians and debris by the PLA. However, a group of civilians, some relatives of the students, lined up to face a double row of soldiers who themselves stood or knelt in firing positions with a column of tanks and the debris of Tiananmen Square behind them. According to a wide range of accounts, including my own, these civilians were shot at repeatedly, leaving at least twenty casualties.[24] A BBC sound recordist at the time recalls: 'From the balcony [in the Beijing Hotel] it was clear that many of the shots were aimed well over the heads of the crowd as the bullets whistled past us at our elevation, but others were intended to kill.'[25] As the bodies were carried away on trishaws the standoff died down and a column of tanks broke through, moving slowly east along Chang'an Avenue.

Waiting for them a few hundred metres down the road – directly opposite the Beijing Hotel – stood a man in a white shirt and dark trousers, carrying two shopping bags. Alone he blocked the path of the tanks, watched by groups of nervous bystanders and perhaps fifty journalists, camera crews and photographers on balconies on almost every floor of the Beijing Hotel. They were prevented from leaving the premises by the PSB (Public Security Bureau).

I remember lying prone on a balcony on the sixth floor with the *Newsweek* photographer Charlie Cole, photographing the event around noon on 4 June.[26] On the balcony after the event, which lasted less than three minutes, a conversation ensued with a writer for *Vanity Fair*, T.D. Allman. Allman insisted (correctly as it turned out) on the significance of the spectacle. I recalled images from 1968 in Prague and Bratislava where protesters stood up bare-chested against Russian tanks, and similar accounts from China during the Japanese invasion. Tank man felt very distant by comparison. The photographs I had taken, as seen through the lens, appeared to me to lack the impact of, for example, Josef Koudelka's images from Prague. My rolls of film were smuggled out of China the following day packed in a small box of tea and carried to Paris by a French student. The transparencies were later processed, duplicated and distributed from Magnum's office in Paris.[27]

Images and reports of the tank man incident emerged slowly. The first the world saw of the tank man was on television on 5 June. Television drew the world's attention to the incident. George Bush referenced it after watching CNN. 'I was very moved today', Bush Senior intoned at a news conference on the morning of 5 June, 'by the bravery of that one young individual that stood alone in front of the tanks, rolling down, rolling down the avenue there.'

The CNN footage, smuggled out of China on 4 June, was first downlinked from Hong Kong's Media Centre late on 4 June or early 5 June local time.[28] Reportedly, other US and European networks recorded and broadcast the CNN satellite feed.[29] CNN's Tom Mintier narrated the story of the tank man's *ballade* from a landline in Beijing: '... the world witnessed a daring act by one man against insurmountable odds. Armed with only courage, standing in the middle of the street facing more than a dozen tanks bearing down on him, he refused to move. He demonstrated the will to resist beyond any words that could ever be spoken.' NBC began its report with George Bush's statement.

Suddenly, a photograph that had held virtually no interest the previous day became iconic – yet only where television had broadcast the incident.[30] It became a symbol of courage, but also a symbol of freedom in the face of a totalitarian state. Given the impact of the television footage it was no accident, then, that the only newspapers that featured the *Tank Man* photograph prominently on the front page on 6 June were those published in countries with widespread television coverage of the event featuring their national on-the-spot reporters: for example, in France (*Figaro* and *Liberation*), Italy (*Corriere della Sera*), the United States (*The New York Times, Los Angeles Times, St Louis Post-Dispatch*) and Britain (*Daily Mirror, Daily Express, The Times* and *Daily Telegraph*).[31]

Many newspapers in those countries elected not to publish *Tank Man* at all, but instead used images of the earlier standoff between the PLA and civilians on Chang'an Avenue for the front page.[32] Andrew Higgins, a reporter for the British newspaper *The Independent*, based at the Beijing Hotel, commented: 'I did not see tank man so did not report his effort to stop the tanks. [I] heard about him later – and he seemed far less significant than all the people getting shot.'[33]

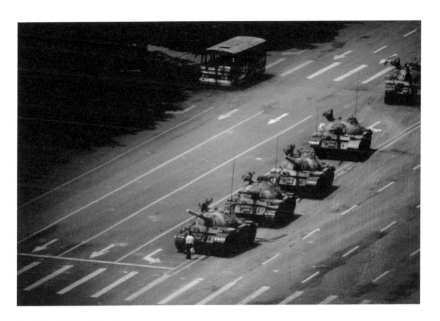

Stuart Franklin, *Tank Man, Tiananmen
Square, Beijing, China*, 1989

Outside the United States, France, Italy and Britain *Tank
Man* barely featured on front pages during 1989. Leading national
newspapers in Germany, Switzerland, Norway, Spain and South
Africa ignored it. The photographs that appeared initially were by
Jeff Widener of the Associated Press and Arthur Tsang of Reuters,
linked to subscription arrangements.[34]
 Internationally, two entirely different photographs featured
more prominently. On 5 June a photograph by an anonymous
Chinese photographer came to light. It depicted a scene where eleven
people were crushed to death by a single army APC in Beijing's
Liubukou district. On 6 June, pictures appeared globally of the 4
June standoff between the PLA and civilians on Chang'an Avenue
(based on a survey of twenty-five international newspapers). Both
these photographs described and expressed the massacre of Chinese
civilians. In China the news focused on the slaughter of soldiers, and

especially Liu Guogeng, the soldier who shot four protesters and was later beaten to death and set on fire.[35] During 1989 the *Tank Man* photograph became more iconic in the West, but almost unrecognizable in China. My photograph was printed double-page in *Time* magazine on 19 June. Cole's image was published in *Newsweek* at the same time. Both featured prominently in the year-end editions.[36] Here was a modern-day version of David and Goliath or Horatius saving Rome, a symbol of courage – a *super-icon*, or 'the icon of the revolution' as *The Guardian* described it on 4 June 1992. *Time* magazine named the 'unknown rebel' Man of the Year: a man, and an image, 'like a monument in a vast public square created by television'.[37]

In one study of my image by Robert Hariman and John Lucaites, the authors considered that the *Tank Man* photograph diverted the rhetoric on Tiananmen: 'As the image of the man and the tank achieved iconic status it has acquired the ability to structure collective memory, advance an ideology, and organize or direct resources for political action.'[38] The photograph has gradually become metonymic for Tiananmen, over-writing the images that were so compelling at the time and that spoke to the massacre that had occurred. Why would this be so? Or, as Richard Gordon asked, 'Why are Westerners so fascinated by this image? Is it because it fits so nicely with the story we expect to see – good against evil, young against old, freedom against totalitarianism?'[39]

The peculiar aspect of the *Tank Man* photograph is that it didn't surface very quickly at all, at least not until the sequence was seen on television. In 1972, despite arguments over showing nudity on the front page, Nick Ut's photograph of children running from a napalm attack on a South Vietnamese village made the next days' papers. *Tank Man* didn't. While the Beijing crackdown held the front pages between 4 and 6 June, the *Tank Man* photograph might have seemed less newsworthy than the very real and murderous behaviour of soldiers shooting to kill unarmed civilians.

In those days the news agenda moved on swiftly. In Poland, Solidarity had just won a landslide victory. In Iran, Ayatollah Khomeini passed away on 4 June, the same day that *Tank Man* appeared. By 6 June the world had turned its attention, briefly, to

the capsizing of the Ayatollah's shroud-wrapped body during raucous scenes at the funeral.

That might explain a moment of distraction, slowing tank man's rise to celebrity status, but not the reason why the image itself remained iconic once the television footage faded from memory. The problem of amnesia has resurfaced in accounts told and retold over the twenty-five years since 4 June 1989.[40] China's own official amnesia over the massacre itself – the failure to name the dead, the failure to apologize to its own people – continues.

Confusion by some media outlets (e.g. Associated Press and CNN) over the timing of the shooting at the corner of the Square, followed by the tanks rumbling through on the morning of the 4 June, has served to separate, both temporally and spatially, the tank man incident from the Beijing massacre, particularly the massacre on Chang'an Avenue. It also disconnects us from a possible rationale – outrage – behind the tank man's actions after the killing of innocent civilians, a few minutes earlier, up the street.[41]

Perhaps a friend or relative had just died, or been injured. These are unvoiced views of a possible motive. We now have an image of *everyman* – an anonymous, ethnically unidentifiable man, unremarkably dressed, in a space that bears no place identity, defying a row of tanks that appear ready to envelop him, but which in fact (as both George Bush and the Chinese government were quick to point out) showed restraint.

Continued reference to the *Tank Man* photograph has had the effect of obscuring the harsher realities of the Beijing massacre that the Chinese government would want us to forget: the crushing of students and bicycles, the morgues piled high with bodies, the victims of various moments of cold-blooded killing and so forth. Isn't the notion of the iconic photograph as a label to distinguish certain photographs as 'special' a rather redundant modernist conceit in a postmodern age?

When the iconic label is conferred on images such as Dorothea Lange's 1936 *Migrant Mother* photograph or the *Tank Man* photo-graph, it reifies the image in question, abstracting it from its social and political context. What do we learn about the Depression in

1930s' America from looking at *Migrant Mother*? Very little, apart
from the fact that some farmers struggled. We learn absolutely
nothing about factory closures, mass unemployment or urban
poverty – all issues that affected the lives of ordinary Americans.
The same applies to the *Tank Man* photograph in relation to the
Beijing massacre. A man stood in front of a tank and survived: in news
terms, in relation to everything else that happened, a nonstory.

Joe Rosenthal's photograph of the raising of the flag at Iwo Jima,
Old Glory goes up on Mt. Suribachi (1945), was also labelled iconic. Its
political purpose was to raise the hopes of a nation struggling at war;
the photograph became 'an icon of American patriotism.'[42] Yet this
image supplants the facts of the battle, such as the deaths of one-
tenth of the 70,000 US fighting force (quite apart from the 18,000
plus Japanese who died there), reducing the month-long campaign
into a simplified image of victory.

The issue of the iconic photograph weighs into broader discus-
sion on the documentary impulse and its necessary connection to
visual storytelling and the dissemination of news content. While
photographers in the field may take a view about what is happening
somewhere in the world, that view may become radically altered
when editors assembling the material in London, New York or Paris
wish to paint their own picture of events. The only clear space where
documentary photographers have felt free to set out their own stories
– as authors – is in making photobooks, which is why photobooks
have become, over time, the heart and soul of documentary practice.
Josef Koudelka's book *Wall* is a case in point where the rhetoric – his
rhetoric – remains undiluted or constrained. This summarizes the
complex relationship between documentary and its practitioners,
and explains why documentary film – driven by a director's idea –
is often seen by those in power to be a dangerous revolutionary
force. Documentary photography, with supporting text, offers an
equally powerful challenge to the corruption of power, provided
that the media organizations themselves remain balanced and
distanced from corporate or political influence. For those who have
fought for freedom from tyranny and racism, for peace and public
services, photography became – and still is – an instrument of self-
organization. For example, the demonstrations held in about sixty

countries to oppose the imminent war in Iraq on 15 and 16 February 2003 were some of the largest antiwar protests in human history. I was in London's Hyde Park that Saturday listening to the politician and activist Tony Benn and others arguing against the war. The photographs of marchers that I took, full of the passionate cries of the young and old, became a tiny part of that argument. I wanted to make a difference.

I felt exactly the same in 2015 photographing the bull-necked boss of the British Fire Brigade's Union, Matt Wrack, urging a crowd to march and defy public spending cuts. I wanted my pictures to help in their cause, to be a small voice. I recall being incredibly proud once that a picture of mine of nuclear disarmament campaigners taken outside an atomic weapons research establishment in Britain, made it onto the cover of *Newsweek* magazine in January 1982. The history of street photography is made up, in part, of work like this, work that sits on the side of protest, with its roots in the worker photography movement of the 1920s and 30s.

6
(RE)INTERPRETING
EVERYDAY LIFE

The rhetorical impact of photography and film is so effective that our entire way of experiencing life – in cities, at work and on holiday – can be represented as either utopian or dystopian depending upon the interpretative whim of the photographer and the visual language used to shape meaning out of everyday life, lessening the need for textual explanation.

The technique of waiting for or inducing a moment when a required mood occurs has already been explored in discussions on Dorothea Lange, Don McCullin and Gilles Caron. Portraitists also use this technique as a matter of course, usually in an attempt to portray the subject rather than mirror the feelings of the photographer. Examples from the rhetorical toolbox including colour, contrast, lighting, focus, how the picture is framed and camera angle; these form a small piece of the puzzle of how photographic language can shape opinion and portray a message that, for example, mass tourism is unsustainable or cities are evil. Most documentary photographs are tendentious in one way or another, and used to effect, photography has a small but powerful voice.

Colour is a utensil in the rhetorical toolbox that photographers (and artists) use to add enforced meaning to documentary work. Warm coloured lighting (reminiscent of firelight or candlelight) connotes a friendlier environment than green fluorescent or cold blue light. Green lends a disquieting mood to a photograph. It is often the residual unfiltered colour that daylight film makes of fluorescent light. Early polaroid film had a green cast. Walker Evans used this to heighten the sense of mystery in his 1974 photographs of ice-cream advertisements. Blue has always been a colour associated with loneliness or despair (hence the Blues). The paintings from Picasso's blue period (1901–4), inspired by a friend's suicide and the artist's subsequent depression, include paintings such as *The Tragedy* (1901) that use sombre tones to reinforce the mood of sadness: the same palette we find in the chill blue of Japan's industrial badlands in Naoya Hatakeyama's photobook *Lime Works* (1996). Two photographs taken in Haiti during 1987 by Maggie Steber and Alex Webb depict the same scene of a dead man lying in the recess of a building: the image bathed in blue reinforces the sense of tragedy. Steber wrote

of her photograph, *Dead Blue Man*, 'He's surrounded on three sides by the walls of the alcove, which caused the colour to be deeply saturated. I think both these elements add to the mystery of the image.' Years later, Webb added, 'Colour isn't just about colour. Colour is emotion.'

The British photographer Martin Parr, in his photobook *Benidorm* (1997), on mass tourism in Spain, used highly saturated colour images to emphasize the lobster-red of rapid sun-tanning alongside dyed hair, make-up and vibrant swimwear, to add rhetorical force to his critique of consumption and mass tourism. In other projects Parr used lighting, normally a ring-flash mounted on the lens, to achieve a similar effect, as direct flash tends to offer an unflattering view of a subject. In *The Last Resort* (1985), for example, there is a picture of two children enjoying an ice cream at New Brighton, a seaside resort near Liverpool. The flash caught ice cream falling from a boy's chin mid-drip, using the effect of frozen detail to build critique. Parr's work on the Tokyo subway and his images of opulence taken at various art fairs and race meetings for his project on luxury are examples of critique using lighting (coupled with an offbeat moment) as a tool. The epitome of this, I think – combining harsh lighting with a seized moment – is a photograph of a woman caught beside a bucket of champagne at a ski resort in St Moritz, her tongue sticking out. Such critical framings – subjects caught in the crossfire of unflattering lighting and candid expressions – lie at heart of satirical documentary expression for Parr, the New Yorker Bruce Gilden and Ukraine's Boris Mikhailov. Satire is an important rhetorical device and much of its visual language has been invented, or at least shaped, by Parr.

Bright colours and flash photography do not, of course, always connote crassness. John Hinde's – or, strictly, his assistants' – saturated and often staged photographs from the 1960s of happy holidaymakers at the British all-inclusive holiday camp Butlin's, designed as postcards to attract more custom, feature primary colours to suggest hedonism and opulence. Parr, in fact, took summer work at a Butlin's holiday camp in the Yorkshire seaside town of Filey where he worked as a 'walkie' photographer in 1971, while studying at Manchester Polytechnic.

Martin Parr, from the series
'Benidorm', 1997–9

Given the ability of the rhetorical toolbox to influence the viewer's perception of the subject, the question that emerges is: to what extent does the subject of the photograph deserve respect? I recall having a discussion about this once with Parr when trying to find some common ground to define Magnum's documentary practice. I was eager to highlight the word 'respect'; Parr wasn't. He argued that, as a documentary photographer, he should not feel obliged to treat white South African racists (his example) respectfully. While understanding his view I have always leant more towards a gentler approach. Probably more can be gained, as Nelson Mandela and others have shown, by advancing towards a perceived enemy with a hand of friendship.[1] I am not a practicing Christian, nor have I always practiced what I preach, but there is an interesting discussion in St Matthew (6:23) that has stayed with me since childhood: 'But if thine eye be evil, thy whole body shall be full

of darkness.' Frankly, I don't regret absorbing this lesson, but from some perspectives it probably limits my scope as a documentarian.

The viewer's perception of morality – or a sense of evil – can be shaped by the rhetorical use of lighting. Consider the photograph by the renowned portraitist Arnold Newman of the German industrialist Alfried Krupp (1963). Asked if his personal feelings ever shaped the way he chose to photograph someone, Newman replied, 'There's only twice I ever tried to deliberately show an individual as bad, and that was Alfried Krupp and Richard Nixon. Actually, I didn't do it on purpose to Nixon – he did it to himself. I deliberately put a knife in Krupp's back, visually. He was a friend of Hitler's and Hitler let him use prisoners as slave labor. If the prisoners fell, he just unchained them and they went directly into the crematoriums in Auschwitz.' Newman placed the lighting strategically: 'I was trying to figure a way to show who he really was without being obvious. I lit from both sides and I said, "Would you lean forward". And my hair stood up on end. The light from the sides made him look like the devil. It is an un-retouched photograph. He actually was a handsome man.'

The way in which a photograph is framed, its perspective, is itself rhetorically significant. Lee Friedlander's photobook *America By Car* (2010) is a road trip through the United States with every image shot through car windows, the people and landscape viewed, as they are customarily seen, as objects spotted whilst driving. Across two pages in the book we see a herd of cattle in Nebraska through one window, a small black bird in Death Valley, California through another. The landscape in both images appears the same: miniaturized, contained and framed within a discourse about car use.

Another rhetorical device, the low camera angle that lends dignity, is often visible in photographs made during the 1940s and 50s with a twin-lens reflex camera, caused by the fact that the lens through which the picture is taken is the lower one. Wayne Miller, in his 1940s' project *Chicago South Side*, published much later, in 2000, used this mechanical advantage to powerful effect. Most of the pictures comprise sympathetic portrayals of Afro-Caribbean migrants to the industrial heartlands of Chicago and Detroit. At the time these were gateway cities where improved transportation

Lee Friedlander, *Nebraska*, 1999,
from the book *America By Car*

during the late nineteenth century 'annihilated space',[2] allowing
Chicago especially to profit from lumber, grain storage, meat-packing
and, finally, manufacturing. Miller's pictures take in the social fabric
of Southside Chicago – the 'other side of the tracks', as he tells it. A
strike captain standing outside a meat-packing factory appears defiant,
and – photographed from below – both dignified and in the right.
The rhetorical force of the low camera angle seems to take sides in the

dispute between the employees and the striking workers. The Russian Constructivist photographers deployed low camera angles to lend stature to tractor drivers, miners, farmers and, in one famous image, a *Pioneer Girl* (1930) by Alexandr Rodchenko, elevating the workers and peasants within the class system that they were trying to destroy, raising them up with a low camera angle. (In this last case, however, it is probable that Rodchenko's aim was less to elevate the stature of the pioneer girl and more to raise the status of photography whereby it would be considered as art.) While photographs taken with a low camera angle have the tendency to raise up the subject, the opposite effect can occur when the camera looks down on its prey, appearing to belittle rather than dignify the subject. Of course this may be intentional, to give a sense of scale amid urban or industrial spaces.

Influencing our view of individuals or societal tendencies can also be achieved thematically. It is widely known that people are moved more by images of children in distress than of adults in the same situation. When images of the impact of the Syrian army's use of the nerve agent Sarin on the civilian population of the Damascus suburb of Ghouta were disseminated during August 2013, the pictures that were published mostly showed rows of children who had succumbed to the deadly gas. One British orthopedic surgeon from Stockport, Amer Shoaib, was so moved by the resemblance to his own children that he risked his life to work inside Syria later that year. He helped to save lives on both sides of the Syrian border with Turkey, basing himself at the Bab al-Hawa hospital, a target of frequent attacks, reportedly by sympathizers of the Syrian president, Assad.[3]

Zoomorphic images of animals that look like children are equally powerful. A well-known image by Duncan Cameron of a Canadian baby 'white coat' harp seal being clubbed to death, first published in 1969, led to such widespread outcry (one petition bore the signatures of 400,000 Belgian schoolchildren) that the Canadian government partially banned the practice later that year. Religious iconography is also frequently deployed to add rhetorical power to photographs of animals and humans. Brent Stirton's award-winning photograph of a Virunga Mountain gorilla, one of seven to become a victim of poaching in the space of two months during 2008, was photographed

in the Democratic Republic of Congo. The 225-kilogram (495-pound) silverback was tied to wooden cross-pieces and hauled uphill by park rangers and weeping villagers in a scene connoting Renaissance images of Christ's descent from the Cross.

Aid agencies have regularly milked the donor appeal of the Madonna and child trope. In the aftermath of the 1984 Ethiopian famine (the first BBC television coverage of which was facilitated by Oxfam), Oxfam's 1987 UK report entitled *Images of Africa* concluded that mother-and-child photographs were the dominant strategy across the newspapers. Yet Oxfam perceived as a problem that the pictures represented Africans as 'passive victims'.[4] This spurred a change to look for more 'positive' images.

In 1997 the World Press Award was presented to Hocine Zaourar for a photograph of a distraught survivor of a particularly ruthless massacre in Algeria. The photograph depicts two women, one supporting another. Both are dressed indistinguishably from figures in a Renaissance painting. Hence the photograph became known as the *Bentalha Madonna* (after the village just south of Algiers where the killing took place) or, later, the *Algerian Madonna*.[5] It was the fact that both the Algerian Madonna and Brent Stirton's dead Virunga silverback, as photographed, connoted biblical events that carried such rhetorical power.

City living, in one example of photographic tendentiousness, has been portrayed in film and photography in a highly polarized way. Cities are seen either as the cause of moral decay (think of the films *Batman*, Tim Burton, 1989; or *Blade Runner*, Ridley Scott, 1982) or as sites of opportunity or chance encounters as in the films *An American in Paris* (Vincente Minnelli, 1951), *Notting Hill* (Roger Michell, 1999) and *The Double Life of Véronique* (Krzysztof Kieślowski, 1991). Photography has similarly viewed the city through a parallel pair of lenses.

The post-industrial British port city of Liverpool is rarely seen through the rose-tinted spectacles of its famous son John Lennon. Paul Trevor's Everton pictures in the photobook *Survival Programmes* (1975, discussed in Chapter 3), Peter Marlow's bleak photobook *Looking Out to Sea* (1993) and Tom Wood's gaze from buses in the photobook *All Zones Off Peak* (1998, see overleaf) all paint the city in

determined sweeps of a mucky brush. In Wood's work, which typically (for him) shifts from black and white to colour, there is little respite from the depressing tone set in pictures such as *Walton Breck Road, Anfield* (1987) or *Gilmos, East Lancs Road* (1983). Uninviting houses and grim-faced Liverpudlians all: women in headscarves smoking; others unkempt, disabled or merely incredibly sad. The north of England was not always seen so darkly. In his 2005 photobook *Photie Man*, Wood captured New Brighton, a seaside resort across the Mersey river from Liverpool where his images were more balanced, less gloomy. And in 1976 Martin Parr spent a year documenting the Crimsworth Dean Methodist Chapel, near Hebdon Bridge. Here are quiet and sympathetic photographs of the chapel and its congregation, half-lost in a wooded valley below an outdoor hiker's paradise in the South Pennines. Interestingly, it is here we witness Parr's professional evolution from respectful engagement to satire as we turn from images of those bent in Sunday prayer to an anniversary tea where three elderly women and a large handbag are parked on a pew. The farthest figure, mouth wide open, is scoffing cake.

I confess my own photographs of Britain's northern cities – Manchester, Newcastle and Belfast – from the 1980s are pretty dark. I was once assigned by *The Observer* magazine to photograph what was described on the basis of inhouse research as 'the most dangerous street in Britain'. That was in Glasgow. Preconceptions of the way cities should look are determined as much by editors as photographers. New York, as portrayed in Bruce Davidson's photobook *Subway* (1986), is seen much as in Ridley Scott's 1982 film *Bladerunner*: as a graffiti-scrawled landscape of guns and gang warfare. The only element missing from Davidson's pictures is the electronic enhancer, a device used by Harrison Ford's character Deckard for restoring the three-dimensionality of a photograph, for the full horror to become explicit. These are transport dystopias. No one is cycling through cherry blossom. In Africa, Johannesburg fares little better. In Mikhael Subotzky's photobook *Ponte City* (2014) and Guy Tillim's photobook *Jo'burg* (2005) we find decay and claustrophobia amid broken dreams of urban regeneration. No one looks happy.

In Japanese photobooks produced in the 1960s and 1970s, Tokyo appears similarly tainted, its vibrancy reduced to dystopia.

Tom Wood, *Netherton, Liverpool*, 1988,
from the book *All Zones Off Peak*

This ambitious new megacity reached a population of 10 million
in 1964, the year in which it became the first Asian city to host the
Olympic games. Rich in autumnal colour (the games were held
in October), emboldened with a new spirit of social reform and
optimism, Tokyo nevertheless became the object of a strange kind
of monochrome revolt by three influential photographers in three
monographs: Takuma Nakahira's *Kitarubeki Kotoba no Tameni* (For
a Language to Come, 1970), Daido Moriyama's *Sashin yo Sayonara*
(Bye Bye Photography, 1972) and Yutaka Takanashi's *Toshi-e*
(Towards the City, 1974). All three photographers were involved in
the whirlpool of rebellious thought on photography that morphed
into the coterie magazine *Provoke*, launched in 1968.

Zigzagging through a haunted city, dazzled by the night, its
cowed population wintered on the blurred slopes of grainy diagon-
als. This was social landscape – Japanese style. It has proved one of
the most powerful influences on documentary photography since
Surrealism. It was a pre-punk revolt, a frustrated encounter between

art and politics that dragged photography kicking and screaming out of its craft-based perfectionism, to which it has rarely looked back. *Provoke* also opened the curtains onto photography's theatre of the absurd, its continuum of despair, pushing a boulder up a hill then rolling back down to the valley. This was the metaphor Albert Camus used in *The Myth of Sisyphus* (1942) in coming to terms with the cycle of life's disappointments. For Camus, hope resided on the way down, the acknowledgement of truth, which becomes, for the photographer, merely documents: unique, delicate, poised. I have the feeling that the angst expressed through *Provoke*'s dystopian vision of the city is based on this.

The need for a new language for photography arose out of the years of confusion between 1964 and 1968. In 1968 Shomei Tomatsu, together with Takuma Nakahira and others curated a landmark exhibition held in Tokyo called 'One Hundred Years of Photography: The History of Japanese Photographic Expression'. Through his research for the exhibition, Nakahira perceived that it was largely an uncritical documentary archive, revealing an acute lack of artistic freedom. At the same time Tokyo was being destroyed and reconstructed in pursuit of modernity. Students were on the streets in Tokyo and Paris, opposed to capitalism, opposed to the state and wanting to be free.

In kicking off *Provoke*, Nakahira, Yutaka Takanashi, Koji Taki and Takahiko Okada issued a manifesto: 'Images are not in themselves ideas ... they belong on the reverse side of language, and at times, images explosively ignite the world of language and concepts.'[6] The American photographer William Klein's influence was there in the contrasty graininess, especially his photobook *Life is Good & Good for You in New York* (1956): the city, as Klein described it, lit up like a pinball machine. In Nakahira's *For a Language to Come* (1970) there are records made by a camera and a man out late, photographs of subway trains and streets in blurred chiaroscuro, a view through cataracts: damaged or perhaps re-awakened eyes.

Blur, like most novel ideas, was not entirely new. The Pictorialists benefited from the optical aberrations of early lenses to ape the untranslatable blur that Impressionist painters knew as *le Flou*.[7] Man Ray, too, directed a film in 1928 – *L'Étoile de Mer* (The Starfish)

– that was almost entirely out of focus and in the late 1940s the influential New York-based art director of *Harper's Bazaar*, Alexey Brodovitch, was pushing photographers such as Robert Frank towards similar forms of experimentation.[8]

Reflecting on Eugène Atget, Nakahira wanted to return to a world that would not be self-referential, where he could lose all *a priori* pre-imagined ideas surrounding the language of photography.[9] He was searching for a fresh start, and his pictures of people on the street convey a sense of being lost. In one photograph a mother and child are descending steps, blurred and drifting. This is no Madonna and child. Emerging into bright light is a third figure. The photograph appears to be taken in a subway station. The sense of loss, anomie and disorientation – the polar opposite of homeliness – infuses Nakahira's photograph.

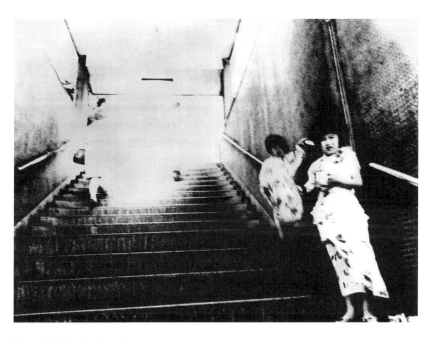

Takuma Nakahira, from the book
For a Language to Come, 1970

Cities, or some cities at least, have consistently been portrayed with magic and wonder. Romantic visions of Paris in film and photography appealed to the public on both sides of the Atlantic, especially as disseminated after World War II by soldiers returning home from fighting in Europe. André Kertész's photobook *Paris je t'aime* (Paris, I Love You, 1931) and the Alexey Brodovitch-designed book *Day of Paris* (1945), published in New York, satisfied a demand, as did Ed van der Elsken's photobook *Love on the Left Bank* (1954), which showed the city as exotic and alluring. In her autobiography *Just Kids* (2010), singer Patti Smith recalls arriving in New York and finding a battered copy of *Love on the Left Bank* in a second-hand bookshop. She wrote of its 'grainy black-and-white shots of Paris nightlife … The photographs of the beautiful Vali Myers [there are several in the book], with her wild hair and kohl-rimmed eyes, dancing on the streets of the Latin Quarter deeply impressed me.' When the singer eventually met up with the charismatic Australian artist and *bon viveur*, Myers tattooed a lightning bolt on Smith's kneecap. Even Paris's insalubriousness, so poetically glossed in Louis Aragon's novel *Le Paysan de Paris* (1926), is re-varnished and somehow shines, flash-lit, in Brassaï's photobook *Paris de Nuit* (1933).

The construction of cities, too, is portrayed with optimism. Lewis Hine's 1932 documentary project *Men at Work* begins with a short essay by the photographer entitled 'The Spirit of Industry'. Hine writes, 'This is a book of Men at Work, men of courage, skill, daring and imagination. Cities do not build themselves, machines cannot make machines, unless back of them all are the brains and toil of men.' The book portrays the building of the New York skyline: brawny men in overalls and flat-hats, rigging irons and lifting hooks, chains, cranes and vertigo-inspiring views of the city. On the cover a young man wearing shorts, hiking boots and worker's gauntlets – no top – grins from some dizzy height. In another picture we see the 'safety man', matinee idol looks, high on a gantry, who appears to personify the protagonist of Ayn Rand's novel *The Fountainhead* (1943).

A similar image of the photographer Margaret Bourke-White, perched on a steel eagle-like art-deco gargoyle protruding from the sixty-first floor of New York's Chrysler Building, was taken by her assistant. These were heady days for the US car industry: the

Chrysler Building's decor (or some of it) was modelled on automobile radiator caps. Over in Detroit, the Mexican muralist Diego Rivera was at work completing twenty-seven murals for Ford Motors, glorifying the workers on the company's assembly-line. The Swiss-born American photographer Robert Frank might have seen them when he reached the city in the summer of 1955, whilst documenting *The Americans*. The mood then was still upbeat. Despite Frank's own 1950 Ford Business Coupe breaking down in Detroit, he described the factory as 'God's factory, if there is such a place', although the photographs he made that were not published in *The Americans* are more prescient of the change in perception of manufacturing as exploitative that was to come.[10]

Architectural euphoria spread to Brazil's new capital, Brasilia, designed by Lúcio Costa and Oscar Niemeyer and photographed by Lucien Clergue and others during the late 1950s. Russian new-build cityscapes of the time had the vertigo-inducing tendency to look down rather than up, and thus appear to have been taken by dithering suicides. Georgy Petrusov's *New Building* (1928–30) is a case in point.

Manufacturing, at least, basked in Promethean glory in Russia, Europe and America from the 1920s until its fall from grace in the late twentieth century. There were exceptions to the city's august representation, but not many: Walker Evans's 1935 photograph of a cemetery overlooked by a steelworks and Jakob Tuggener's skeptical look at Swiss munitions manufacturing, which used montage to powerful effect in his *Fabrik: Ein Bildepos der Technik* (Factory: An Epic Picture of Technology, 1943). Fritz Lang's 1927 film *Metropolis*, portraying factory workers as exploited automatons, reached Europe, in a sense, before its time. The public had not quite finished celebrating the wonder of manufacturing. The view of mass construction remained euphoric. During the 1930s, the United States under Franklin D. Roosevelt and the Soviet Union under Joseph Stalin saw manufacturing as the road to economic security and full employment.

Life magazine's first cover story, published in 1936, depicted the newly-built Fort Peck Dam high on the Missouri River. Here was monumental fluted concrete, man's answer to the mountain.

Pictures by Margaret Bourke-White portrayed workers – some of the 10,000 employed on the project – as heroes. The Hoover Dam on the Colorado River, another Roosevelt New Deal project completed in 1936, promised irrigated land for the tenant farmers heading out of the Dust Bowl. Such a gargantuan concrete structure had never been attempted before. A thousand miles to the northeast, more labourers were chiselling giant relief carvings of four presidents – not including either Hoover or Franklin D. Roosevelt – into the granite face of Mount Rushmore. Step up Prometheus.

At the same time in Russia, the magazine *USSR in Construction* became one of the principal propaganda vehicles of the Soviet era. The 12 December 1933 issue featured documentary photographs by Alexandr Rodchenko depicting the heroic construction of the Baltic–White Sea Canal in his customary canted verticals. One story was told, another left out. The story told alongside Rodchenko's photographs was of skilled workers trained in forty trades, and of former convicts becoming conscious for the first time of 'the poetry of labour, the romance of construction work. They worked to the music of their own orchestras.' The untold story was that more than 200,000 labourers lost their lives in the process – and that in the end the canal was too shallow to be used.[11]

In Germany, pride in manufacturing runs deep in the documentary film archive held in Berlin's Sony Centre. Industry was not seen as a subject for criticism before the 1970s. E.O. Hoppé's photobook *Deutsche Arbeit* (German Labour, 1930), one of many with a similar title, portrayed the coke plants and steelworks of the Ruhr with dignity. In 1931 Albert Renger-Patzsch went further and published *Eisen und Stahl* (Iron and Steel), a celebration of the beauty of manufacturing and the concept of form and function taught by László Maholy-Nagy, then director of the Bauhaus. This was the epitome of the *Neue Sachlichkeit* (literally, new matter-of-factness)[12] movement in photography, roundly criticized at the time by philosopher and cultural critic Walter Benjamin, who perceived that it was 'impossible to say anything about a dam or a cable factory except this: the world is beautiful.'[13]

After World War II the German car industry, characterized by Peter Keetman's photobook *Eine Woche im Volkswagenwerk*

(One Week in the Volkswagen Plant, 1953), continued to be viewed with pride. In France it was less big industry that was feted than industry as part of the necessary function of cities. Robert Doisneau's photobook *Pour Que Paris Soit* (This is Paris, 1956) documented the printing of newspapers, the minting of coins, the street cleaners.

Across the Atlantic in the United States, Lee Friedlander was commissioned by Ohio's Akron Art Museum in 1979 to document the industrial area of the Ohio River Valley. 'This is the America that no one has been looking at', wrote Leslie George Katz in the afterword of *Factory Valleys* (1982), the resulting photobook.[14] In one photograph a steel wire appears to pierce a factory worker through the left eye. In another, metal filings are inhaled and sucked into one worker's head as his long hair, floral shirt and gloved hands are, seemingly, pulled towards the machine. These are both illusions created by the rhetorical use of careful alignment and flash photography. The photographs connote a confrontation between man and machine, and at the same time between man and nature, which was unequal and exploitative.

The glory of the iron, steel and car industries, in representation at least, had soured by the 1980s. The Canadian photographer Edward Burtynsky's father, an immigrant from Ukraine, had worked on the production line at General Motors. Burtynsky junior has spent the better part of his career documenting industrial despoliation in film and photography. The expression the 'toxic sublime' headlined an article by Carol Diehl (she claims not to have coined the phrase) discussing Burtynsky's 2006 series *Manufactured Landscapes*.[15] Benjamin's questioning of the beauty of manufacturing processes can equally apply to their environmental impact. The word 'sublime' here holds the dialectical problem for all the aestheticization of this kind of landscape in its grasp since it simultaneously connotes both majesty and terror. The Irish statesman Edmund Burke's concept of the sublime, set out in *A Philosophical Enquiry into the Origin of Our Ideas of the Sublime and Beautiful* (1756), positioned beauty alongside danger: 'Whatever is fitted in any sort to excite the ideas of pain, and danger, that is to say, whatever is in any sort terrible, or is conversant about terrible objects, or operates in a manner analogous to terror, is a source of the *sublime*.'

The disturbing aspect of Burtynsky's work is that it is so painterly. Take the example of *Uranium tailings #5* (1995), photographed in Ontario. Its russet and ochre palette meanders from sandbar to distant pines, collecting some detail in marbled indigo en route. The substantial meaning of the photograph is utterly invisible. Only the word 'uranium' in the title adds the necessary punctum, or ingredient of terror, to the piece. Diehl referenced J.M.W. Turner's paintings in her review, suggesting that, 'Just as Turner documented the birth of the Industrial Revolution, Burtynsky appears to be recording the moment of its demise.'[16]

If Burtynsky documents the Industrial Revolution's demise by way of environmental despoliation, 'Another Country', a joint exhibition of work by Chris Killip and Graham Smith, lit the path of social decline and abandonment – in Killip's case literally, with flashlights. The show opened at London's Serpentine Gallery in 1985. Echoing Friedlander's work, the photographs depict the wider social vista of Britain's industrial northeast, a landscape abandoned by the Thatcher government. Manufacturing fell into terminal neglect. Shipyards were closing. I recall watching the last ship built on the River Tees being launched at Smith's Dock in 1984. In the same year I witnessed the break-up of the Wallsend dockyards on the River Tyne. In Killip's photobook *In Flagrante* (1988), John Berger writes: 'Today the shipyards are silent, many of the mines are closed, the factories shattered, the furnaces cold ... Everything which constituted the loves of those living there is now being treated as irrelevant.'[17] Many of the photographs published in *In Flagrante* were exhibited in 'Another Country'. The work, and its positioning in London, exposed the north–south divide in Britain, which Berger described as 'not one between wealth and poverty but between the safe-guarded and abandoned'.[18]

The photographs by Killip and Smith take us to the pubs of Middlesbrough, the miner's strike of 1984–5 and the desolate industrial heartland punctuated with advertisements for black beer and cigarettes. In one photograph in *In Flagrante*, a child stares at the viewer from back-to-back housing through net curtains. Behind we see an allotment garden walled with old front doors and strips of corrugated iron. The pithead of a mine rises foggily in the

Chris Killip, *Torso, Pelaw, Gateshead,*
Tyneside, 1978, from the book *In Flagrante*

background. Another photograph is of a man is sitting on a wall.
We don't see his face, only the details of his hands and his clothes.
Reading up the picture we pass from half-shined metal-worker's
shoes – both with broken laces – to soiled turned-up trousers to a

gabardine factory coat with a poorly repaired patch pocket. Every stitch of the dark cotton used in the repair of the pocket, every turn of the needle carrying the thread, presents a mini-history. Curled hands emerging from the sleeves rest on a brick wall and tell of age. Sixty maybe. This photograph is important for two reasons. First, it performs a function that only photography can achieve: the creative treatment of actuality as revealing detail through stillness. Second, it is both rhetorical and ambiguous. So many of the signs that we search for in an image are missing. The face, the area of a picture we rush to for clues, is missing. The background, the spaces where we look for context, is also absent. What remains is a living still life of exquisite detail from which our stories, our fictions and our metaphors can be built. Here begins a journey into the non-didactic, into the psychological control centre of what constitutes a large part of documentary practice: the ambiguous image.

Facelessness once more emerges in a photograph by Sibylle Bergemann in a photobook titled *Ein Gespenst verlässt Europa* (A Ghost Leaves Europe, 1990)[19] showing the construction of two monuments – vast, industrial statues of Karl Marx and Friedrich Engels – decapitated under a brooding sky, their upper bodies replaced by prophetic dark clouds, waiting for the Berlin Wall to topple. The work is subtle, iconoclastic and ambiguous. All the photographs in the series were taken in East Germany during the 1980s. Some of the statues are wrapped for transit and appear as Egyptian mummies or as a covered woman wearing a black chador. In one, Karl Marx is flying through Berlin as Superman, attached to a crane. These are some of the most subversive and rhetorically powerful images I have seen, and yet they are ambiguous and somehow innocent. They speak of industry depicted as theatre. They are statues that would be imposing, but that are rendered impotent, headless and surreal.

On the subject of headlessness, consider two photographs from another industrial project: *Workers* by Sebastião Salgado, produced between 1986 and 1991. One depicts a welder in the Brest military shipyard in France in 1990. As in the Killip and Bergemann photographs, we don't see his or her face. What we see instead of a face is

Sibylle Bergemann, *Marx-Engels Monument,
Gummlin, Island Usedom, Mecklenburg-Western
Pomerania, July 1985, GDR*, 1985, from the book
Ein Gespenst verlässt Europa

a steel buttress with a hole in it where the head should be. Something
akin to a robotic eye stares out, whilst a gloved right hand holds the
oxyacetylene torch. Little is clear, in fact, except that the photograph
connotes (to me at least) that the industrial world is de-humanizing.
The caption explains only that the photograph was taken in 1990
during construction of the nuclear-powered aircraft carrier *Charles
de Gaulle*, the flagship of the French navy.

The second photograph was taken in 1986 at a gold mine in the
Serra Pelada, Brazil showing a man at the top of a ladder reaching the
heights of a stepped gorge. String tied around the worker's forehead
supports a sackful of earth resting on his shoulders. We don't really
see why the man is carrying a sack, but other photographs in the
series tell that story. As if descending from heaven, a hand appears
to offer help but at the same time offers nothing. Emerging at the top
left of the image, the floating hand contributes a formal shape that

connects itself, compositionally but not materially, to the struggling mineworker. Contradictions abound and, as in the pictures by Killip and Bergemann, the image provides clues for which there are no definitive explanations.

Photography is able to portray entire ways of life, such as city living, tourism and manufacturing, as documentary 'truth' whilst freighting considerable critique (or the reverse). Ambiguity, as seen in the work of Killip, Bergemann and Salgado, is often reinforced by a sort of surreal mystique, adding further to what can be read as rhetorical. In broad terms, however, from the late nineteenth century until the 1950s manufacturing was viewed through the documentary lens as an heroic pursuit. Subsequently, the making of things that we use, even the growing of food that we produce, has been represented ever more critically as the majority of people have become more, rather than less, dependent on the processes depicted.

The last example I would like to discuss is the issue of nuclear energy. Oddly, I don't think documentary film or photography ever did the atomic power industry any favours, except perhaps in the Soviet Union during the 1950s. Eisenhower's 'atoms for peace' idea never caught on. Apocalyptic would be the best word to describe the industry's representation in film and photography since the first commercial operation began in 1956 at Windscale, UK until today. At the same time about 10 per cent of the world's population, approximately three-quarters of a billion people, count on it for electricity.

No matter how safe atomic energy can be made, and no matter how sensible it may seem as the answer to cheap electrical power, the public at large are scared – and rightly so. If the accidents at the nuclear power plants at Three Mile Island (1979) and Chernobyl (1986) weren't enough, consider Fukushima Daiichi (or Fukushima number one).

During the afternoon of 11 March 2011 one of the most powerful earthquakes in history rocked the northeast coast of Japan close to a boiling-water nuclear power station (these are quite common: there are thirty-five in the United States alone). Fourteen-metre-high (46 foot) waves disabled the emergency generators designed to cool

the reactors resulting, eventually, in a nuclear meltdown. The area was evacuated. Reportedly, few lives were lost due to direct radiation exposure. Nevertheless the photography that emerged – abandoned towns and villages, workers in white protective coveralls carrying dosimeters, dead and bloated cattle and fields of plastic bags – had considerable impact, not least because of their ambiguous and, therefore, scary nature.

One of the many challenges for photographers documenting the aftermath of nuclear disasters is that radiation is invisible. However, some of the most haunting images to emerge from Fukushima depict fields or woodlots of dumped black or bright blue plastic bags. Radioactive waste, shades of the toxic sublime, appeared in *The Lost Hometown* (2013), a photobook by Yuki Iwanami. A photograph of a cherry tree in blossom seems bestowed with added vigour, a pink florescence above a bed of radiation bags. Here again, it is both the ambiguity of the photograph, set in semi-rural scenes, together with the surrealistic intervention of large quantities of plastic bags, which proves effective.

Of course we are accustomed to seeing plastic bags in fields: they go hand in hand with modern farming. What makes the Fukushima bags different are the quantity, the site (they were not always in fields) and the manner of tying them (with knots at the top). More than that, there are captions and context. These are the most powerful and yet ambiguous, surreal yet polemical, images that exist to tell the story of the Fukushima nuclear disaster. Because of the crisis, Japan has reduced its nuclear power production by 45 per cent and Germany by 23 percent since the disaster. The representation of the disaster may have been one of the contributing factors to raising public awareness of its devastating aftermath.

7
ON VISUAL POETRY
AND AMBIGUITY

The photographer Robert Doisneau once said: 'If my work speaks it does so by being a little less serious, a little less solemn, and by its lightness it helps people to live.'[1] Doisneau's 'lightness' can be as affective as the forceful didacticism of reformist photography. There can be more psychological insight and reach in quieter work, and much of its power is little understood. We are far from knowing how the brain processes images. Surrealism, an artistic revolution that came of age in the 1920s, was a tour de force because it challenged us to see the world differently, with a certain poetic lightness that, artistically, punched above its weight.

Photography, early on, became symbiotically connected to Surrealism, to the extent that at one point the painter Salvador Dalí claimed, 'Nothing proves the truth of surrealism so much as photography.'[2] Surrealism became something of a wild animal befriended by the art world. It grazed on the dialectical tension between dream and reality, between what is actually there and what we imagine. It found expression in photography because all the unlikely juxtapositions that a camera captures in an instant are precisely those incongruities that we don't see because they don't belong to the practical side of everyday life. Often they involve reflections in windows.

Consider a photograph by the American photographer Charles Harbutt titled *X-Ray Man, Gare Montparnasse, Paris* (1973, see overleaf). It appears to depict a view through the window of a bus as it passes through a busy street. Outside, people stroll past. Some seem to be gazing into the bus, including a figure that is actually a face on a poster. A bus passenger who was travelling to a specific destination would likely see the scene differently, without the reflections. That's because the photographer was not in the bus but outside on the street, capturing three scenes simultaneously: the reflections of houses on the bus window, the view through the bus of the people looking in and a self-portrait. This, as an example, is why Dalí was able to say that photography proves the truth of surrealism. In terms of photographic language, surrealistic seeing forms much of the visual poetry and ambiguity that photographers find so alluring. In fact, for some photographers the language itself, its inherent formalism, *became* the documentary impulse as much, if not more, than the subject of the photograph.

Charles Harbutt, *X-Ray Man*,
Gare Montparnasse, Paris, 1973

Surrealism's nineteenth-century roots (or some of them) can be
traced to Charles Baudelaire and his comments on the leisured *flâneur,*
the dawdling observer, 'a prince who, wearing a disguise, takes
pleasure in everything.'[3] Paris, and especially Montparnasse, became
a creative hub where artists and photographers gathered. Man Ray, an
American raised as Emmanuel Radnitzky, moved there in 1921. Four
years later he became part of the first joint Surrealist exhibition, and
a neighbour of the photographer Eugène Atget whose photographs
he collected and reproduced in the magazine *La Révolution surréaliste.*
Atget enjoyed the unlikely juxtapositions of reflections in antiquarian
shop windows and of statues apparently coming to life in the Parc
de Seaux as he set out to document the streets of Paris (see overleaf).
His photographs work in the same way that Charles Harbutt's does.
Much of the visual language of street photography was invented by
Atget who, after his death, became the first star of the genre to rise.
Inventive as Atget was, he remained poor and unknown during his

lifetime, hawking his prints for virtually nothing until discovered in 1925 by Berenice Abbott.

Atget's greatest follower was Walker Evans, known for his work for the FSA in 1930s. As the curator John Szarkowski recognized: 'Evans did the bedrooms and kitchens, the boutiques, the signs, the wheeled vehicles, the street trades and the ruins of high ambition. It was years before it was noticed that Evans had reworked Atget's catalogue of potential subject matter.'[4] What Evans lacked in originality of purpose, he made up for in energy and consummate skill. The aim here is to recognize the connection, especially in his early work, to an emergent interest in a form of 'surrealist realism' which coalesced in the late 1920s and 30s and came together in New York in April 1935, when a photographic exhibition was held at the Julien Levy Gallery called 'Documentary and Anti-Graphic Photographs'. The term 'anti-graphic' signalled a turn away from Constructivist-style graphics, with the tendency towards dramatic diagonals, to a more emotional approach. The three photographers exhibited were Evans, Manuel Álvarez Bravo and Henri Cartier-Bresson, all of whom had connections to Man Ray and Atget. Álvarez Bravo wrote: 'Atget, I believe, wound up shaping my thinking: well not so much, but my way of looking, he made me gaze differently ... there was a defined path for my work.'[5] You only have to look at Álvarez Bravo's photographs, such as *Absent Portrait* (1945) or *Fallen Sheet* (c. 1940s), to see the surrealism that was so important to his vision. *Fallen Sheet* is a haunting image, if only because it is so reminiscent of photographs of victims of famine; it is as if they have gone, leaving only a shroud.

This way of gazing differently cannot be understated. Surrealism was to become a primary influence, almost the *raison d'être,* of European and American documentary street photography from the 1920s until the 1970s, and perhaps beyond. Both Cartier-Bresson and Álvarez Bravo knew André Breton, the surrealist movement's founder, who travelled to Mexico in 1938. In Breton's part-autobiographical novel *Nadja* (1928), the idea of the *flâneur* became reinvigorated. The street was to become the locus for serendipitous encounters with the public at large but also, romantically, with women. *Nadja* recounts the story of Breton's chance meeting

Eugène Atget, *Au Tambour*, 1908

with Nadja in Paris, their short romantic attachment and their ultimate separation.

The curator Peter Galassi, in his introduction to *Henri Cartier-Bresson: The Early Work* (1987), defines the species thus: 'Alone, the Surrealist wanders in the streets without destination but with a pre-determined alertness for the unexpected detail that will release a marvellous and irresistible reality just below the banal surface of ordinary experience.'[6] By way of Surrealism the sorry male existentialist (camera in hand) found solace, as Susan Sontag observed in her introduction to Walter Benjamin's collected writings: 'Surrealism's great gift to sensibility was to make melancholy cheerful.'[7]

Benjamin was more critical on the subject. Taking a Marxist position he linked Surrealism to solipsism and political quietism, disengaged from the struggles of socialism: 'The reader, the thinker, the loiterer, the *flâneur*, are types of illuminati, just as much as the opium eater, the dreamer, the ecstatic. And more profane. Not to mention that most terrible drug – ourselves – which we take in solitude.'[8] The unfettered space/time capsule free from the demands of customary adulthood – a form of extended childhood, living in an eternal present (no past, no future) – offered a growing band of early street photographers the freedom they craved, especially those without pressing financial burdens.

The surrealistic street photography of Cartier-Bresson and his acolytes was generally less politically charged. Born in Chanteloup, Seine-et-Marne, on 22 August 1908 (he died in 2004), the eldest son of a well-to-do haute-bourgeois family, Cartier-Bresson was influenced by Breton, whose meetings he attended in Paris, and the Cubist painter André Lhote, who taught him 'the pleasures of geometry.'[9] 'Surrealism', wrote Clément Chéroux about Cartier-Bresson, 'made a deep impact: the subversive spirit, the taste for games, the scope given to the subconscious, the pleasure of strolling through the city, and the openness to the pleasures of chance.'[10] Setting out to photograph the street in the 1930s, Cartier-Bresson pursued his interest in the geometry of photographs, which, though filled with people, are often constructed according to the rules of the golden ratio. For the writer John Banville, Cartier-Bresson was 'the great geometer among photographers.'[11]

This interpretation holds for a number of Cartier-Bresson's photographs, but not others, for example some of the early reportage work commissioned by *Life* magazine in China. Formalism is strong in the photograph titled *Andalucia* (1933), of a child looking down across the shadows of a walled town and the surrealistic photograph *Srinagar, Kashmir* (1948) of Muslim women on the slopes of Hari Parbal Hill in Srinagar facing the Himalayas, gesturing but at the same time appearing to hold up a cloud. 'I owe an allegiance to Surrealism', Cartier-Bresson once wrote, ' because it taught me to let the photographic lens look into the rubble of the unconscious and of chance.'[12] *Kashmir* was taken shortly after Gandhi's funeral, which Cartier-Bresson covered as a photojournalist. He had photographed Gandhi just hours before he was assassinated. *Andalucia* and *Kashmir* were both published in his second book, *Images à la Sauvette* (The Decisive Moment, 1952).

The strength of Cartier-Bresson's street photographs lies in both their perceptive grasp of the human condition and their ambiguity, the whole scene caught in a 'decisive moment'. In 1951 he told a journalist that his primary interest was *'l'homme; l'homme et sa vie, si courte si frêle, si menacée'* ('Man, man and his life, so short, so frail, so threatened').[13] I am spoilt for choice but *Rue Mouffetard* (1954), his famous picture of a boy out shopping on a Sunday morning in a Paris street, proudly clutching two bottles of wine, seems to encapsulate this spirit of 'I was there and this is how life appeared to me at that moment', as Cartier-Bresson wrote in his photobook, *The Europeans* (1955). *Rue Mouffetard* was selected as the last picture in the book.

Cartier-Bresson rejected the view that he was primarily focused on geometry as aesthetics. 'Not at all', he lectured John Berger. 'It's like what mathematicians and physicists call elegance, when they're discussing a theory. If an approach is elegant it may be getting near to what's true.'[14] In another context but on the same subject, Josef Koudelka, who trained as an aircraft engineer before becoming a photographer, used the word 'balance' to explain compositional elegance: without balance, he explained, an aircraft can't take off.

The documentary value of Cartier-Bresson's work – 'I was there and this is how life appeared to me at that moment' – is essential to grasp. His style might have conformed to the influences of the time,

Henri Cartier-Bresson,
Srinagar, Kashmir, 1948

such as formalism and Surrealism, yet his approach consistently reveals a sensitivity and respect towards the world around him. It is important to understand that the style that a photographer adopts (type of camera, film, aesthetic) is not always the same as his or her approach as a human being towards life going on around him or her. In my view, Cartier-Bresson was without doubt the most influential documentary photographer of the twentieth century.

In New York in the mid-1930s Cartier-Bresson befriended the youthful Helen Levitt, who was working on a project in Spanish Harlem. *A Way of Seeing*, the photobook of images that she produced during the hot summers of the 1940s, reflects some of Cartier-Bresson's influence, most especially, as writer James Agee noted, a sort of innocence that pervades the work. In the last photograph in *A Way of Seeing*, water erupts from a fire hydrant over a hot city street (see overleaf). In the middle of the scene a child runs across the street towards the extended arm of her mother. This is no floating arm to

enhance the picture's design but, as Agee enthused, a 'magnanimous arm': 'No one could write, paint, act, dance, or embody in music the woman's sheltering and magnanimous arm, or tilt of smiling head, or bearing and whole demeanor ... She is the sweetness of life and tenderness of death.'[15] Agee used a line from Yeats's poem *The Second Coming* (1919) to underscore Levitt's approach: 'the ceremony of innocence'.

By the 1950s and 1960s Cartier-Bresson had become a distant idol for a whole generation of scattered youth. Three photographers – Sergio Larrain in Chile, Robert Frank in Switzerland and William Eggleston in the United States (to take just a sampling) – were so influenced by his work that it furthered their own practice and in turn determined the way that documentary photography came to be appreciated from then on. At the same time the ambiguity of poetry, very much influenced by Surrealism, came to chime with the evolving space of documentary practice. Cartier-Bresson's stated disdain

for captions – he argued in a 1971 interview with Sheila Turner-Seed that 'photographs should have no caption, just location and date' – was again influential.[16] The picture should tell its own story.

In 1952, while working on a personal project on the Chilean port town of Valparaíso, Larrain took a photograph that was to become as significant in the history of photography as *Rue Mouffetard*. *Pasaje Bavestrello, Valparaíso* (see overleaf) depicts two almost identical young girls descending a staircase. The poet Pablo Neruda, who worked with Larrain on an article about Valparaíso published in the Swiss magazine *Du* in 1966, wrote of the city in the article:

Stairways! No other city has spilled them, shed them like petals into its history, down its own face, fanned them into the air and put them together again, as Valparaíso has. No city has had on its face these furrows where lives come and go, as if they were always going up to heaven or down into the earth.[17]

Larrain was twenty-one years old when he took this quintessential image of Valparaíso. At the time he was living in virtual isolation and considered he had reached a sort 'state of grace' as he walked around with his camera. His vision was so clear, yet still serendipitous in that he wasn't searching for anything in particular but sensed instinctively the perfect chance moment to photograph. A surprising number of Larrain's street photographs are framed vertically; convention in street photography favours the landscape view. The photobook *Valparaíso* (1991), designed and edited by Xavier Barral and Agnès Sire with text by Pablo Neruda, collects this early magical work on Valparaíso. It is one of the most coveted books of twentieth-century documentary photography, if its price at auction is any indication.

Another important photobook is the Swiss-born photographer Robert Frank's *The Americans*, first published in Paris in 1958. Frank's energy came, in essence, from a singular rebel heart, and the book is without doubt the twentieth-century photography's purest expression of existentialism. Extentialism is linked to surrealism in that both attempt to resolve comparable dualisms: Surrealism between dream (or the imagination) and reality; existentialism (at least in Sartre's view) between an emancipatory view of human life and the background constraints of living in a

capitalist society.[18] In every way Robert Frank's book exudes freedom, much as did Sartre's wartime trilogy The *Roads to Freedom* (1945–9): freedom in the choice of subject, the freedom of unfettered time and space and the freedom of the open road. Jack Kerouac, author of *On the Road* (1957), wrote the introduction, emphasizing again the book's existentialist roots.

The book reads like an autobiographical novel, midway between fact and fiction. There were influences of course: Cartier-Bresson, Jakob Tuggener and especially Walker Evans, who supported Frank's Guggenheim grant application that led to the project's funding. The work's documentary value lies in its ambiguity, its confident subjectivity, its lack of demands upon the reader and its poetic encapsulation of the United States at a particular moment in time, at the height of capitalist endeavour. John Berger considered this idea in the singular dimension of time: photographs are ambiguous because they 'have been taken out of a continuity'.[19] However, there is more to ambiguity than this. It is the poetic dimension of the work in every sense that drives the narrative. As in great poetry, the particular effortlessly transcends to the general. In this way the work reaches out and moves us. This notion of work reaching out and moving us is, for me, an essential test of documentary value. At the end of his life the writer Leo Tolstoy wrote of the need for art to 'infect' us:

> If men were not possessed of this other capacity – that of being infected by art – people would perhaps be still more savage and, above all, more divided and hostile. And therefore the activity of art is a very important activity, as important as the activity of speech, and as widely spread.[20]

Frank himself once said that when people look at his pictures he wanted them 'to feel the way they do when they read a line of a poem twice.'[21] Here we get to heart of the difference between didacticism and ambiguity in documentary photography, traceable from Atget's surrealistic visions of Paris to a picture of a woman, divine and curious, gazing at Frank's camera from across a coffee-shop counter in Indianapolis railway station.

Sergio Larrain, *Pasaje Bavestrello, Valparaíso*, 1952, from the book *Valparaíso*

The photograph somehow transcends what appears almost a snap-shot to achieve something more generally felt. There is its context: that the picture is normally seen connected to others in the book, like a stanza in a poem. There is a magnetism we feel through the glance of the waitress behind the counter who has stopped working to look at Frank, curiously – tenderly. Their lives collide, as the lives of Breton and Nadja had done in a Paris street, by chance.

The third photographer to be influenced by Cartier-Bresson is William Eggleston. There is a photograph taken by his wife of Eggleston dozing on a bed in a Paris hotel room. Cartier-Bresson's *The Europeans* is open at his feet: he had been absorbed in it until he fell asleep. Rather than imitating the master, Eggleston developed his own unique approach, not just of thinking about the world around him, but also of documenting it. In an interview with the curator Mark Haworth-Booth, Eggleston defined his way of seeing:

I think I have often wondered what other things see – if they saw like we see. And I've tried to make a lot of different photographs as if a human didn't take them. Not that a machine took them, but that maybe something took them that was not merely confined to walking on the earth. And I can't fly, but I can make experiments.[22]

Eggleston photographed for a long time in virtual isolation in the Deep South of America, eventually in colour on the *Los Alamos* project from 1966 to 1974. The photobook *Los Alamos* has a cinematic quality in the sense that wide street scenes are interspersed with close ups – cutaways – of everyday objects: sauce bottles, a juke-box, sticks of candy-floss, a menu that together build an evocative but somewhat surrealist picture of the American South. The *Los Alamos* photography has a lyric charm and perceptiveness, especially in its engagement with the unexpected and offbeat. This aesthetic appealed to John Szarkowski, who exhibited Eggleston's early colour work at New York's Museum of Modern Art (MoMA) in 1976, signalling a broad acceptance of colour photography in the art world. Szarkowski was the director of MoMA from 1962 to 1991.

Both Szarkowski and his immediate predecessor at MoMA, Edward Steichen, wielded considerable sway over the way documentary photography was to unfold in Europe and the Americas in the postwar era.

Both tried, in their different ways, to engage with the zeitgeist of the time. During the Cold War in the 1950s and 1960s, Steichen used the institution, in Tolstoyian style, to offer the idea of photography as a universal language that could heal the planet's ills. Szarkowski perceived a new subjectivity, of which Eggleston's work was an essential ingredient – the birth of the 'me generation' – as a paradigm shift. In opening the 'New Documents' exhibition in 1967 he wrote:

> In the past decade a new generation of photographers has redirected the technique and aesthetic of documentary photography to more personal ends. Their aim has been not to reform life but to know it, not to persuade but to understand. The world, in spite of its terrors, is approached as the ultimate source of wonder and fascination, no less precious for being irrational and incoherent.

The photographers exhibited were Diane Arbus, Lee Friedlander and Garry Winogrand. All became, in turn, influential within documentary photography. Both Friedlander and Winogrand embraced the power of ambiguity in photography inherited from Cartier-Bresson. Winogrand argued that, 'There is no special way that a photograph should look'.[23] Unlike Friedlander, Winogrand was a gregarious socialite. He liked to meet up with other photographers, such as Tod Papageorge and Joel Meyerowitz, for morning coffee at MoMA and then wander out into the city. Papageorge recalls Winogrand's influence: 'Where, before, I searched for subjects for my pictures, I now looked for, well nothing in particular … as my intuition directed me.'[24]

These photographers weren't list-makers who make copious plans on paper, as were Frank and the British photographer working in the 1960s, Tony Ray-Jones. As Szarkowski remembered him, Winogrand was more interested in photographing than writing about photography: 'I think the main reason he resisted explaining himself was that he didn't want to smother under a pile of words that special, poetic ambiguity that makes a photograph beautiful.'[25] Winogrand once stated: 'I photograph to find out what something will look like photographed.'[26]

After leaving Dartmouth College, Winogrand studied painting, and later design, under Alexey Brodovitch, an exile from Bolshelvik

Russia who was art director of *Harper's Bazaar* from 1934 to 1958. Brodovitch invited students of photography to his Manhattan apartment, where he set up his own 'design laboratory'.[27]

Winogrand had a penchant for photographing politicians, businessmen, women and animals. His first photobook, *The Animals* (1969), came from wanderings around the zoo. Szarkowski, who wrote the afterword, concluded that the richness of Winogrand's observation, the sophistication of his graphic command, amounted to virtuosity. Many, including the wildlife photographer Michael Nichols, have followed Winogrand's photographic attempts to understand our curious relationship with the animal kingdom. But this early book, full of humour and insight, still stands up, in my eyes, as a monument of its time. One photograph in *The Animals* depicts a couple in identical check shirts watching two elephants. One elephant has deposited its trunk invitingly on the wall that separates the animals from the public. To the left of the couple another couple is watching through a hole in a large cardboard box that they wear almost to their knees. The surrealistic and absurd relationships framed by the camera between the couple, the elephants and the anonymous couple in the box raise a number of questions but supply no clear answers. It is this type of ambiguity that underlines the difference between documentary photography as practiced here by Winogrand and the more urgent and didactic work discussed earlier in this book.

For his second book, *Women are Beautiful* (1975), Winogrand photographed the street. Although he hadn't planned what he wanted to show, he was demonstrably interested in one thing, as Helen Bishop noted in the introduction: 'The proudest possession of the Winogrand women are their breasts. These are not subtle suggested contours: they are thrust forward, nipples erect, barely covered when not totally exposed.'[28] What *Women are Beautiful* demonstrates is that one clear strand of the documentary impulse is the pursuit of beauty, or the perception of it, much as I discussed earlier when writing about the death mask *L'Inconnue de La Seine* or the work of Albert Renger-Patzsch. This also underlines the subjective nature of documentary photography. New York's city streets in the postwar period might have been photographed in

Garry Winogrand, *New York*, 1962,
from the book *The Animals*

a myriad of different ways – as they were by Evans, Levitt, Arbus,
Richard Avedon (in his 1949 series *New York Life*) and Elliott Erwitt.
Each body of work frames the city differently. There is no right or
wrong, only an impulse to photograph.

New York street photography of the 1960s, exemplified here by the
work of Winogrand and Papageorge, was a busy junction linking a new
wave of documentary photography with the eloquence and surrealism
of Atget, Evans and Cartier-Bresson. The American photographer
Alex Webb was fourteen when he was first enthralled by *The Decisive
Moment* and the picture of the station master in Valencia who peers,
apparently one-eyed, from behind a painted gate as a child, out of
focus behind him, looks towards the camera.[29] Yet while the influence
of 'street photography and the poetic image' – to steal Webb's book
title – has endured, the notion of the decisive moment has not.

Much of the choreographed and serendipitous moments that
were captured on film became, over time, somewhat self-referential.

Photographers were producing work for other photographers, as if to say, 'Look how I caught that bucket echoing that curtain in the foreground, which connects with that elongated cloud in the sky.' And so forth. The subject seemed to evaporate, leaving the poem looking lovely, but ultimately meaningless.

This does not mean that documentary photography of the street has not moved on. During the 1980s, a new approach began in the city but reached out to the suburbs and the countryside. Photographers were continuing to work poetically and ambiguously, but in ways that were less determined by any defining moment. The work of Stephen Shore, Luigi Ghirri, Guy Tillim and Alec Soth points to an evolving direction for documentary. What links much of their work is a cool, detached engagement with place.

Stephen Shore's 1982 *Uncommon Places* opened up a fresh approach to documentary, influenced first by the Kunstakademie Düsseldorf, where Bernd and Hilla Becher taught photography, then by an influential exhibition held in Rochester, New York in January 1975, 'New Topographics and Man-Altered Landscape'. Shore was the only photographer to exhibit in colour. A critical detachment pervades the work, once more acknowledging the influence of the Bechers and Evans. Most of the photographs were made carefully with large-format cameras on colour negative film. The care and deliberation in the picture-taking and the timelessness of the resulting photograph was a rejection of the idea of there being a decisive moment, an idea intrinsically linked to the development of miniature cameras during and after the 1920s.

Stylistically, there are strong connections between Shore's approach in *Uncommon Places* and Ghirri's in *Il profilo delle nuvole* (The Profile of Clouds, 1987). Shore's photograph of *Broad Street, Regina, Saskatchewan* (1974) seems somehow linked to Ghirri's *Fidenza* (1985–6). In Shore's photograph we find figures in a landscape in unsaturated shades, recalling the paintings of Edward Hopper. In Ghirri's picture the flat tones and haunting mood of the Italian surrealist Giorgio de Chirico prevail. In both photographs the people are stationary, un-posed but somehow lost in an alien land. These are thoughtful documentary images, theatrical but not

operatic, where the street has been set to stage a silent play. There is no narrative, only the constructions that we, the viewer, can make of the images. The work carries psychological rather than political force. By contrast, two photographs by Alec Soth and Guy Tillim feel more political. Alec Soth's photobook *Sleeping by the Mississippi* (2004) explores America's often neglected 'third coast', an area of the country that has received comparatively little attention from artists and photographers. Mississippi is less the subject of the book than its organizing structure, merging poetry with documentary vision. Soth himself concedes the poetic approach:

I see poetry as the medium most similar to photography ... or at least the photography I pursue. Like poetry, photography is rarely successful with narrative. What is essential is the 'voice' (or 'eye') and the way this voice pieces together fragments to make something tenuously whole and beautiful.[30]

Sleeping by the Mississippi takes us on a journey downstream, its sultry meanders seemingly driven by whim, until we reach an island in the river somewhere in Louisiana. There, the largest maximum security prison in the United States unfolds in a place called Angola, named, we are told, after the country from whence were brought the slaves who originally farmed the estate.

Surrounded on three sides by the Mississippi River, the Angola State Prison maintains 18,000 acres of prime farmland producing corn, soybeans and beef. The inmates work a forty-hour week. The photograph of the prison from 2002 could not be quieter in terms of its representation. Compared to contemporary work on American chain-gang labour by Jane Evelyn Atwood, James Nachtwey and Chien-Chi Chang, Soth's work gives equal value to both the flat agricultural landscape and the labour force. Everything occurs at a distance, far in the distance, and positioned in the bottom third of the frame. Small figures in a large landscape: a similar conceptual framework was explored both by Shore and, more fully, by Andreas Gursky while at Kunstakademie Düsseldorf. Gursky's were mountain views; this is flatland.

There are two tiny white men in the picture. One sits in the grass to the left of a field on which the prisoners are toiling, holding a rifle. Another is astride a chestnut horse, watching over the thirty-five

or forty equally tiny black inmates. Although the composition is important, there is no decisive moment here: the scene would unfold in a similar way all day. Instead there is space for our reflection. The photograph, with its two elevated white men dominating a landscape of black labour, is reminiscent of an early picture by Eugene Richards from the Arkansas Delta. In the Richards picture the white farmers are on a truck while the labourers down below are picking cotton.

Let's move to the South African photographer Guy Tillim's photograph, included in his book *Avenue Patrice Lumumba* (2008), titled *Typists, Likasi, DR Congo* (2007). It immediately reminds me of something the philosopher Alain de Botton wrote about DR Congo in his book *The News* (2014). De Botton suggested that because we have no idea what everyday life is like in many parts of the world, because these regions are only reported from when disasters occur, we have no basis upon which to feel empathy. Yet here it is, a day at the office in DR Congo. Photographically, there is no decisive moment

Guy Tillim, *Typists, Likasi, DR Congo*, 2007,
from the book *Avenue Patrice Lumumba*

at all. The typists will be there all day, except of course when they go for lunch. However, the fact that the picture was not published in a newspaper but in a book appealing to art-lovers raises a problem not with the ongoing work of documentary photographers but with the space where that work can be studied and understood.

I find three things engaging in Tillim's photograph: its normalcy – that a powerful image has emerged from what may be considered a boring subject; its colour palette – subtle greens with brown and ochre; and the expression of the subjects, their sombre glances contrasting with the smiling couple in the advertisement on the wall. Two of the three in the typing pool are looking at the camera, not as passive victims in rags as in Don McCullin's depictions of people looking at the camera, but as smartly dressed Africans who appear self-reliant.

Surrealism and a poetic vision have together woven a path through the world of street photography in much documentary work produced over the past 150 years. The staying power and force of these strategies of measured ambiguity in photography owe much to the psychological and emotional way in which images communicate: further research and a deeper understanding of which are long overdue.

8
MANIPULATION, STAGING AND THE FUTURE OF DOCUMENTARY PHOTOGRAPHY

'*Manipuler une image, c'est mentir*' (To manipulate an image is to lie) commented Patrick Baz, World Press Photo contest juror and French photojournalist, in the journal *Nouvelle Observateur* in 2015. The context of his comment was that 22 per cent of the photographers who entered the penultimate round of the 2015 World Press Photo contest had been disqualified. In 2014 the figure had been 8 per cent. Each year the contest, which has been running since 1955, attracts approximately 6,000 professionals. In 2015 the brouhaha focused on factually incorrect captions and evidence that a peculiar miscellany of inanimate objects (a garden hose, cigarette butts, electrical wires, parts of a car) had been photoshopped out of submitted pictures. In other images that were rejected, day turned into night and buildings appeared out of thin air.

As further controversy emerged, the news photography industry closed ranks. Santiago Lyon, director of photography at the Associated Press (AP), set the tone: 'The bright red line is the addition or subtraction of elements of a picture.' In 2011 AP had erased all the pictures of one contract photographer from their archives for the crime of removing a shadow from a picture of children playing football – the photographer's shadow.

In 2015 in Amsterdam, where the presidium flies in each year to confer its laurels, industry-wide rules on manipulation and factual captioning were re-established during panel discussions. The rules on staging were less clearly defined. One loquacious panelist, in a discussion on the rules of documentary, raised the subject of Norman Mailer winning the Pulitzer Prize for fiction with a work of journalism – *The Executioner's Song* (1979). The audience sat in silence wondering, I can only assume, what was coming next.

Each year prizewinners' photographs are suspended from iron scaffolds set between vaulted Gothic stonework inside Amsterdam's deconsecrated Nieuwew Kerk (New Church). In the airy, curved space between the choir screen and the taffeta-curtained cloisters, photographs that have passed inquisition hang in testament to some of the best of current news and documentary photography: Jérôme Sessini's coverage from Ukraine; Darcy Padilla's twenty-one-year project about one American family's distressing life.

The primary reference point for the World Press jurors has been, until 2015 when the organization drafted its own code of ethics, supplied by the Society of Professional Journalists and the International Federation of Journalism, which both underline probity. The latter states clearly: 'Respect for truth and for the right of the public to truth is the first duty of the journalist.' Some argue that lies only occur at the point where an image is described in a caption, others that photographs have never told the truth, manipulated or not. Either way, the ethics that govern the world of photojournalism are not the same as those applied to other forms of image-making, and this is where mix-ups arise.

Confusion often reigns because the term 'photojournalism' is used – both within the field and more widely – as a synonym for, rather than as a subdiscipline of, the more encompassing and progressive term 'documentary'. The confusion is heightened because contemporary documentary photography lies somewhere between journalism and, for lack of a better word, art. Once more, Seamus Heaney's notion of 'undeceiving the world' might be valuable in the context of photo-manipulation and staging. While the ethics that govern photojournalism differ from those applied to other forms of image-making, the ethics of deception are, I think, constant. Staying with the notion of undeceiving, then, it follows that any form of false information related to a photograph (or a painting, for that matter) is lying notwithstanding the fact that photography is, and always has been, an interpretive act.[1] And yet manipulation is almost a necessary adjunct to digital photography; digital photographs are, in a sense, pre-manipulated due to processes determined by software and hardware manufacturers long before the act of post-processing begins. The question is merely the degree to which photographs are altered to cater to specific audiences. Some commentators feel that even limited post-production is a form of deception and, thus, problematic.

Digital photographs are made up of pixels (or picture elements), each a mere sample of the original image. Simply put, resolution and fidelity to the original scene depend upon the number of pixels the camera captures, and each camera manufacturer does this differently. One 'megapixel' roughly translates to a million pixels, set out some-what like a Roman mosaic. De-mosaicing is the process by which the

camera creates the image that we finally see, interpolating (literally filling in information) from other pixels to make a seamless whole. The lower the camera's resolution, the more painting-in takes place. Manipulation includes the toning (area lightening or darkening) of captured images using one of the ninety-nine filters offered by a proprietary brand. The cloning or altering of pixels to add or remove elements from the image – a spot on someone's chin, say, or a bird in the sky – is also manipulation. Newspapers permit limited toning, but no cloning other than to remove dust specks – dependent, of course, upon where you live. In Soviet Russia, for example, manipulation was seen as a consummate skill rather than a code violation. Dmitri Baltermants' image *Grief* (1942), taken of the aftermath of the fateful battle of Kerch, is actually two photographs sandwiched together as one.[2] The photographer used a second negative to print a dramatic sky over the picture of inconsolable relatives reclaiming their dead between tracks of the departed tank battalions.

Two well-known historical examples of manipulating photographs both involve adding plumes of smoke. The first, a World War II image by Yevgeny Khaldei, *Raising a flag over the Reichstag* (1945), combined both staging and manipulation. When the Soviet army eventually succeeded in capturing Berlin's symbolic Reichstag building, late at night on 30 April 1945, it was too dark to take the flag-raising picture, reportedly inspired by Joe Rosenthal's iconic image at Iwo Jima. The Reichstag event was therefore staged by Khaldei three days later, on 2 May. He added plumes of smoke from a separate negative for dramatic effect. Later, under official government orders, Khaldei also had to remove a wristwatch from the arm of one of the soldiers who was wearing two, which suggested that he might have been looting.

The second example applies to a Lebanese photographer, Adnan Hajj, working for the news agency Reuters. Controversy arose because the photographer was found to have doctored an image taken during the 2006 Israeli–Lebanon conflict by adding smoke rising from buildings in Beirut. Reuters removed every picture by Hajj from its digital archive after he uploaded a second doctored image showing an F-16 fighter firing missiles when it wasn't.

Propaganda and manipulation are closely related. In 2008 the news service Agence France Presse (AFP) sent out a photograph

of Iranian missile testing from Sepah News, the media arm of the Iranian Revolutionary Guard. It was only after the picture appeared on BBC News and several prominent front pages that *The New York Times* discovered the image had been doctored: a fourth missile had been added.

It is for reasons like these that manipulation of news images is taken so seriously. People's sensitivities have changed since the early 1970s, when a distracting fencepost was innocently removed from a Pulitzer prize-winning image depicting the killing of a student at Kent State University. Today 'people are tired of being lied to': Maria Mann, director of the Frankfurt-based European Pressphoto Agency (EPA), who has witnessed the change of mood first-hand, has little patience with manipulation from photographers or government-led propagandists. One problem, for Mann, is that the volume of content being sent to news agencies 'works in the favour of those who want to deceive'. Another is that the industry, over recent years, has been facing two crossed curves: the exponential growth of content providers against a dearth of editors and editorial support for photographers. Yet the underlying issues are historical, predating the digital era.

The notion of 'truth' in photography, the promise of verisimilitude, has long been questioned. Too many examples exist of political malfeasance: Leon Trotsky, Britain's King George VI, Joseph Goebbels, Mussolini's horse's groom, Chinese political leaders, a Russian cosmonaut and several commissars and various female Israeli cabinet ministers have all, at one time or another, been airbrushed out of published news pictures. Yet, shortly after photography's invention, law courts in Europe and later in the United States began to accept photographs as admissable evidence. Photographs of signatures, seals, land claim documents, property damage or 'caught in the act' pictures all became admissible in court, albeit categorized as illustration. Passport photographs, first used alongside identity documents in Germany in 1865, promised a reliable likeness of the traveller or pension claimant.

Today, global news organizations have largely agreed principles on limited post-processing, such as slight adjustments to the colour and tone. The principles around staging, however, are less unanimous, despite its popularity within contemporary documentary. Lars

Boering, World Press Photo managing director, defines staging as 'something that would not have happened without the photographer's involvement'. Staging and photojournalism make uncomfortable bedfellows, but portraiture is one area where exceptions to the World Press rules exist.

The staged portraits from Europe's military academies for which the Italian photographer Paolo Verzone is known won a portrait award. 'Portraiture', Verzone told me, 'is the last secret playground, because you are free from constraints. The staging is part of the accepted process, not only by the [photography] industry but because all the portraits in the history of mankind have been staged.' A Spanish cadet is posed in a theatre; another in front of some painted torpedoes. Both formed part of the prize-winning portfolio. For Verzone, military cadets are the perfect subject: they don't fidget and are used to being told where to stand. 'It's the beauty of the portrait to be staged. There's so much to invent in the photographic portrait', Verzone enthused. 'It's just the beginning.'

The truth is, I don't recall photographing a prominent scientist, novelist or artist without there being some degree of posing or staging. Are staging and posing synonymous? Almost. In photography we pose a subject, but stage a scene. Often this comes to the same thing. Posing is where we ask someone to look round or move into better light. Staging is a more pronounced form of setting up. An unnatural location is used as a background for the picture or unfamiliar clothes are worn. After the 'Kodachrome revolution' at *National Geographic* magazine in 1935, photographers used to carry a red shirt in their camera bag to reclothe subjects because someone wearing red would 'add colour' to the photograph (red was the chosen colour because Kodachrome film could see it well but had problems reliably recording greens). That was staging.

Photographs taken in a studio setting are conventionally referred to as posed, even though the whole situation is staged. One danger of staging is the ease with which the resulting image can become confused with actuality, especially over time, as both the labels describing pictures and the photographer's intent become separated from the images. Oscar G. Rejlander's portrait *Night in Town* (c.1860) appears startlingly similar in mood to John Thomson's *The Crawlers*

(c.1877). The former, which shows a boy in rags, head bowed, sitting on some steps, was staged with a model and photographed in a London studio.[3] The latter depicts a destitute woman in a crumpled dress on workhouse steps in London's Shorts Gardens. Time readily erases the difference.

There are only a few degrees of separation between August Sander's portrait titled *Jobless* (1928), one of a series of German 'types' he either posed or staged, and Jeff Wall's enigmatic staged photograph *Men Waiting* (2006). In the manner of Elizabethan-style character monologues, the figures in both photographs (or most of them) look down and to the viewer's left. In theatrical convention this would connote reflection upon a negative emotion experienced in the past. Wall, a Canadian photographer who claims his work to be 'near documentary', has been open about his method since his first overtly staged work in 1982. Wall is best known for a *tableau mort* photographed on a studio set in Canada, *Dead Troops Talk* (1992), re-enacting an imaginary ambush in Afghanistan. In the photograph actors take on the role of dead or injured Afghan soldiers. In *Men Waiting* Wall borrowed the naturalistic style of photojournalism to pose unemployed men outside a factory gate in Vancouver. He had gathered them in a van and moved them to the location. The twist is in the fact that the picture is black and white, because black-and-white photographs, shot in a documentary style, appear more convincing than colour, further blurring the line between staging and reportage.

Staging – the setting up of pictures – has coexisted within documentary since its inception. Today, outside the newsroom, staging is not only hip: it has *come out*. There is more overt endorsement of it – and reaction to it – than ever before. As a form of visual storytelling, staging has an acknowledged role within contemporary photography, creating its own narrative language that is driven, primarily, by a documentary impulse. As the art historian Oliva María Rubio, artistic director of La Fábrica (which presents the annual festival Photo España), puts it: 'The thinking around documentary is different [today]... Photography is creating new narratives, ones less focused on the craft of making good photographs, more on telling stories that are meaningful.'

Prior to Louis-Jacques-Mandé Daguerre's conferred status as photography's inventor in 1839, the entrepreneurial Frenchman had acquired a reputation as a painter and creator of illusionist effects, and from 1816, as a designer of stage settings for the Paris opera.[4] You could say, therefore, that photography and staging were born as twins. In the same paper that announced the invention of photography, Daguerre also described the diorama, commonly seen today as a small replica landscape or scene, such as the African savannah, showcased behind glass in a museum. As dioramas evolved in city museums from New York to Texas, hunters and taxidermists, such as Carl Akeley, began to stage natural tableaux of stuffed animals posed in front of suitable stage-flats. When Akeley's Africa Hall opened in 1936, it became a showpiece of The American Museum of Natural History. The diorama presented itself, in the eyes of Donna Haraway, as 'an altar, a stage, an unspoiled garden of nature ... [where] the gorilla was the highest quarry of Akeley's life as artist, scientist, and hunter.'[5] Constructed to house the burlesque or macabre, dioramas have diversified over time. They were lit carefully in early city museums, alongside waxwork movie stars and royalty. As with the ancient waxworks of kings and national heroes borne through the streets at state funerals, exactitude bowed to effect.

Meanwhile, early portrait photography readily took to fakery and staging its own tableaux in which subjects were posed in settings designed to evoke or replicate classical or religious motifs. The photographer Julia Margaret Cameron's *Angel of the Nativity* (1872) is an apt example in which a child model poses in prayer with wings attached to her back.

While staging and portraiture co-existed organically, however, staging also spread into war photography. Before setting off to photograph the American Civil War, the photographer Mathew Brady rented ornate studios in New York and Washington DC to house props for staged portraits throughout the 1860s. Brady's associates, Timothy O'Sullivan and Alexander Gardner, were accustomed to posing Washington's *bon chic, bon genre* amid a fringed Gothic chair, a Corinthian column, a gold clock whose hands never moved and a leather-bound tome. Moving on to photograph the aftermath of the Battle of Gettysburg in July 1863, the pair saw little difference

between posing a model in the studio and moving a dead sharp-shooter from one redoubt to a better setting nearby.

Similarly, the British photographer Roger Fenton, a favourite of Queen Victoria and Prince Albert, staged the royal children in theatrical costume. In one series in 1854, shortly before he set sail for the Crimean War (1853–6), he dressed and posed them as interpretations of the four seasons, complete with fake snow for winter. Once docked in the Crimean port of Balaclava in 1855, Fenton off-loaded his mobile darkroom – a converted wine-seller's wagon – and set off uphill with two assistants to look for signs of a battle. On a stretch of road leading to the besieged city of Sevastopol he took two photographs: one of a road dotted with cannonballs, and one without. Considerable debate continues as to whether one or both of the photographs were staged and how the photographs were taken. Was the round-shot being collected for reuse or assembled for dramatic effect? We'll never know for sure.

Robert Capa's renowned photograph of the falling soldier during the Spanish Civil War is likely staged but we'll never know for certain. *Life* magazine published it on 12 July 1937 with the caption 'Robert Capa's camera catches a Spanish soldier the instant he is dropped by a bullet through the head in front of Córdoba'. The journalist Phillip Knightley, in his book *The First Casualty* (1975), questioned why there was 'no explosion in the skull' and why the militiaman was still wearing his cap.[6] Historical evidence from an expert, Patricio Hidalgo Luque, and research by Professor José Manuel Susperregui point to the fact that the soldier was posing.[7] On 3 September 1936, when the picture was probably taken, the nearest lightly armed cadre of Franco's forces was billeted in another hilltown 10 kilometers (6.25 miles) of open country to the south. Espejo, where Capa made the picture, did not come under attack until 22 September, nearly three weeks after the photographer and his companion, Gerda Taro, had left town.

I became curious about the debate over Robert Capa's 'moment of death' image, so I travelled to Spain to meet Professor Susperregui. It was the sixth anniversary of Susperregui's historic visit to Espejo when, after considerable research, he had discovered where the iconic photograph was taken. Susperregui and I met in Madrid

Robert Capa, *Falling Soldier,* 1936,
original silver gelatin print, marked
up for publication in *Life* magazine,
12 June 1937

and travelled towards Andalucía on Spain's version of the bullet
train. He sat next to the window, pulling books, maps and papers
out of a rucksack. Two small foldout tables were bedecked with
the professor's research on Capa, including a square-format Reflex
Korelle camera with Zeiss Tessar lens that Susperregui believes to
be the model used by Capa on that day in 1936. Susperregui is the
archetypal professor: white hair fringing an inquisitive brain. We are
similarly absent-minded. Córdoba – our stop – sped past, leaving us
little choice but to alight a hundred miles south of our destination, in
Seville. We reached the village of Espejo the following day. There the
topography matches the landscape and distant hills behind Capa's
few surviving photographs from that day – the day he photographed
not one but two fallen soldiers at exactly the same spot, including the

famous one. Earlier in the day the same 'dead and dying' militiamen had posed closer to the village with Spanish Mauser rifles.

In September 1936, the view from Cerro del Cuco – Cuckoo Hill, where the experts say the falling soldier picture was taken – would have showed hills bristling with harvested wheat and barley. Twenty-five years ago, olive groves replaced the cereal crops as far as the low mountains on the eastern horizon. Today, the view has changed almost beyond recognition. The olives, which partially obscure the view of the hills, are guarded by large barking greyhounds, which the locals race. Back then Capa was a gutsy twenty-one-year-old who went on (two days later – his birthday) to document terrified civilians fleeing the aerial bombardment in Cerro Muriano and much later to make the memorable photographs of the D-Day landings. In Spain, Capa's impulse was to tell the story of the war, access to which had proved difficult. His sympathies lay on the Republican side but he struggled to cover the military campaign during the early stages of the war, because of lack of access to the front. Staging was therefore the only way he could see of showing the loyal Republican soldiers in action.

The following year, in 1937, Capa worked in Spain on *The March of Time*, a monthly newsreel series overseen by Henry Luce. From its beginnings, staging in documentary film was not only accepted but encouraged. Luce dubbed staging 'fakery in allegiance to the truth.'[8] In one *March of Time* newsreel, a Time Inc. office boy was cast as the emperor of Ethiopia; in another a Nazi attack on Jewish stores in Germany was redone in the retail district of New London, Connecticut. Neither were filmed by Capa.[9] However, no one batted an eyelid on 24 June 1937, when Capa staged an entire attack scene in Peñarroya, northwest of Córdoba, where according to diaries written by the general in charge of the garrison, 'an imaginary fascist position was stormed as men, with terrifying roars and passionate battle-lust, leapt and bounded double-time into victory'.[10] This sort of dramatic *mise-en-scène* was eagerly anticipated by the public of the time. Capa was working as a 'film reporter' accompanied by his companion Gerda Taro a few months before she died. Wearing a beret over her strawberry-blond hair and a revolver on her belt, Taro was popular with the Peñarroya militia, on account of her beauty and for bringing

American Chesterfield cigarettes. There was a great deal of laughter on that June day. Reportedly, at least according to the commander's war diary, Capa was happy with the staged attack: '[Capa] said that an actual attack wouldn't look as real as this.'[11] Henry Luce's idea of 'fakery in allegiance to the truth' was obviously working.

Staging in documentary film appears to have been publicly accepted, from the faked 'over the top' sequence in Geoffrey Malins and John McDowell's 1916 film, *Battle of the Somme*, to a staged walrus hunt and seal-fishing saga in Robert J. Flaherty's *Nanook of the North* (1922) and in plenty of films featuring wildlife since. The spirit of John Grierson's idea of documentary as 'the creative treatment of actuality', contradictory as it appeared at the time in 1926,[12] seemed to fit the internal dialectics of factual film-making.

More recently, in 1999, the film director Werner Herzog defended staging in his so-called 'Minnesota Declaration: Truth and Fact in Documentary Cinema': 'There are deeper strata of truth in cinema, and there is such a thing as poetic, ecstatic truth. It is mysterious and elusive, and can be reached only through fabrication and imagination and stylization.' Herzog's view echoes that of the nineteenth-century painter and critic John Ruskin who argued, in support of J.M.W. Turner's impressionist approach, for a 'moral truth' over a 'material truth'. Since 1936, if not before, documentary photography has by contrast struggled with the acceptance of either ecstatic or moral truth. The public has expected an unqualified truth.

In late August 1936, at the same time as Capa was settling into life in Barcelona at the start of the Spanish Civil War, US President Franklin D. Roosevelt was riding the rails on the 'Dustbowl Special', a train dispatched from Washington DC to the Dakotas three months before the coming presidential election. Roosevelt wanted to see for himself the devastation inflicted on the social landscape by the worst drought in living memory. Organized mass gatherings to pray for rain were a daily occurrence in South Dakota. In the town of Mitchell, thirteen church towers rang their bells as a signal for the 11,000 townspeople to fall to their knees.[13]

A few weeks earlier, in nearby Pennington County, the young photographer Arthur Rothstein was working to lend explanatory

power to the drought story. He had found a steer's skull along a dried-up river basin and moved it around a little onto cracked mud. He photographed it in three or four places. The resulting pictures were met first with praise, then outrage. After they were published in the *Washington Post*, the press saw an opportunity to use the images to paint the whole Democratic 'New Deal' project of reaching out to the poor as fakery. Other contemporary and historical photographers suffered in the sideswipe. Walker Evans, who that same summer had re-arranged the objects on a tenant farmer's mantelpiece and added an alarm clock, drew unwanted scrutiny. So did Edward Curtis who, while photographing Native Americans, took to removing alarm clocks, along with every other modern device, from the scene. The photographer Tim O'Sullivan, who had turned to landscape photography after the American Civil War, even attracted retrospective criticism for tilting his camera while photographing Witches Rocks in Utah in 1869. John Szarkowski called this 'willful aggression toward the principles of record-making.'[14] In Europe and Russia, canted pictures angled their way into the avant-garde, as the archive of Russian Constructivism testifies.

Despite these condemnations, staging proceeded unhindered. W. Eugene Smith reportedly staged a first communion photo-graph while documenting life in the Spanish village of Deleitosa in Extremadura. He arranged that Lorenza Nieto Curiel, the girl who appeared in the picture, be dressed as she was for a Holy Communion ceremony that had occurred a month earlier. While completing another story about the doctor and theologian Albert Schweitzer, which appeared in *Life* magazine in 1954, Smith added a silhouetted saw and hand to the lead picture, presumably to show the workman side of Schweitzer's character. Both the magazine and the wider public almost certainly had no idea that the pictures were faked. In 1950 *Life* magazine hired the French photographer Robert Doisneau to make a story about lovers in Paris. The aim was to portray the city as quaint and romantic, playing to the nostalgia of servicemen return-ing from fighting in Europe. Doisneau used young hopeful actors to stage the photo-essay. It's uncertain exactly when the photograph was unveiled as being staged, however the move came back to bite forty years later when the couple who feature in the photograph *Le*

baiser de l'hôtel de ville unsuccessfully sued Doisneau for using them as models and profiting from the work. Today, Doisneau, Smith, Capa and others would be seen as part of the avant-garde, so long as their staged pictures were kept out of the news pages.

As staging gathered momentum, the technique and scope of the work advanced on several fronts: from staged portraiture to staged impersonations and autobiography, to imagined metaphysical or historical re-enactments or painted-over scenes, to cinematographic movie sets. Early signs of this new direction include Léon Gimpel's photographs of staged World War I battles on a Paris street in 1915, with children as the actors, and the photographer John Hinde's illustrations for an instructional book by Stephen Spender on home defence during World War II using entirely staged photographs of families conducting first aid, for example, or wearing gas masks, a prelude to his later work at Butlin's holiday camps. It's uncertain whether the Hinde photographs were designed to fool the public into thinking the pictures reflected reality or not, but the staged aesthetic of the genre they represent is evident in a new international wave of contemporary documentary work being produced in Africa, Latin America, the Middle East, India, Europe and the United States.

In many cultures storytelling is the key non-visual way in which the documentary impulse is kindled. Arctic hunting communities in Greenland and the Sami people of Scandinavia use the months of darkness to build cultural and historical cohesion through storytelling, either in family groups or wider circles; often the tone of the stories is self-deprecating, such as how I slipped on the ice whilst fishing. In Carlos Fuentes's novel *Terra Nostra* (1975), Hernán Cortés's invasion of Mexico is explained as both a military conquest and a spiritual defeat. Similarly, in Mario Vargas Llosa's novel *The Storyteller* (1989) the exploitative designs of the Viracochas (the white people) are played out in the Peruvian rainforest and explained by Saúl Zuratas who, in the novel, becomes the storyteller of the fictional indigenous tribe, the Machiguenga Indians.

Contemporary documentary has attempted to engage with storytelling and the way that remote cultures see themselves and their lives and how they perceive the spirit world as a fundamental

part of reality. Early examples of this work were Claudia Andujar's photographs in *Amazonia* (1978), a photobook she worked on with the photographer George Love. Collaborating closely with the Yanomami on the borders of Brazil and Venezuela, Andujar engaged in the trance-inducing ritual of reanu, experiencing the effects of the powerful hallucogenic *yakaona*. She describes, and at the same time tries to photograph, her out-of-body state of mind, 'no longer possessing a physical body and [becoming] a "universal being", as if we continued to exist outside our bodies.'[15] In one photograph in *Amazonia* a long dreamy exposure captures a monkey's face staring out of the night mingled with traces of coloured lights. The work is unstaged but opens the path to exploring new forms of metaphysical narrative. Other images reach back to animistic pre-Columbian concepts of *images-as-presence* (presentation rather than re-presentation) where the photograph serves as a three-dimensional object imbued with both meaning and physical presence rather than simply an image.

At the 2014 Lagos Festival of Photography, directed by Azu Nwagbogu, staged narratives dominated the event. Cristina de Middel and Patrick Willocq both presented African narratives. De Middel, who began her photographic career working on a Spanish newspaper, now sees herself as a documentary photographer working on complex narratives in which each picture is staged. 'I want to explain the world, as I would to my mother,' she emphasized to me at a festival of photography in Goa.

Her latest series, *This Is What Hatred Did* (2014), draws on the last line of a novel by Amos Tutuola, *My Life in the Bush of Ghosts* (1954) – an early example of magical realism that predates by over a decade Gabriel García Márquez's more celebrated *One Hundred Years of Solitude* (1967). De Middel's series is a metafictive essay built from staged photographs based on a folktale told by the Yoruba people that connects the story of Nigerian popular resistance to the slave trade and the spirit presence in the bush at the edge of the Lagos Lagoon. De Middel's work brings a notable story to life, invoking the imaginative power of magical realism but at the same time giving documentary voice to a remembered past and cultural present.

Patrick Willocq's series *I Am Walé Respect Me* (2013) explores a rite of passage and a tribute to motherhood, fertility and femininity

Patrick Willocq, *Walé Asongwaka Takes Off*, 2013
from the series 'I Am Walé Respect Me'

among the Ekonda pygmies in the Congo. Willocq worked with the *walés* (nursing mothers) to produce visual representations of the dreams and fantasies that women have while they live in seclusion with their parents for two to five years after the birth of their first child. 'I proposed to some *walés*, whom I've known for over a year, to participate in staged photographs that bear witness to a part of their personal history,' Willocq explained. 'Each set-up worked as a visual representation of one of the subjects that the walé would sing about on the day of her release from seclusion.'

In a photograph from the series, titled *Walé Asongwaka Takes Off*, the nursing mother Asongwaka is seen in an aircraft fashioned from rush sleeping-mats. Willocq told me that he divined the idea from the shark-submarine in *Red Rackham's Treasure*, a Tintin comic book. In actuality at 10 p.m. each night a plane flies high over the Équateur province of the Democratic Republic of Congo. Asongwaka, gazing up, sings of her dream to have the means to fly one day. Willocq

interpreted that aspiration as expressing a desire for 'some form of superiority'. Asongwaka's song was used as a script to build a set for the staged photograph. The smaller airplanes in the photograph are carved from wood, while the blue-sky backdrop is crafted from sleeping mats; both are painted by local artists. While Willocq's photographs seem to fit with twenty-first-century postcolonial collaborative approaches to photographing people living in the tropics, it nevertheless shares a methodology, although not necessarily a vision, with the German photographer and plantation manager Robert Visser who staged theatrical scenes throughout central Africa, including – famously – an execution (c.1890–1900) involving a masked swordsman, a kneeling supplicant and a village elder who plays the part of prosecutor.[16] Willocq's tableaux are empowering for the Ekonda pygmies (whose ancestors survived King Leopold's murderous rubber-tapping regime), yet they connect, as documentary artefacts, to a number of colonial-era staged photographs from the Congo.

Willocq's photographs seem derivative of the Polish photographer Casimir Zagourski's staged work on the Congolese Mangbetu people from the 1930s and of the photography of the Information and Documentation Centre for Belgian Congo and Ruanda-Urundi (Inforcongo) in a series of ethnographic projects commissioned by Belgium's colonial administration during the 1950s.

While staging is not a new idea – an illusion that any study of the photographic archive from the highlands of Papua New Guinea since about 1900 would obviate – what is contemporary, however, is the focus on *self* rather than the *other*: the emphasis on inward-looking narratives rather than those located at a distance from the photographer's own cultural milieu.

The self-representation of motherhood is the subject of the 2014 series, *Kinderwunsch* (literally the desire to bear children) by the Spanish photographer Ana Casas Broda, who has lived in Mexico since 1974. The photobook of the series follows the artist's life from 2006 to 2011. In the text, Broda describes her experience of artificial insemination in 2003 and 2008, and almost five years of fertility treatment, which resulted in the birth of her two sons, Martín and

Lucio. It also describes the trauma of her parents' separation and her grandmother's long illness.

The photographs are intimate staged portraits where Broda engages visually with the experience of losing ownership and control of her body as her children's needs, at every turn, reigned supreme. Broda's photographs connect with important staged work on feminine subjectivity from the 1970s by Hannah Wilke, Cindy Sherman and Francesca Woodman. But the mood is different. Woodman, at least, appeared in control of her body as she explored voyeurism and the female nude. Broda's work is about losing control. She writes: 'I am attentive to the changes in my expectant body. A body that is no longer mine. Unfamiliar sensations. There is no struggle against this, only the sensation that I am a passenger on a voyage.' Throughout the book the staging is collaborative, a time for the family to connect: 'We play, then we come up with ideas. We put together a scenario and they do whatever they want.' In one revealing 'half staged' photo-graph from 2010 (see overleaf) Martín, then nearly seven years old, sits in the foreground at home in Mexico City, holding a Play-station controller. Concentrating fully on a game of Sonic Riders,[17] Martín appears oblivious of his mother, who lies naked and asleep on the couch behind, and unaware – it seems from the photograph – of all the sacrifices she has made to bring this child into the world.

The impulse to document the role of motherhood has often centred on interpreting the Madonna and child idea as a simplified act of nurturing. The work of Willocq and Broda digs much deeper into these fragile – indeed, symbiotic – relationships, recalling the work of the Argentine photographer Adriana Lestido completed during the 1990s. *Madres e Hijas* (Mothers and Daughters, 2003) is not staged but deepens our understanding of the reciprocal support mechanisms that exist between mothers and daughters. The photographs show the comfort and strength that daughters bring to their mothers in difficult times, challenging the ubiquitous Madonna stereotype.

Little comfort, however, can be found in a bleak series of staged photographs from Iran by photographer Gohar Dashti. Her 2014 series *Today's Life and War* emerges from her experiences of the

Ana Casas Broda, from the book *Kinderwunsch*, 2014

eight-year Iran–Iraq War (1980–8), which dominates her childhood memory. Dashti harnesses the psychological effect of the war through staging images in a suburb of Tehran where a battlefield has been re-created as a permanent stage-set for a film. In the foreground of one picture a wedding couple sits in a rusty broken-down car. Only the pink ribbons tied to the car's chassis give any sense of hope, of a future. According to Dashti, the post-war couple is symbolic of a generation tied up in memories of war as a background to their daily life. The war resulted in between half a million and a million casualties. I travelled through Iran in the middle of the conflict. I recall a man in Shiraz telling me 'everyone has lost someone'; no one living in Iran could escape the impact of the war.

In India, the photographer Gauri Gill photographed the land-scapes surrounding the Adivasi ethnic community in coastal Maharashtra. The project, which began in early 2013, is called *Fields of Sight*.[18] However, on looking through her early contact sheets, Gill felt that so much of the narrative – the great stories that had made

the villages come alive for her, as told by her host, Rajesh Vangad –
were absent in the pictures she took:

How could I convey what happened in the village in those months
in the 1970s when the violent mobs of a powerful political party
raided it and villagers fled and fell upon each other in terror; or
the particular full moon night in October when a great forest on
a hill comes alive, and all the people who spend that night in the
forest see shining eyes glitter around them – as even the most
dangerous animals are benign that night, when everything glows
from the aura of the moon; or the stories of great overlords who
come calling in secret to the homes of innocent, hospitable men,
bringing gifts and drink and returning with deeds of land; or the
mythical stories that encompass everything that has come or is
yet to come.[19]

Gill created a way of intertwining the remembered narratives with
the photographic record by collaborating with Vangad, a traditional
Warli painter from the Adivasi community. Vangad uses Warli
iconography to draw figurative pictures describing his own and the
larger Adivasi community's stories, or histories, onto the photographs,
in which Vangad himself features (see overleaf). Gill described
the process to me: 'We decided to collaborate in a more active way.
Rajesh would inscribe his drawing over my photograph, meet my
text with his own. Or I would construct a photographic scene or set,
in which he might stand and speak. Over the course of the last year,
through works mailed back and forth between Delhi and Ganjad and
subsequent meetings, we selected several photographs and worked
on them to reflect the narratives that arose from our conversations.'[20]
Writing about *Fields of Sight*, the academic Inderpal Grewal notes:
'Vangad's painting covers the photograph, populating the landscape
with stories of loss, power, ethics and the politics of land that come
from his history, his language, his community ... Vangad and Gill
together re-create in a new language the practice of collaboration
of the painted photograph. The past is narrative, but narrativizing
continues, through mixing the historical and generational practices
of Warli painting into the language of the photograph.'[21] This refers
to a long tradition of hand painting over photographs in the Indian
subcontinent, from nineteenth century *carte-de-visite* watercolour

painting on albumen prints to contemporary over-painted studio portraiture, in which normally lightly printed monochrome portraits are hand coloured using gouache paint [22] – Gill and Vangad's collaboration both stemmed from and broke with this tradition.

In Europe staging continues to evolve as photographers use this form of intervention between art and documentary to subvert stereotypical notions of employment and immigration (in the work of Marta Soul), quaintness in Ireland (the work of Jill Quigley) or political space (through the impersonations of Alison Jackson). In a 2014 European project on the centenary of World War I, the Italian photographer Alex Majoli re-created battle scenes with re-enactors in the Italian Alps that, to echo Robert Capa, probably look more real than the few images that survive in the German and Italian archives of fighting above the snow-line. The documentary impulse behind Majoli's work was to allow people to see and understand what it might have been like, as an Italian soldier, to fight in World War I: how it felt to be there. As Majoli told me, the re-enactors take their work very seriously through diligent study of costume, military tactics and wartime experiences.

In the United States, Gregory Crewdson's staged work is concerned less with subverting stereotypes and more with psychological experience or effect. To understand Crewdson's photographs and how they link to some of the other documentary photographs described in this book, I found it helpful to watch him work. I saw how he projects his own vision of suburban America onto various stage-sets of his own making in much the same way as, for example, W. Eugene Smith went through a lengthy process to carefully select the Spanish village of Deleitosa and the cast of subjects, such as the peasant famers, to project his own vision of, and pathos towards, a country he wanted to represent as backward and poor. *Gregory Crewdson: Brief Encounters* (Ben Shapiro, 2012) is a documentary film showing the working life of Crewdson as he prospects for and then arranges the photography of unremarkable scenes of suburban life during his five-year photographic project *Beneath the Roses*. The cast – figures seen through the windows of clapboard houses or lonely motels – are instructed one by one to 'look sad.' Separate teams of assistants make it rain or snow, according to Crewdson's wishes. The documentary is, in fact, the most perfectly

Brechtian account of the pursuit of the photographer's twin subjects: twilight and sorrowful suburbia. Crewdson recalls always being fascinated 'by the poetic condition of twilight, by its transformative quality: its power of turning the ordinary into something magical and otherworldly. My wish is for the narrative in the pictures to work within that circumstance. It is that sense of in-between-ness that interests me.'

There is a good deal of in-between-ness in Crewdson's work. That is what makes it so ambiguous and thus interesting. In one scene in the film, Crewdson is in a meeting trying to decide over using a fake or real baby for a scene he's imagined in a motel room. When eventually the fake snow and real baby arrive, the infant won't stop crying. Crewdson's sole concern is that the pre-imagined, pre-drawn, live painting happens. If the characters don't fit the drawing, they just irritate him. As the fog machine backs away, the characters – a mother and a two-week-old baby – lie apart on

Gauri Gill and Rajesh Vangad, *Great Raid and Battle*, 2014, from the series 'Fields of Sight'

a pastel green bed. Lit separately, in deeper space, we view a bathroom modelled after Hitchcock's *Psycho* (1960). In the end the forty or so sheets of 8 x 10 inch film – shot by Crewdson's 'director of photography' rather than himself – are considered for sections that might form part of the final adjusted composite image. In one picture the baby's arm looks right; in another the snow is better, and so forth. So many details, so much careful painting with light: Crewdson is a perfectionist.

Crewdson's obsessive documentary impulse is towards a vision of American suburban life that shuttles between fiction and reality. He consciously blurs the two: the photographs include real local people who have been cast to populate the image and the real small-town homes where the photographs are staged. The fictional element is in the staging, the lighting, the props and the acting out of the characters under Crewdson's direction. The aim, in Crewdson's words, is to draw out 'something psychological'. In the documentary film and in subsequent interviews, Crewdson constantly refers to childhood memories (his father was a Freudian psychoanalyst); to the Brooklyn brownstone house where the family lived and his father worked; to his own failed marriage.

Crewdson's work is, in a sense, documentary as therapy. It is a photographic project centred on a man's obsession to record the American vernacular in twilight. An archaeology of twilight. It reaches to the edges of public and private space, of night and day. It answers the call from fellow Yale alumni, the geographer John Brinckerhoff Jackson, to those who document the landscape: don't forget to include the drive-ins, the suburban sprawl, the railroad.

Crewdson's work brings to mind a 1968 photograph from Colorado Springs by Robert Adams in which a lone housewife stands silhouetted in a window of a suburban bungalow. Perhaps Adams placed her there or perhaps he waited in the front yard for her to move into position. In either case the photograph feels as staged as Crewdson's *Beneath the Roses*. Adams's photograph was shown in the 1975 'New Topographics' exhibition alongside work by Stephen Shore, Lewis Baltz, Bernd and Hilla Becher and Frank Gohlke. Many of Shore's surreal street scenes of small-town America in his series *Uncommon Places* (1982) feel staged – or at least theatrical

Gregory Crewdson, *Untitled (Birth)*, 2006
from the series 'Beneath the Roses'

– and portray 'something psychological' as Crewdson's do. The
difference is that Crewdson's photographs were staged.

Crewdson's final photograph in the series *Beneath the Roses* is
shot on a street in Lee, Massachusetts. The picture, *Brief Encounter,*
is an elaborately staged photograph comprising three characters
ranged across a snowed-over 1950s' street scene. One man leans into
light (one of the seventy-five lights used in the photograph) cast by a
cinema showing the film *Brief Encounter* (David Lean, 1945). Another
figure drives through fresh snow (some added and retouched). A lady
in red sits in a cafe. Here Crewdson comes closest to Edward Hopper
and blurs the edges, less between reality and fiction, more between
realist painting and photography, which from the perspective of
documentary is what makes this project so inviting.

What then of 'truth'? I asked my art historian guide in Madrid,
Oliva María Rubio: 'The history of photography has already shown
that photography can lie … The idea that photography is the truth

or the sole basis of reality has been surpassed. Reality is what we construct for ourselves.' How does this square with the manipulated smoke plumes discussed earlier? Rubio is not referring to news images, which she believes should not be manipulated, but to documentary practice in general. Which brings me to consider the visual representation of everyday actuality in the newspapers, television and new media.

There is clearly a distinction to be drawn between the public need for the news pages to be factual as against more interpretive or illustrative content of equal documentary value. In the manner in which images are delivered or viewed, however, such compartmentalization is not always possible, which is why some documentarians are so opposed to staging. Michael Kamber, who curated an exhibition on staging and manipulation in 2015 at the Bronx Center for Documentary Photography, told me: 'The statement we are making is simple. We need to get this right if photojournalism is to have credibility moving forward. It's really not that complicated: don't stage your photos; don't pay your subjects; don't mis-caption or misrepresent your work; don't add or remove pixels from a frame.'

Fakery in the news sections of newspapers, using various forms of staging, is as old as photography itself, ranging from the sublime to the ridiculous. Recall the various attempts to fool the public about the existence of ghosts, fairies in the garden or the presence of a monster in a Scottish loch employing, on one occasion, the use of a toy submarine. Nessie's footprints were then convincingly impressed on the lakeshore and photographed with the dexterous use of a hippopotamus-foot umbrella stand. Strange as it may seem today, the plump four-toed imprint of a hippo was once accepted as belonging to a reptile. One could continue into the realm of aliens or UFOs, but photography does not require post-processing to lie: artifice is legion.

Entertainment, both fiction and reality, is now brought into our homes in a range of presentational styles. The theatre's royal box has become the easy chair at home. The proscenium arch morphs into the frame of the television or portable computer. The principal difference between television documentary and the still photograph active in the same genre is that with photography there

exists, as in the theatre, a 'fourth wall' separating the viewer from the activities going on in the photograph. In a documentary film the invisible 'fourth wall' of the theatre is broken by a narrator. As with Crewdson, in photographs the 'fourth wall' is only broken down when the photographer acts as both guide and narrator. The same would happen if we saw Chancel explaining his project *Arirang* (2008), discussed earlier, in a film. He would break the illusory wall and the ambiguity that exists in the photograph would be removed by explanation.

Almost everything we see today on our personal screens appears a little like theatre if you think about it: the boxing, the tennis tournament, the film première, the electoral debate, the state funeral, the moon walk, the bank robbery, the shaming of a public figure or the lottery draw. Of course all these events are actually happening as we watch them. But why are these events relevant to us, and not others? Much of the documentary impulse behind staging and new ways of creating documentary photography, such as the use of found photographs, is to create new stages, new podiums, from which to engage with narratives hitherto ignored or deemed irrelevant by the mainstream media. Staging, in this context, is another way of 'breaking the silence.'

The future challenge within documentary photography has less to do with staging *per se*, because so much of what we see or witness as news is staged anyway (think of the word *photocall,* literally the call for a photographer to capture a staged event), and more to do with who owns the stage – the means to communicate or narrative device. And that surely is the point of staging. There is also the question of intimacy with the facts, however they are interpreted into an evolving visual language, which John Grierson felt to be the distinguishing mark of documentary. Done with integrity, then, staging becomes a means of 'undeceiving the world', of taking us beyond the normative stage of images or stories that we are being persuaded to see through mass culture, stereotyping or cultural leaning, to something else – an alternative reality, perhaps – and there should always be an appetite for that in a progressive society. As I prepared to leave Madrid, I asked Oliva María Rubio: 'Where do the boundaries of documentary lie?' 'I didn't say there were any,' she laughed.

AFTERWORD: 'THE OLD KNOT IN THE HEART'

The story of documentary reaches back at least 10,000 years to when it was a record commanded by shamans and kings, scribes and tenured artists. Only very slowly did the power to tell stories with images become available to most of us. The democratization of documentary practice has emerged over just a few hundred years and, in photography, over less than a century – not long to move from a privileged elite of camera owners to near-universal ownership of a camera or camera-phone. Social media have accelerated the power-sharing process further. The 'me' generation uses photography as a shared visual diary to document 'my experience' of people and places the world over. This process, however, is not without its pitfalls. The reliance on, or enjoyment of, receiving 'likes' for images posted online is reminiscent of the reader surveys I used to see at *National Geographic* magazine, in which the public invariably wanted to see more cuddly pandas and suchlike. But shouldn't editors lead rather than follow? The same, I think, should apply to documentary photographers.

Photography's sudden democratization was not unique. When Henry Ford built the Model T in 1908, he shared a similar democratic vision, 'to put the world on wheels'. In a very short time people the world over had achieved two convergent dreams inconceivable in 1839, at the dawn of photography. The first was mobility: the ability to travel widely and freely. The second was fixing memory: the ability to retain the experience of a place, person or event with little effort. Photography and mobility advanced a dual, symbiotic project: to travel, to see, to photograph – as Mary Ellen Mark once wrote, 'my camera is my passport'.

When Sigmund Freud wrote about photography, it was as a function of memory rather than vision. In the words of the academic Mary Bergstein, 'Freud's psychic location for memory is a place within the mind, but some of his ideas suggest that this mental picture also worked like a slideshow, with the projection of images from outside enlarged on a psycho-spatial screen.'[1] The graphic example of the picture-show oversimplifies the complex way in which the visual cortex at the back of the brain sorts and stores images, and how this sorting is connected to memory.

That ambiguous photographs may possess a power equal to that of more didactic images I can only assume is because there is

a great deal that we still don't understand about the way we read photographs. There is uncertainty, too, about how photographs trigger responses or memories held in the unconscious mind. As I reflect on the many stories in this book about the documentary impulse, I realize that all of them relate to memory: the desire to bear witness, to remember or be remembered, so that others will not forget. The ultimate purpose in photographing the slaughtered civilians in the Crimea or the Holocaust, the starving in southern Sudan, the refugees from Syria or Chinese students occupying Tiananmen Square, is to preserve a memory.

Some of the most significant essays in the documentary archive are also, sometimes, very personal. Heart-breaking stories of breast cancer and its impact on the people we care most about, for example, have been told in the photobooks *Sentimental Journey* (1971) by Nobuyoshi Araki and *Exploding into Life* (1980) by Dorothea Lynch and Eugene Richards, while touching stories about childhood have been relayed by photographers including W. Eugene Smith, Elliott Erwitt and Larry Towell. Some of these images that have become so familiar that few realize that they are of the photographer's own family: Elliott Erwitt's picture of his first wife, Lucienne Matthews, with their six-day-old daughter Ellen, taken in an Upper East Side apartment in New York in 1953, is still part of the permanent 'Family of Man' exhibition in Lichtenstein. All of these photographs begin with what is close.

The documentary impulse embraces a dualistic approach to the treatment of actuality. Creativity, or the extent to which creativity is applied, is a selective process. At the same time, and in the background, lies the onus of fidelity, of recording things as they are. These words spring from a centuries-old advisory by the English philosopher Francis Bacon, which the photographer Dorothea Lange supposedly kept pinned to her darkroom door: 'The contemplation of things as they are, without substitution or imposture, without error or confusion, is in itself a nobler thing than a whole harvest of invention.'[2] There is a marked difference between contemplating things as they are and things as we perceive them.

Perhaps we have to assume that, by documenting things as we perceive them or, better, as we experience them, we come to

an empirical and therefore subjective understanding of the world around us. In looking at contemporary documentary photographs, confusion emerges over what is meaningful as opposed to what is meretricious. Perhaps this uncertainty might end, to borrow Seamus Heaney's comment on poetry, in a focus on *undeceiving* the world.

This comes back to the honesty or singularity of intent of the photographer, as well as his or her ability to move us. Writing on art, Leo Tolstoy argued that 'Art is that human activity which consists in one man's consciously conveying to others, by certain external signs, the feelings he has experienced, and in others being infected by those feelings and also experiencing them.'[3] I think what Tolstoy was suggesting was that, yes, the empirical approach is valid, but that from the empirical should, ideally, come a message that can be universally shared and understood. Tolstoy's concept of needing to be *infected* by art is critical. Art and photography, to be sustainable, must reach out and communicate, must touch us, must make us walk across town to see it on the walls of a gallery, must make us buy the book. Documentary photography must function in this way. W. Eugene Smith's 'Nurse Midwife' photo-essay and Ernest Cole's photobook *House of Bondage* both reflect on racism – and both essays move us, talk to us, in the way I think Tolstoy meant. 'Nurse Midwife' touches us because Smith was overwhelmed by what he experienced in South Carolina and his passion energizes the work. Cole's work moves us because of its depiction of the conditions under which black South Africans were forced to live under apartheid.

The social theorist Henri Lefebvre, in considering the ubiquity of images in social space, recognized a certain transcendental quality in some images that touch us. Occasionally, he writes, 'an artist's tenderness or cruelty transgresses the limits of the image. Something else may then emerge, a truth and a reality answering to criteria quite different from those of exactitude, clarity, readability and plasticity.'[4] I am not convinced we know how this process works exactly. I am often moved by quite calm, ambiguous and passive images, such as Guy Tillim's photograph of a daily office scene in the Congo, but I am not sure why.

One complex challenge for the future of documentary photography, and I refer to it frequently in this book, is its struggle to

engage with history and process. The challenge of history, as raised in 1975 by the journalist Phillip Knightley in his book *The First Casualty*, is especially relevant in the age of embedded journalism. Is the most significant story the one we are being told or the one being hidden from us? Breaking the silence is a necessary element of documentary practice. Many times in the past 150 years, however, darkness has covered the most painful or atrocious stories. There are too many to begin to list here, but this book has shone light on a small fraction of them. Hopefully with the democratization of photography many tragedies, big and small, that remained obscure in the past will find some way of getting out.

Engaging with process and change is another, connected, issue. In the photography of the Nuba or from Papua New Guinea and Brazil, for example, the documentary value is questionable in certain forms of salvage ethnography in which the photographers' intent appears to be denying change. The extent to which images of poverty carry documentary value can also be called into question. Text can be helpful, but only when it serves to drive the narrative, as it does in Dorothea Lange and Paul Taylor's photobook *An American Exodus* (1939) or Dorothea Lynch and Eugene Richards' *Exploding into Life* (1986). Without some form of guiding narrative, documentary photography can risk becoming at best self-referential and at worst stigmatizing or voyeuristic.

I don't mean that ambiguity is problematic. On the contrary, the psychological effect of images that are subtle or surreal is perfectly valid. Much depends on the subject, however. In compelling photographs of black and Hispanic chronic crack cocaine users in Richards' later photobook, *Cocaine True Cocaine Blue* (1994), some explanation up front might help us to understand the background to the story better than waiting until the end for an explanation.

Overall, I am highly optimistic about the future of documentary photography. I hope that photographers, especially those working in news, will retain the respect they deserve. Criticizing those who risk everything to bring us the facts in words and pictures for being 'voyeuristic' is lamentable. It is alarming to think of how many photographers have died young, simply driven by an impulse to document, to bear witness and report back. In this book I have sought

to understand what drives documentary: what impels people – for the most part poorly rewarded – to risk their lives, their relationships and their financial security to document the world around them.

I see now, reaching back to the beginnings of documentary over 10,000 years ago and projecting forwards to today, that there are many documentary impulses, not just one. In the distant past, documentary seems to have been driven by several factors. In the relief carvings from Nineveh, we can see it as an expression of power. Shamanistic, animistic or religious ritual and the desire to make images or pictograms to preserve collective societal memory drove another body of documentary practice, as seen in cave paintings and in Mexican codices.

In photography, the will to confine people, places and experiences of this life to memory often begins at home. But there is something else. The Canadian novelist Michael Ondaatje wrote, in his 2011 novel *The Cat's Table*: 'We all have an old knot in the heart we wish to untie.' Many of us are driven to document for this reason, to engage in the act of untying a knot in the heart, to unravel a personal paradox. It drives our curiosity, both journalistic and existential. It drives an impulse to raise questions about perceived wrongs or social challenges, such as war in Biafra or Iraq, domestic abuse or drug addiction. It drives an impulse to search for beauty, however it is perceived, or a lost or vanishing Eden. It drives a search for evidence of atrocity, genocide or ethnic cleansing. Ultimately photography, for some, becomes a very personal narrative, a form of therapy, as we have seen in the work of W. Eugene Smith, Josef Sudek and Gregory Crewdson.

Documentary is concerned with narrative; with visual story-telling; with being, to quote W. Eugene Smith, 'a catalyst to thinking'. In an essay for *Camera* magazine in 1974, Smith wrote what would become his final credo: 'Photography is a small voice at best. Daily, we are deluged with photography at its worst, until its drone of superficiality threatens to numb our sensitivity to all images. Then why photograph? Because sometimes – just sometimes – photographs can lure our senses into greater awareness. Much depends on the viewer; but to some, photographs can demand enough of emotions to be a catalyst to thinking.'[5] Smith's words echo Lefebvre's, but here, in this book about the documentary impulse, I feel it is appropriate that the great photojournalist W. Eugene Smith be given the last word.

NOTES

Trachtenberg (New Haven: Leete's Island Books, 1980). p274.

CHAPTER 1

1 See Jean Clottes, *Un Archéologue Dans Le Siècle* (Paris: Errance, 2015).
2 See *Cave Art* (London: Phaidon, 2008). p25.
3 Ibid. p15.
4 See Serge Gruzinski, *The Conquest of Mexico* (Cambridge: Polity Press, 1993). p176.
5 Tenochtitlán, founded in 1345, had a population of 60-80,000 in 1519 when the Europeans arrived. Tikal's population was 50,000. That of Dzibilchltan 40,000. Paul Bairoch, *Cities and Economic Development: From the Dawn of History to the Present,* trans. Christopher Braider (London: Mansell Publishing Ltd, 1988). pp57-68.
6 Ibid. p350-352.
7 See Joseph Arthur de Gobineau, *The Inequality of Human Races*, trans. Adrian Collins, vol. 1 (London: Heinemann, 1915). p149.
8 See Neil MacGregor, *A History of the World in 100 Objects* (London: Allan Lane, 2010). p428
9 See Judith Barringer, *The Hunt in Ancient Greece* (Baltimore: John Hopkins University Press, 2001), p203.
10 See A.G. Bannikov, 'Zapodevniks and Nature Protection,' in *Zapovedniks of the Soviet Union* [in Russian], ed. A.G. Bannikov (Moscow: Kolos, 1969). p17.
11 See Fernand Braudel, *Civilization and Capitalism 15th-18th Century: The Structures of Everyday Life,* 3 vols., vol. 1 (Berkeley: University of California Press, 1979). p49.
12 See Braudel, *Civilization and Capitalism 15th-18th Century: The Structures of Everyday Life, 1.*
13 See Thomas Piketty, *Capital in the Twenty First Century* (Paris: Éditions de Seuil, 2013).
14 It should also be acknowledged that many so-called 'historical' paintings, while important visualisations of the past, have been shown by historians to be factually inaccurate. A case in point is

INTRODUCTION

1 See John Grierson, 'The Documentary Producer', *Cinema Quarterly, 2,* 1933. p7-9.
2 See Forsyth Hardy, *John Grierson: A Documentary Biography* (London: Faber & Faber, 1979). p43. It is also claimed that Antoine Hércules Romuald Florence used the term *photographie* in Brazil five years before it was used in Europe. Wendy Watriss and Lois Parkinson Zamora, eds., *Image and Memory: Photography from Latin America* (Austin: University of Texas Press, 1998). p25.
3 The first attempt failed in 1916 after Flaherty dropped a lighted cigarette into the cans holding the camera negative, destroying 30,000 feet of film. Returning to reshoot, Flaherty focused on Nanook and his family. Hardy, *John Grierson: A Documentary Biography.* p41. The final film followed Dziga Vertov's early montage work and predated Eisenstein's quasi documentary film *Strike* (1924) by three years.
4 See John Grierson, 'Postwar Patterns,' in *Documentary: Documents of Contemporary Art,* ed. Julian Stallabrass (Cambridge: MIT Press, 1946). p30.
5 Ibid.
6 See Max Kozloff, *The Privileged Eye: Essays on Photography* (Albuquerque: University of New Mexico Press, 1987). p258.
7 See Roland Barthes, 'Rhetoric of the Image,' in *Classic Essays on Photography,* ed. Alan

Cesare Maccari's painting *Cicero Denounces Catiline* (1889). See Mary Beard *SPQR* (London: Profile Books, 2015). p33.
15 See Cas Oorthuys, *Rotterdam Dynamics of a City* (Amsterdam and Antwerp: Contact, 1959).
16 See Ernst Friedrich, *War against War*, vol. 1 (Berlin: Freiejugend, 1924).
17 See Michael Fried, *Why Photography Matters as Art as Never Before* (New Haven: Yale University Press, 2008). p143.
18 Cited in Philip Steadman, *Vermeer's Camera* (Oxford: Oxford University Press, 2001). p15.
19 Ibid. p30.
20 See Kerry Brougher, 'Impossible Photography,' in *Hiroshi Sugimoto*, ed. Kerry Brougher and Pia Müller-Tamm (Ostfildern: Hatje Cantz Verlag, 2010). p24.
21 See Aaron Scharf, *Art and Photography* (London: Allan Lane, 1968). p212
22 Cited in Ibid. p206.
23 Cited in George Mather, *The Psychology of Visual Art* (Cambridge: Cambridge University Press, 2014). p93.
24 See Jonathan Green, *The Snapshot* (New York: Aperture, 1974). p47.
25 See Paul Joyce, *Hockney on Photography: Conversations with Paul Joyce* (London: Jonathan Cape, 1988). p18.
26 Cited in Mather, *The Psychology of Visual Art.* p27.
27 See John Ruskin, *Modern Painters* (London: Andre Deutsch, 1987 (1873)). p13.
28 Cited in Scharf, *Art and Photography.* p249.
29 Cited in ibid. p252.
30 See E.H. Gombrich, *Art and Illusion: A Study in the Psychology of Pictorial Representation* (London: Phaidon, 2002). p173.
31 See Wendy Watriss and Lois Parkinson Zamora, eds., *Image and Memory: Photography from Latin America* (Austin: University of Texas Press, 1998). p25.
32 Cited in Anon, 'Photography Reviewed,' *Cosmopolitan Art Journal* 2, no. 2/3 (1858).
33 Cited in Hiram Bingham, 'In the

Wonderland of Peru,' *National Geographic Magazine*, April 1913.

CHAPTER 2

1 See James Faris, 'Navajo and Photography,' in *Photography's Other Histories*, ed. Christopher Pinney and Nicolas Peterson (Durham and London: Duke University Press, 2003).
2 See Robert J. C. Young, *Colonial Desire: Hybridity in Theory, Culture and Race* (London: Routledge, 1995). p113.
3 See Joseph Arthur de Gobineau, *The Inequality of Human Races*, trans. Adrian Collins, vol. 1 (London: Heinemann, 1915). Gobineau argues at one point that 'The fact that certain Tahitians have repaired a whaler does not make their nation capable of civilization.' p154.
4 See Francis Galton, *Hereditary Genetics: An Inquiry into Its Laws and Consequences* (London: Watts and Co., 1950). p329.
5 Ibid.
6 Cited in Christopher Pinney and Nicolas Peterson, *Photography's Other Histories (Objects/Histories)* (Durham, North Carolina: Duke University Press, 2003). p3.
7 Cited in Stuart Franklin, 'Before 1930: The Strange and the Exotic,' in *In Focus: National Geographic Greatest Portraits*, ed. Leah Bendavid Val (Washington DC: National Geographic, 2001). p91.
8 Auguste Bal's archive is held at the Royal Museum for Central Africa, Tervuren, Belgium.
9 See David Van Reybrouck, *Congo: The Epic History of a People* (London: Fourth Estate, 2014). pp64-65.
10 See Christraud Geary, *In and out of Focus: Images from Central Africa, 1885-1960* (London: Philip Wilson Publishers, 2002)
11 Cited in Franklin, 'Before 1930: The Strange and the Exotic'.
12 See Martha Macintyre and Maureen MacKenzie, 'Focal Length as an Analogue of Cultural Distance,' in *Anthropology and Photography 1860-1920*, ed. Elizabeth Edwards (New Haven and London: Yale University Press,

1992). p163.
13 See Max Quanchi, *Photographing Papua: Representation, Colonial Encounters and Imaging in the Public Domain* (Newcastle: Cambridge Scholars Publishing, 2007). p69.
14 See Catherine Lutz and Jane Collins, *Reading National Geographic* (Chicago: University of Chicago Press, 1993). p174.
15 See ibid
16 See John Bale, *Imagined Olympians: Body Culture and Colonial Representation in Rwanda* (Minneapolis and London: University of Minnesota Press, 2002). p110.
17 See Adolphus Frederick Mecklenburg, Duke of 'In the Heart of Africa,' (London: Cassell, 1910). pp279-281.
18 See James Faris, 'Photography, Power and the Southern Nuba,' in *Anthropology and Photography 1860-1920*, ed. Elizabeth Edwards (New Haven and London: Yale University Press, 1992). p214.
19 See Russell Miller, *Magnum: Fifty Years at the Frontline of History* (London: Secker & Warburg, 1997). p65.
20 Cited in George Rodger, *George Rodger: Village of the Nubas* (London: Phaidon, 1999). p9.
21 See Oskar Luz and Horst Luz, 'Proud Primatives, the Nuba People,' *National Geographic Magazine* 1966.
22 Ibid. p698.
23 See Chinua Achebe, 'An Image of Africa: Racism in Conrad's 'Heart of Darkness',' *Massachusetts Review* 18, Winter 1977.
24 George Rodger was not interested in helping Riefenstahl, partly be cause of her known Nazi connections: 'I am quite sure', he wrote, 'considering your background and mine, I don't really have anything to say to you at all', but also because he was afraid for the future of the Nuba. Robert Block, 'Then and Now,' *Independent on Sunday*, 28th March 1993. p16.
25 See Kevin Brownlow, 'An Indelible Love for Africa,' in *Leni Riefenstahl's Africa* (Cologne: Taschen, 2002). p9.

26 See Susan Sontag, 'Fascinating Fascism,' *The New York Review of Books*, 6 February 1975.
27 See Leni Riefenstahl, *The Last of the Nuba* (London: Collins, 1976).
28 See Susan Sontag, 'Fascinating Fascism.' *The New York Review of Books*, 6 February 1975.
29 See Candace Slater, 'Amazonia as Edenic Narrative,' in *Uncommon Ground*, ed. William Cronon (London and New York: W.W. Norton, 1995). p115.
30 Abraham Lincoln signed the Yosemite Park Act in 1864 amid the Sierra Nevada Gold Rush and the forcible removal of the Yosemite Indians. See Mark David Spence, *Dispossessing the Wilderness: Indian Removal and the Making of the National Parks* (Oxford: Oxford University Press, 1999) pp102-106.
31 Ibid. p131.
32 Letter from Ansel Adams to Stewart L. Udall, Secretary of the Interior. 8 August 1964.Michael L. Fischer, 'Introduction – Ansel Adams,' in *Yosemite/Ansel Adams*, ed. Andrea G. Stillman (Boston: Little Brown and Company, 1995); Ansel Adams, *Yosemite/Ansel Adams* (Boston: Little Brown Publishing, 1995).
33 See Ansel Adams, *Yosemite/Ansel Adams* (Boston: Little Brown Publishing, 1995). p96
34 See Sebastião Salgado, *Genesis*, ed. Lélia Salgado (Cologne: Taschen, 2013). Caption to the photograph on p205 (caption enclosure p13).
35 See Adams, *Yosemite/Ansel Adams*, p96.
36 See Susie Linfield, *The Cruel Radiance: Photography and Political Violence* (Chicago: University of Chicago Press, 2012). p44.
37 See Salgado, *Genesis*, p7.
38 See Ariella Budick, 'Sebastião Salgado: Genesis, ICP, New York,' *Financial Times*, 15 October 2014.
39 See Van Reybrouck, *Congo: The Epic History of a People*, p92.
40 See Christina Twomey, 'Severed Hands: Authenticating Atrocity in the Congo, 1904-13,' in *Picturing Atrocity: Photography in Crisis*, ed. Geoffrey Batchen, et al. (London:

Reaktion Books, 2012).

41 See Mark Twain, 'King Leopold's Soliloquy,' (Boston, Mass.: P. R. Warren, 1905); ibid. p39.

42 See Ian Berry, *Living Apart: South Africa under Apartheid* (London: Phaidon, 1996). p87

43 See ibid. p12.

44 See Mary Warner Marien, *Photography: A Cultural History* (London: Laurence King, 2010). p325.

45 See Ernest Cole, *House of Bondage* (New York: Random House, 1967). p20.

46 See Struan Robertson, 'Ernest Cole in the House of Bondage,' in *Ernest Cole*, ed. Gunilla Knape (Göttingen: Steidl, 2010). p32.

47 See Jim Hughes, *Shadow & Substance* (New York: McGraw-Hill, 1989). p26.

48 See Glenn G. Willumson, *W. Eugene Smith and the Photographic Essay* (Cambridge: Cambridge University Press, 1992). p151.

49 Cited in Hughes, *Shadow & Substance*. p280.

50 Ibid. p168.

51 See Wayne F. Miller, *Chicago's South Side 1946-1948* (Berkeley and Los Angeles: Thames & Hudson, 2000).

52 See Mary Warner Marien, *Photography: A Cultural History*. (London: Laurence King, 2010). p313.

53 See Stuart Franklin, 'Wayne Miller,' in *Magnum Magnum* (London: Thames & Hudson, 2007). p372.

CHAPTER 3

1 See Liza Picard, *Dr Johnson's London* (London: Phoenix Press, 2001). p124.

2 See John Tagg, *The Burden of Representation: Essays on Photographies and Histories* (London: Macmillan, 1988). p152.

3 See Derrick Price, 'Surveyors and Surveyed: Photography out and About,' in *Photography: A Critical Introduction*, ed. Liz Wells (London: Routledge, 1998). pp81-81 and Abigail Solomon-Godeau, *Photography at the Dock: Essays on Photographic History, Institutions, and Practices* (Minneapolis: University of Minnesota Press, 1991). p176.

4 See Luc Sante, *Low Life* (London: Granta Books, 1991). pp34-35.

5 See Patricia Pace, 'Staging Childhood: Lewis Hine's Photographs of Child Labour,' *The Lion and the Unicorn 26*, no. 3 (2002). p325.

6 See Vicki Goldberg, *Lewis W. Hine: Children at Work* (Munich: Prestel, 1999). p19.

7 See Daile Kaplan, ed. *Photo Story: Selected Letters and Photographs of Lewis W. Hine* (Washington and London: Smithsonian Institution Press, 1992). pxxiv.

8 Cited in Cornell Capa, *The Concerned Photographer* (New York: Grossman Publishers, 1968).

9 This may have been because Hine had not wanted to surrender his negatives and control his own printing. See letters from Roy Stryker in Kaplan, *Photo Story: Selected Letters and Photographs of Lewis W. Hine.*

10 See Tagg, *The Burden of Representation: Essays on Photographies and Histories*. p169. Tagg suggests that more than a third of the original archive was lost in this way. William Jones published a (2010) book *Killed: Rejected Images of the Farm Security Administration* depicting 157 of these perforated images.

11 See Milton Meltzer, *Dorothea Lange* (New York: Farrar, Strauss & Giroux, 1978). p128.

12 Cited in Dorothea Lange and Paul S. Taylor, *An American Exodus: A Record of Human Erosion* (New York: Reynal & Hitchcock, 1939). p102.

13 See ibid. p135.

14 It was a different photograph from the series that was published in the *San Francisco News* on 10 March 1936. *Migrant Mother* was first published in the *Survey Graphic* in September 1938. See also Milton Meltzer, *Dorothea Lange*. (New York: Farrar, Strauss & Giroux, 1978). p134. It is also not clear why Nipomo, a homestead in San Luis Obispo, is usually written inaccurately as Nipoma.

15 Cited in ibid. p133.

16 Cited in Robert Coles, *Doing Documentary Work* (Oxford: Oxford University Press, 1997).

17 Heide Fehrenbach and David Rodogno, eds., *Humanitarian Photography: A History* (Cambridge: Cambridge University Press, 2015).

18 Ibid.

19 See Julio Cortázar, 'Humanitario', in *Humanitario*, ed. Sara Facio and Alicia D'Amico (Buenos Aires: La Azotea, 1976). p7. See also Basaglio, *Morire Di Classe.*

20 See Primo Levi, *If This Is a Man and the Truce* (London: Abacus, 1987). p33.

21 Cited in Michel Foucault, *Madness and Civilization: A History of Insanity in the Age of Reason* (London: Routledge, 1967). p241.

22 Ibid. p72.

23 Cited in Eugene Richards, *A Procession of Them* (Austin, Texas: University of Texas Press, 2008).

24 See *The Fat Baby: Stories by Eugene Richards* (London: Phaidon, 2004). p429.

25 See Cortázar, 'Humanitario'.

26 See Anne Wilkes Tucker, 'Photographic Facts and Thirties America,' in *Observations: Essays on Documentary Photography*, ed. David Featherstone (Carmel, California: The Friends of Photography, 1984). p48.

27 See Evelyn Waugh, *Brideshead Revisited* (London: Chapman and Hall, 1960 (1944)).

28 Paul Trevor, by email, June 2015.

29 See Nicholas Battye, Chris Steele-Perkins, and Paul Trevor, eds., *Survival Programmes: In Britain's Inner Cities* (Milton Keynes: Open University Press, 1982). p24.

30 Ibid. p7.

31 See Oscar Lewis, 'The Culture of Poverty', *American* 215, no. 4 (October 1966), p21.

32 See Stephen Nathan Haymes, María Vidal de Haymes, and Reuben Miller, Jonathan Miller, eds., *The Routledge Handbook of Poverty in the United States* (London and New York: Routledge, 2015). p43. In 2011 43.6 million people lived below the poverty line. When Oscar Lewis wrote on the subject in 1966 he claimed that 18 million families – a little more than 50 million individuals were living below the poverty line

in the United States. Lewis, 'The Culture of Poverty'. If the figure is correct the percentage would have been higher, accounting for population increase, unless the poverty line itself has shifted.

33 Amartya Sen wrote that 'The starving person who does not have the means to command food is suffering from an entitlement failure, and the causal antecedents of this may lie in factors far away from food production as such.' A. Sen, 'Food Entitlements and Economic Chains', in *Hunger in History: Food Shortage, Poverty and Deprivation*, ed. L. Newman (Oxford: Blackwell, 1990). p375.

34 Cited in Jim Goldberg, *Raised by Wolves* (New York: Scalo, 1995). pp296-297.

35 Jessica Dimmock (2006) cited from her Inge Morath Award text. http://www.ingemorath.org/index.php/2010/05/jessica-dimmock-usa-2/?show=all

36 See Charles Hagen, 'Review/Photography; 'Cocaine True': Art or Sensationalism?,' *The New York Times*, 11 March 1994. Hagen did not ask for a re-ordering of the narrative, but wrote, in a piece titled 'Art or Sensationalism': 'Mr Richards too closely follows the standard media version of the impact of drugs.'

37 By the editor of *Granta*, Bill Buford (1986). The book tells the story of Dorothea Lynch's life and death from breast cancer in intimate and yet unflinching honesty. The photographs are by Eugene Richards.

38 Cited in Stephen Nicholas, 'Afterword,' in *Cocaine True, Cocaine Blue*, ed. Eugene Richards (New York: Aperture, 1994).

39 See Darcy Padilla, *Family Love* (Paris: La Martinière, 2015). Translation from French provided by Darcy Padilla.

40 Cited in ibid.

41 Ibid.

42 See Mason Klein and Catherine Evans, *The Radical Camera* (New Haven and London: Yale University Press, 2011). p31.

43 See Anne Wilkes Tucker, 'A Rashomon Reading,' in *The Radical Camera*, ed. Mason Klein and Evans Catherine (New Haven and

London: Yale University Press, 2011). p72.

44 See Ken Light, *Witness in Our Time*, 2nd ed. (Washington: Smithsonian Books, 2010). p35.

45 See Monique Berlier, 'Reading of the Family of Man,' in *Picturing the Past: Media, History and Photography*, ed. Bonnie Brennen and Hanno Hardt (Urbana and Chicago: University of Chicago Press, 1999). p209.

46 Cited in Marien, *Photography: A Cultural History*.

47 Kate Soper, *Humanism and Anti-Humanism* (London: Hutchinson, 1986).

48 John Banville, in conversation with the author, 2015

49 Jim Hughes, *Shadow & Substance* (New York: McGraw-Hill, 1989).

50 Ibid.

51 Shannon Jenson, application text for the Inge Morath Award. www.ingemorath.org/index.php/2014/09/shannon-jensen-a-long-walk/ Accessed September 2015.

CHAPTER 4

1 See Michel Poivert, *Gilles Caron: Le conflit intérieur* (Arles: Editions Photosyntheses, 2013). p167.

2 Cited in Christian Frei, 'war photographer,' (Switzerland, 2001).

3 Ernst Friedrich, *War against War*, vol. 1 (Berlin: Freiejugend, 1924). p21.

4 Ernest Hemingway, 'Dying, Well or Badly,' *Ken*, 21 April 1938.

5 See Julian Stallabrass, 'The Power and Impotence of Images,' in *Memory of Fire: Images of War and the War of Images*, ed. Julian Stallabrass (Brighton: Photoworks, 2013); Paul Wombell, *Battle Passchendale 1917 – Evidence of War's Reality* (London: Travelling Light, 1981); and Phillip Knightley, *The First Casualty* (New York and London: Harcourt Brace Janovich, 1975). p99.

6 See A.J.P Taylor, ed. *The Russian War* (London: Jonathan Cape, 1978). p54

7 Ibid. p12

8 Ibid.

9 Elie Wiesel, *Night* (London: Penguin, 1972). p34.

10 Rupert Jenkins, ed. *Nagasaki Journey: The Photographs of Yosuke Yamahata* (Rohnett Park, California: Pomegranate Artbooks, 1995). pp102-103.

11 Doryun Chong, ed. *Tokyo 1955-70: A New Avant-Garde* (New York: The Museum of Modern Art, 2012). p101.

12 See Stuart Franklin, 'Griffiths, Philip Jones (1936–2008),' in *Oxford Dictionary of National Biography* (Oxford: Oxford University Press, 2012).

13 Cited in Peter Howe, *Shooting under Fire: The World of the War Photographer* (New York: Artisan, 2002). p72. For a report on the tide of disillusion sweeping Vietnam, see Larry Burrows, 'Vietnam: A Degree of Disillusion,' *Life*, 19 September 1969. pp66-75.

14 Cited in ibid. p134. Obafemi Awolowo was an accomplished lawyer, educated at the University of London. See Chinua Achebe, *There Was a Country: A Personal History of Biafra* (London: Penguin Books, 2012). p45.

15 See Chibuike Uche, 'Oil, British Interests and the Nigerian Civil War,' *Journal of African Studies* 49 (2008). p113.

16 See Don Mitchell, 'There's No Such Thing as Culture: Towards a Reconceptualization of the Idea of Culture in Geography,' *Transactions of the Institute of British Geography* 20 (1995). Poivert, *Gilles Caron: Le conflit intérieur*. p167. Also, Jacques Bergier and Bernard Thomas, *La Guerre Secrète Du Pétrole* (Paris: Éditions Denoël, 1968).

17 See Frederick Forsyth, *The Biafra Story* (Barnsley: Pen & Sword, 2007).

18 Frederick Forsyth, in his account of the Biafran War, was quick to praise the journalist but failed to mention the photographer. Michael Leapman, by contrast, described the pair (he and Ronald Burton) as a team who had travelled together for ten days through the war-torn country noting that most of the weapons being aimed at the Biafrans were British. Michael Leapman, 'The Land of No Hope,' *The Sun*, 12

June 1968. p2. It is also known that the Soviet Union were decisive military players in federal Nigeria's air war against Biafra.

19 See Alex Mitchell, *Come the Revolution: A Memoir* (Sydney: NewSouth Publishing, 2011). p145.

20 See Don McCullin, *Unreasonable Behaviour: An Autobiography* (London: Jonathan Cape, 1990). p124

21 Ibid. p124

22 See Terence Wright, *Visual Impact: Culture and Meaning of Images* (Oxford: Berg, 2008).

23 See Don McCullin, *Sleeping with Ghosts: A Life's Work in Photography* (London: Jonathan Cape, 1994). p96.

24 See McCullin, *Unreasonable Behaviour.*

25 See Ibid. p174.

26 See Lasse Heerten and Dirk Moses, 'The Nigeria–Biafra War: Postcolonial Conflict and the Question of Genocide,' *Journal of Genocide Research* 16, no. 2-3 (2014). Links had already been made between the Igbo and the Jewish diaspora, due to the Igbo's openness to emerging opportunities – unencumbered by traditional cultural constraints – to Jewish intellectual successes, and subsequent victimization. See Achebe, *There Was a Country.* p75.

27 See James Nachtwey, *Inferno* (London: Phaidon, 1999).

28 Ibid. p469.

29 James Nachtwey, in conversation with the author, September 2015.

30 See Nachtwey, *Inferno*. p470.

31 See Alex de Waal, *Famine Crimes: Politics and the Disaster Relief Industry in Africa* (London: Villiers Publications, 1997). pp163-167.

32 James Nachtwey, in conversation with the author, September 2015.

33 See Alex de Waal, *Famine Crimes: Politics and the Disaster Relief Industry in Africa* (London: Villiers Publications, 1997); Mike Davis, *Late Victorian Holocausts* (London: Verso, 2001).

34 See Alex de Waal, 'A Fitful Apocalypse,' *Times Literary Supplement*, 26 March 1993

35 John Taylor contests Sontag's argument in John Taylor,

Body Horror: Photojournalism, Catastrophe and War (Manchester: Manchester University Press, 1998).; Susie Linfield, in a measured discussion, appears to support Sontag's views on the subject, certainly in her discussion on James Nachtwey in Susie Linfield, *The Cruel Radiance: Photography and Political Violence* (Chicago: University of Chicago Press, 2012).

36 Cited in Lucy R. Lippard, 'Susan Meiselas: An Artist Called,' in *Susan Meiselas: In History*, ed. Kristen Lubben (Göttingen: Steidl, 2008). p218. Originally published in 'Culture Maker – Jay Kaplan Interviews Photographer Susan Meiselas', CULTUREFRONT, Fall 1993, pp. 48-56.

37 See A.J.P Taylor, *The Russian War*. p 141.

38 James Nachtwey, in conversation with the author, September 2015.

39 See Sebastião Salgado, *L'Homme en Détresse*. 1986.

CHAPTER 5

1 See Wilhelm Korner, 'Vom Arbeitfoto Zur Sozialen Und Politischen Reportage I,' *Arbeiterfotografie* 17 (1979).

2 Josef Koudelka, *Wall: Israel and Palestinian Landscapes 2002-2012* (New York and Paris: Aperture and Xavier Barral, 2013). p42/43.

3 See Daniel Joseph Boorstin, *The Image: A Guide to Pseudo-Events in America*. (New York: Vintage, 1961).

4 See Karl Gernot Kuehn, *Caught: The Art of Photography in the German Democratic Republic* (Berkeley: University of California Press, 1997). p5.

5 See Susan Sontag, 'Fascinating Fascism,' *The New York Review of Books*, 6 February 1975. p3.

6 See Philippe Chancel, *Arirang, Coree Du Nord, Le Plus Grand Spectacle Du Monde* (Paris: Favre, 2008).

7 Ibid.

8 Michael Kamber, *Photojournalists on War: Untold Stories from Iraq* (Austin, Texas: University of Texas Press, 2013). p146/7.

9 See Peter Maass, 'The Toppling:

How the Media Influenced a Minor Moment in a Long War,' *The New Yorker*, 10 January 2011.

10 See Steven Lee Myers, 'At War: Notes from the Front Lines', *The New York Times* blog, 20 August 2010.

11 See Maass, 'The Toppling: How the Media Influenced a Minor Moment in a Long War'.

12 Ibid.

13 See John Gittings, *The Changing Face of China: From Mao to Markets* (Oxford: Oxford University Press, 2005) p78.

14 Tiananmen Square appears on all government seals etc. 'The gate became an emblem, its image replicated in isolation on banknotes and coins, on the front page of all government documents, and in the nation's insignia.' Wu Hung, 'Tiananmen Square: A Political History of Monuments', *Representations*, 35, Summer 1991, pp84-117. p88.

15 See Robert L. Suettinger, *Beyond Tiananmen: The Politics of U.S. – China Relations*, 1989-2000 (Washington D.C.: The Brookings Institute, 2003).

16 See Melinda Liu, 'The Goddess of Democracy,' *Media Studies Journal*, Covering China issue (1999).

17 For example in 1978/9 a 'Democracy Wall' protest movement evolved where news and ideas, often in the form of big-character posters (*dazibao*), were posted in Xicheng District, Beijing.

18 Bai Meng, a member of the student core leadership recalled: 'few of us thought about democracy when we first started. I didn't see any collective awareness at that time.' He Zhou, *Mass Media and Tiananmen Square*. (New York: Nova Science Publishers, 1996).

19 Bai Meng: 'from April 15-27th the VOA [Voice of America] was our primary source of information. The term 'pro-democracy' obviously gave many of us a clue as to what this movement would be. My own idea of a democracy movement was made clearer and reinforced by the VOA's coverage.' He Zhou, *Mass Media and*

Tiananmen Square. p140.
'VOA began to broadcast in China in 1944. The mission was to counteract communism.' Ibid. p77.

20 See Joan Shorenstein Barone Center on the Press, Politics and Public Policy, 'Turmoil at Tiananmen: A Study of U.S. Press Coverage of the Beijing Spring of 1989,' (Harvard: John F. Kennedy School of Government, Harvard University, 1992).

21 See *South China Morning Post,* 4 June 1989, p25.

22 For more on the promotion and funding of pro-democracy movements in Ukraine to gain political leverage see J. Mearsheimer, 'Why the Ukraine Crisis Is the West's Fault: The Liberal Delusions that Provoked Putin', *Foreign Policy* (September/October 2014).

23 Nicholas Kristof and Sheryl Wu Dunn, *China Wakes* (New York: Times Books, 1994). p78.

24 See for example Andrew Higgins 'As the dead are removed many take their place', *The Independent*, 5 June 1989. p11; Catherine Sampson, 'Bravery, hatred and ongoing carnage', *The Times*, 6 June 1989, p1. See Jan Wong, *Red China Blues: My Long March From Mao to Now.* (Toronto: Doubleday, 1996). Also see, *South China Morning Post,* 5 June 1989, pp1/3. In this unattributed account 30 people were reported to have died. Confirmed in Document 32 declassified SITREP from the US Embassy's chronology: '4th June 10.25–12.10 – four separate incidents of indiscriminate fire on crowds in front of Beijing Hotel. At least 56 civilian casualties.' (NSA Archive: http://www2.gwu.edu/~nsarchiv/NSAEBB/NSAEBB16/docs/doc32.pdf).

25 Fred Scott, 25 October 2014, by email.

26 There is still controversy over the date of this event. I made my position on the date clear in Kristen Lubben's (2011) *Magnum Contacts Sheets* while writing on Tiananmen Square. Of about 11 eyewitnesses and fellow travellers who were in Beijing on the day, nine agree that the image was

taken on 4 June (listed here with their affiliations in June 1989): Andrew Higgins, *The Independent*; Guy Dinmore, *Reuters;* Beijing Bureau Chief, Arthur Tsang; *Reuters;* Catherine Sampson, *The Times*; Brian Robbins, *CNN;* Jonathan Shaer, *CNN;* Fred Scott, *BBC;* Eric Thirer, *BBC;* Charlie Cole, *Newsweek*. The Chinese academic Wu Hung also confirms the date of 4 June in Wu Hung, *Remaking Beijing: Tiananmen Square and the Creation of a Political Space.* (London: Reaktion, 2005) p14, as does the Mike Chinoy film (2014) *On Assignment: China.*

27 Magnum Photos was founded in 1947 and today has offices in Paris, London, New York and Tokyo.

28 Jonathan Shaer by email, October 2014.

29 Jonathan Shaer, the CNN cameraman who filmed the tank man sequence claims to be alone in recording with a video camera on a tripod, and therefore to have footage of high quality. Shaer claims that the other US networks were monitoring the satellite feeds, dialled in the correct frequency, and recorded the sequence. There is no encryption. Generally ownership is respected (Shaer, in conversation with the author, 2014).

30 The Reuters photographer Arthur Tsang filed an image of the tank man climbing onto the tank on June 4th, but it garnered little interest from his superiors (Tsang, in conversation with the author, 2014). At the same time CNN transmitted two still images from the video footage from Beijing but they were not broadcast (Ibid.).

31 It should also be noted that in at least four British national newspapers the tank man photograph did not run at all during June 1989: the *Guardian*, the *Independent*, the *Sun* and *Evening Standard*.

32 *Neue Zürcher Zeitung, Sydney Morning Herald, Süddeutsche Zeitung, El Pais* and the *Independent* were some of the national newspapers who chose to run with the stand-off between the PLA and civilians rather than the tank man on their front pages on

6 June 1989.

33 Andrew Higgins by email 15 October 2014.

34 Wire services uniquely at that time had subscription arrangements with newspapers that allowed them to use any image that was transmitted without additional cost. Images from photo agencies carry a licensing fee that few newspapers are willing to pay.

35 See *South China Morning Post* 4 June 1989, p23: CCTV reported on soldiers being attacked. See also, Jan Wong, *Red China Blues: My Long March From Mao to Now* (Toronto: Doubleday, 1996).

36 My picture appeared as the first image in *Time* Year in Pictures. 'Though distant and grainy, this photograph of a Chinese man standing down a tyrannical regime is the most extraordinary image of the year. It is flesh against steel, mortality against the onrush of terror, the very real stuff of courage.' David Perlmutter, *Photojournalism and Foreign Policy: Icons of Outrage and International Crises* (Westport, Conn: Praeger, 1998)

37 Richard Gordon, 'One Act, Many Meanings,' *Media Studies Journal*, Covering China Issue, 1999. p82.

38 Robert Hariman and John Louis Lucaites, *No Caption Needed: Iconic Photographs, Public Culture, and Liberal Democracy* (Chicago: Chicago University Press, 2007). p214.

39 See Richard Gordon, 'One Act, Many Meanings,' *Media Studies Journal*, Covering China Issue, 1999.

40 See for example L. Lim, *The People's Republic of Amnesia: Tiananmen Revisited.* (New York: Oxford University Press, 2014)

41 I am grateful to Charlie Cole for raising this point.

42 Before 1989 it may have been be the most widely reproduced photograph in history. See V. Goldberg, *The Power of Photography* (New York: Abbeville Publishing Group, 1991). As Joe Rosenthal said in 1955: 'It has been done in oils, watercolours, pastels, chalk and matchsticks … It has been sculpted in ice

and in a hamburger.' Cited in ibid. p143. In 1990 it was recreated as an advertisement for h.i.s. jeans in ibid.

CHAPTER 6

1 A more recent example of this approach we find in the film *Pride* (Warchus, 2014).

2 See William Cronon, *Nature's Metropolis* (New York and London: W.W. Norton, 1991).

3 My story on British doctors in Syria, 'State of Emergency' was published in *The Sunday Times Magazine*, 29 December 2013.

4 Cited in David Campbell, 'The Iconography of Famine,' in *Picturing Atrocity: Photography in Crisis*, ed. Geoffrey Batchen, et al. (London: Reaktion Books, 2012). p86.

5 See Michel Poivert, *La Photographie Contemporaine* (Paris: Flammarion, 2010).

6 See Akihito Yasumi, 'The Trajectory of Nakahira Takuma: Situating the Republication of *For a Language to Come*,' in *For a Language to Come*, ed. Nakahira Takuma (Tokyo: Osiris, 2010).

7 Pictorialism's core assertion was that photography could be a vehicle of personal expression rather than factual description Alison Nordström and David Wooters, 'Crafting the Art of the Photograph,' in *Truthbeauty: Pictorialism and the Photograph as Art, 1845-1945*, ed. Thomas Padon (Rochester: International Museum of Photography and Film, 2008). p33. Also see Michel Poivert, 'Degenerate Photography? French Pictorialism and the Aesthetics of Optical Aberration,' *Études photographiques* 23, May 2009 and Pauline Martin, 'Le Flou of the Painter Cannot Be Le Flou of the Photographer,' ibid. p25, May 2010.

8 See Sarah Greenough, *Looking In: Robert Frank's The Americans* (Washington DC: National Gallery of Washington/Steidl, 2009) p18. From 1941–66 Brodovitch ran a 'design laboratory' out of his apartment, by invitation only. Kerry William Purcell, *Alexey Brodovitch* (London: Phaidon, 2002). p6.

9 See Takuma Nakahira, 'Has Photography Been Able to Provoke Language?,' in *For a Language to Come* (Tokyo: Osiris, 2010); 'Looking at the City or, the Look from the City,' in *For a Language to Come* (Tokyo: Osiris, 2010).

10 Cited in Greenough, *Looking In: Robert Frank's the Americans*. p122. Pictures from Frank's maquette *Black, White & Things*, as well pictures of Detroit are published in Robert Frank, *Storylines* (Grönnigen: Steidl, 2004).

11 See Max Kozloff, 'The Utopian Dream: Photography in Soviet Russia 1918-1939,' ed. Los Angeles Schickler/Lafaille Collection (New York: Laurence Miller Gallery, 1992). p12.

12 See Karl Gernot Kuehn, *Caught: The Art of Photography in the German Democratic Republic* (Berkeley: University of California Press, 1997) p3.

13 This was a reference to Albert Renger-Pazsch's book *The World is Beautiful*. See Walter Benjamin, 'The Author as Producer,' *New Left Review* 1, no. 62 (1970).

14 See Leslie George Katz, 'Afterword,' in *Factory Valleys*, ed. Lee Friedlander (New York: Callaway Editions, 1982).

15 See Carol Diehl, 'The Toxic Sublime,' *Art in America*, February 2006.

16 Ibid. p122.

17 See Sylvia Grant and John Berger, 'Walking Back Home,' in *In Flagrante*, ed. Chris Killip (London: Secker & Warburg, 1988). p87.

18 Ibid.

19 See Heiner Müller, *Ein Gespenst Verlässt Europa* (Köln: Kiepenheuer & Witsch, 1990).

CHAPTER 7

1 See Max Kozloff, *The Privileged Eye: Essays on Photography* (Albuquerque: University of New Mexico Press, 1987). p20.

2 See Ian Walker, *City Gorged with Dreams: Surrealism and Documentary Photography in Interwar Paris* (Manchester: Manchester University Press, 2002).

3 Cited in Edmund White, *The Flâneur* (London: Bloomsbury, 2001).

4 See John Szarkowski, *Atget* (New York: Museum of Modern Art, 2003). p17.

5 See Agnès Sire, 'Documentary and Anti-Graphic Photographs: Manuel Álvarez Bravo, Henri Cartier-Bresson and Walker Evans,' ed. Fondation Henri Cartier-Bresson (Göttingen: Steidl, 2004). p30.

6 See Peter Galassi, *Henri Cartier-Bresson: The Early Work* (New York: The Museum of Modern Art, 1987). p15.

7 See Susan Sontag, 'Introduction,' in *One-Way Street and Other Writings*, ed. Walter Benjamin (London: New Left Books, 1979). p20.

8 See Benjamin, 'Surrealism,' in *One-Way Street and Other Writings*

9 One of his favourite books, published in 1931 was Matila Ghyka's *Le Nombre D'Or*. See Clément Chéroux, *Henri Cartier-Bresson: Here and Now* (London: Thames & Hudson, 2014). p74.

10 Ibid. p85.

11 Personal communication, cited in Stuart Franklin, 'Crooked Timber: W. Eugene Smith, Josef Sudek, and Humanist Photography,' *Harper's Magazine*, December 2014.

12 See Henri Cartier-Bresson, *The Mind's Eye* (New York: Aperture, 1999). p98.

13 Cited in Marie de Thézy, *La Photographie Humaniste* (Paris: Contrejour, 1992). p15.

14 See John Berger, 'Henri Cartier-Bresson,' *Aperture*, Winter 1995 1995. p15.

15 See James Agee, 'A Way of Seeing,' in *A Way of Seeing*, ed. Helen Levitt and James Agee (New York: Viking Press, 1965) p77.

16 Cited in Henri Cartier-Bresson, interview by Sheila Turner-Seed, 1971, 2013.

17 See Pablo Neruda, 'El Vagabundo De Valparaíso,' in *Valparaíso*, ed. Agnès Sire (Paris: Éditions Hazan, 1991).

18 See Jean-Paul Sartre, *Search for a Method* (New York: Vintage, 1968). p57.

19 See John Berger and Jean Mohr, *Another Way of Telling* (Cambridge: Granta Books, 1989). p89.

20 See Leo Tolstoy, *What Is Art?* (London: Penguin Books, 1995). p40. The essay was originally published in 1898.

21 Cited in Sarah Greenough, *Looking In: Robert Frank's The Americans* (Washington DC: National Gallery of Washington/ Steidl, 2009). p31.

22 Cited in Mark Haworth-Booth, 'William Eggleston: An Interview,' *History of Photography* 17, no. 1 (1993). p53.

23 Cited in John Szarkowski, *Winogrand: Fragments Fom the Real World* (New York: Museum of Modern Art, 1988). p31.

24 Cited in Juliet Hacking, *Photography: The Whole Story* (London: Thames & Hudson, 2012). p368.

25 Cited in Philip-Lorca di Corcia and Leo Rubenfien, 'Revisiting the Gary Winogrand Archive,' *Aperture*, Spring 2013.

26 Cited in Susan Sontag, *On Photography* (Harmondsworth: Penguin, 1977). p197.

27 See Kerry William Purcell, *Alexey Brodovitch* (London: Phaidon, 2002).

28 See Helen Gary Bishop, 'First Person, Feminine,' in *Women Are Beautiful* (New York: Farrar, Strauss & Giroux, 1975).

29 See Alex Webb and Rebecca Norris Webb, *On Street Photography and the Poetic Image* (New York: Aperture, 2014). p47.

30 Cited in Alec Soth, *Sleeping by the Mississippi* (Göttingen: Steidl, 2004).

CHAPTER 8

1 The acknowledgement of photography as an interpretive act was introduced by the Australian writer and academic David Campbell during a World Press focus group session at Thomson Reuters in London on 20 August 2015.

2 See Tatiana Baltermants, 'Intro-duction,' in *Faces of a Nation: The Rise and Fall of the Soviet Union, 1917-1991*, ed. T. Von Laue and A. Von Laue (Golden, Colorado: Fulcrum Publishing, 1996).

3 See James Ryan, *Picturing Empire: Photography and the Visualization of the British Empire*. (London, Reaktion Books, 1975) p175.

4 See Aaron Scharf, *Art and Photography* (London: Allan Lane, 1968). p24.

5 Ibid.

6 See Phillip Knightley, *The First Casualty* (New York and London: Harcourt Brace Janovich, 1975). p210.

7 See José Manuel Susperregui, *Sombras De La Fotografía* (Bilbao: Universidad del Pais Vasco, 2009)

8 See James L. Braughman, *Henry R. Luce and the Rise of the American News Media* (Washington D.C.: John Hopkins University Press, 1987) p79.

9 Ibid.

10 See Alex Kershaw, *Blood and Champagne: The Life and Times of Robert Capa* (London: Pan Books, 2001); ibid. p55. For the original account of the military diary entry see Alfred Kantoro-wicz, *Spanisches Kreigstagebuch* (Frankfurt am Main: Fischer, 1982). p327.

11 Ibid. p328. Capa also took still photographs on 24 and 25 June that were uncovered in one of the three handmade cardboard suitcases that turned up in Mexico in 2007 containing about 3,500 35mm images from David 'Chim' Seymour, Robert Capa and Gerda Taro. See Cynthia Young, *The Mexican Suitcases*, ed. Inter-national Center for Photography (Göttingen: Steidl, 2010).

12 See Brian Winston, *Claiming the Real II: Documentary: Grierson and Beyond*, 2nd ed. (London: Palgrave Macmillan, 2008). p14 asked: 'What actuality is left after the 'creative treatment'.

13 See Errol Morris, *Believing Is Seeing: Observations on the Mysteries of Photography* (New York: Penguin Books, 2014) p124

14 See John Szarkowski, *American Landscapes: Photographs from the Collection of the Museum of Modern Art* (New York: Museum of Modern Art, 1981). p9.

15 See Claudia Andujar, *A Vulnerabilidade Do Ser* (São Paolo: Editora Cosak & Naify, 2005); see also Horacio Fernández, *The Latin American Photobook* (New York: Aperture, 2011).

16 For more details on Robert Visser's photographic career, see Christraud Geary, *In and out of Focus: Images from Central Africa, 1885-1960* (London: Philip Wilson Publishers, 2002). pp27-29.

17 Ana Casas Broda, in conversation with the author, 2014. Martín remembered the video game he was playing.

18 See Michael Collins, 'Another Way of Seeing: Gauri Gill & Rajesh Vangad,' *Granta* 130 (2015).

19 Ibid.

20 Gauri Gill, in conversation with the author, 2015.

21 See Dr Indepal Grewal in the journal *Trans-Asia Photography Review*, Spring 2015. http://quod. lib.umich.edu/t/tap/7977573.000 5.205?view=text;rgn=main.

22 See Christopher Pinney, *Camera Indica: The Social Life of Indian Photographs* (Chicago: University of Chicago Press, 1998). p80.

AFTERWORD

1 See Mary Bergstein, *Mirrors of Memory: Freud, Photography, and the History of Art* (Ithaca, New York: Cornell University Press, 2010). p18.

2 Cited in Robert Coles, *Doing Documentary Work* (Oxford: Oxford University Press, 1997).

3 Cited in Leo Tolstoy, *What Is Art?* (London: Penguin Books, 1995). p40.

4 See Henri Lefebvre, *The Produc-tion of Space* (Oxford: Blackwell, 1974). p97.

5 Cited in Jim Hughes, *Shadow & Substance* (New York: McGraw-Hill, 1989). p498. Original essay by W. Eugene Smith can be found in *Camera* 35, April 1974, p27.

SELECTED BIBLIOGRAPHY

Geoffrey Batchen, et al. *Picturing Atrocity: Photography in Crisis* (London: Reaktion Books, 2012).

John Berger and Jean Mohr, *Another Way of Telling* (Cambridge: Granta Books, 1989).

Robert Coles, *Doing Documentary Work* (Oxford: Oxford University Press, 1997).

Mark Durden, 'Defining the moment' in *Creative Camera: Thirty Years of Writing*, ed. David Brittain (Manchester: Manchester University Press, 1998), pp290–295.

David Featherstone, ed., *Observations: Essays on Documentary Photography* (Carmel, California: The Friends of Photography, 1984).

Christraud Geary, *In and out of Focus: Images from Central Africa, 1885–1960* (London: Philip Wilson Publishers, 2002).

Heide Fehrenbach and David Rodogno, eds., *Humanitarian Photography: A History* (Cambridge: Cambridge University Press, 2015).

Robert Hariman and John Louis Lucaites, *No Caption Needed: Iconic Photographs, Public Culture, and Liberal Democracy* (Chicago: Chicago University Press, 2007).

Peter Howe, *Shooting under Fire: The World of the War Photographer* (New York: Artisan, 2002).

Jim Hughes, *Shadow & Substance* (New York: McGraw-Hill, 1989).

David Hurn and Bill Jay, *On Being a Photographer: A practical guide* (Oregon: Lenswork, 1997).

Michael Kamber, *Photojournalists on War: Untold Stories from Iraq* (Austin, Texas: University of Texas Press, 2013).

Phillip Knightley, *The First Casualty* (New York and London: Harcourt Brace Janovich, 1975).

David Levi Strauss, *Between the Eyes: Essays on Photography and Politics* (New York: Aperture, 2005).

Susie Linfield, *The Cruel Radiance: Photography and Political Violence* (Chicago: University of Chicago Press, 2012).

Kristen Lubben, ed., *Magnum Contact Sheets* (London: Thames & Hudson, 2011).

Catherine Lutz and Jane Collins, *Reading National Geographic* (Chicago: University of Chicago Press, 1993).

Mary Warner Marien, *Photography: A Cultural History* (London: Laurence King, 2010).

Russell Miller, *Magnum: Fifty Years at the Frontline of History* (London: Secker & Warburg, 1997).

Errol Morris, *Believing Is Seeing: Observations on the Mysteries of Photography* (New York: Penguin Books, 2014).

Takuma Nakahira, 'Has Photography Been Able to Provoke Language?,' in *For a Language to Come* (Tokyo: Osiris, 2010)

Martin Parr and Gerry Badger, *The Photobook: A History Vols. I, II & III* (London: Phaidon, 2004; 2006; 2014)

Christopher Pinney and Nicolas Peterson, *Photography's Other Histories* (Objects/Histories) (Durham, North Carolina: Duke University Press, 2003).

Michel Poivert, *Gilles Caron: Le conflit intérieur* (Arles: Editions Photosyntheses, 2013).

Max Quanchi, *Photographing Papua: Representation, Colonial Encounters and Imaging in the Public Domain* (Newcastle: Cambridge Scholars Publishing, 2007).

Fred Ritchin, *Bending the Frame: Photojournalism, Documentary, and the Citizen* (New York: Aperture, 2013).

Martha Rosler, 'In, around, and after thoughts (on documentary photography)', *The Contest of Meaning: critical histories of photography*, ed. Richard Bolton (Cambridge, Mass.: MIT Press, 1989), pp303–341.

Abigail Solomon-Godeau, *Photography at the Dock: Essays on Photographic History, Institutions, and Practices* (Minneapolis: University of Minnesonta Press, 1991).

Susan Sontag, *On Photography* (Harmondsworth: Penguin, 1977).

Susan Sontag, *Regarding the Pain of Others* (New York: Farrar, Straus and Giroux, 2003).

Julian Stallabrass, ed., *Documentary, Documents of Contemporary Art* (Cambridge, Mass: MIT Press, 2013).

Julian Stallabrass, 'The Power and Impotence of Images' in *Memory of Fire: Images of War and the War of Images*, ed. Julian Stallabrass (Brighton: Photoworks, 2013).

A.J.P Taylor, ed., *The Russian War* (London: Jonathan Cape, 1978).

John Taylor, *Body Horror: Photojournalism, Catastrophe and War* (Manchester: Manchester University Press, 1998).

Marie de Thézy, *La Photographie Humaniste* (Paris: Contrejour, 1992).

Alan Trachtenberg, ed. *Classic Essays on Photography* (Sedgwick: Leet's Island Books, 1980).

Alex Webb and Rebecca Norris Webb, *On Street Photography and the Poetic Image* (New York: Aperture, 2014).

Brian Winston, *Claiming the Real II: Documentary: Grierson and Beyond*, 2nd ed. (London: Palgrave Macmillan, 2008).

Wu Hung, *Remaking Beijing: Tiananmen Square and the Creation of a Political Space.* (London: Reaktion, 2005).

ACKNOWLEDGEMENTS

I wish to acknowledge the many people – friends and colleagues – who have helped to make this book possible. Making a book of this nature is never an individual act: it is a team effort reliant on the generosity of others and their faith in the outcome. Any errors or errors of judgement remain my own. The work was borne of initial conversations with Alain de Botton and Amanda Renshaw. I am grateful for their early enthusiasm and to Christopher Cox and Stacey Clarkson at Harper's Magazine for their encouragement as I began to write on photography. At Phaidon I am grateful to Deb Aaronson for her trust in the idea and in me. The team at Phaidon have shown nothing but kindness and conviction. I'd like to thank the editorial team of Victoria Clarke and Tim Cooke, and especially Ellen Christie – the project editor – who made the book the best it could possibly be, and to Rebecca Price (production), Julia Hasting (for her cover design) and Hans Dieter Reichert (for the book design). I'd like to thank Mark Durden for reviewing the manuscript; James Nachtwey who lent invaluable advice on Chapter 4; and to Martin Parr for his generosity in opening up his photobook collection more than once. Thank you to the many people who lent insight into their areas of expertise: Yoko from Osiris in Tokyo on the Provoke era in Japan; Michel Poivert on the work of Gilles Caron and Philippe Chancel; Marco Longari, Jim Hollander and Kevin Frayer for advice and support in Gaza; Annette Vowinckel and Rudi Thoemmes on East German photography; Oliva María Rubio and the team at La Fábrica in Madrid on staging; Lars Boering and the team at World Press Photo on manipulation; Charlie Cole, Arthur Tsang, Dario Mitidieri, Kate Adie, Andrew Higgins, John Gittings, Jonathan Shaer, Guy Dinmore, Catherine Sampson, Lorelei Goodyear, Fred Scott and Eric Thirer for sharing their memories on Tiananmen Square; and to the Moravska Museum in Brno; the Fondation Gilles Caron and the Philip Jones Griffiths Foundation. I wish to thank my friends and colleagues Rebecca McClelland, Barbara Stauss, Anne Lise Flavik, Leah Bendavid-Val, Biba Giacchetti, Shannon Ghannon, José Manuel Susperregui, Gauri Gill, Patrick Willocq, Paolo Verzone, Darcy Padilla, Ana Casas Broda, Christina de Middel, Paul Trevor and Don McCullin for their interest in my project. Thanks to my students in Paris, London, and Volda University College, Norway who have added meaningful debate: and especially Omar Sejnæs who read an early version of the manuscript. Finally, I would like to thank my friends and colleagues at Magnum Photos, especially Ian Berry, Chris Steele-Perkins, Josef Koudelka, Sohrab Hura, Mark Power, Carl de Keyser, Susan Meiselas, Alex Majoli, Hamish Crooks, Emily Graham and David Kogan, all of whom, in small but important ways, helped shape the book.

PICTURE CREDITS

Phaidon Press Limited
Regent's Wharf
All Saints Street
London N1 9PA

Phaidon Press Inc.
65 Bleecker Street
New York, NY 10012

phaidon.com

First published 2016
Reprinted in 2016, 2017
© 2016 Phaidon Press Limited

ISBN 978 0 7148 7067 0

A CIP catalogue record from this book
is available from the British Library and
the Library of Congress.

Commissioning Editor: Deb Aaronson
Project Editor: Ellen Christie
Production Controller: Rebecca Price

Cover designed by Julia Hasting
Designed by Hans Dieter Reichert

Printed in Hong Kong